Wherever I'm At

Wherever I'm At

An Anthology of Chicago Poetry

Edited by
Donald G. Evans
and
Robin Metz

The Chicago Literary Hall of Fame
in partnership with
After Hours Press
Elmwood Park, Illinois
and
Third World Press
Chicago, Illinois

Front Cover Artwork *Chicago Moth* by Tony Fitzpatrick

Wherever I'm At: An Anthology of Chicago Poetry
Donald G. Evans, Robin Metz, eds.
ISBN 978-0-578-36479-7
Copyright © 2022 by After Hours Press

After Hours Press
afterhourspress.com

Third World Press
thirdworldpressfoundation.org

The Chicago Literary Hall of Fame
chicagoliteraryhof.org

All rights reserved. No part of this book may be reproduced in any manner (except brief quotations for review purposes) without the written permission of the publisher.

Table of Contents

John Brzezinski, *untitled (photo)* .. 10
Foreword
Carlo Rotella ... 11
Introduction
Donald G. Evans ... 15
Poetry and Images
Xavier Nuez, *Step Through the Light (photo)* 20
Elise Paschen, *Kitihawa* .. 21
Averill Curdy, *In The Beginning* .. 22
Luis J. Rodriguez, *A Hungry Song in the Shadows* 23
Ruben Quesada, *When Winter Comes, 2030* 25
Angela Jackson, *Summer and the City* 26
Rachel DeWoskin, *chance, chicago* ... 28
Daniel Borzutzky, *Lake Michigan, Scene 0* 29
René Arceo, *La Búsqueda (artwork)* ... 34
Elaine Equi, *Ode to Chicago* .. 35
Charles Rossiter, *Memorial Day* ... 36
Faisal Mohyuddin, *Ella Fitzgerald, Entering Chicago by Train,
　　　　　　Remembers Her Mother's Voice* 38
cin salach, *construction* .. 40
Ed Roberson, *What Are We Drinking Here* 41
Michael Anania, *Steal Away* ... 43
Dmitry Samarov, *Inside/Outside (artwork)* 47
Kristiana Rae Colón, *where fun comes to die* 48
Naoko Fujimoto, *Lake Michigan* .. 50
Stuart Dybek, *Daredevil* ... 51
Regie Gibson, *It's A Teenage Thang* .. 52
Coya Paz, *list of wishes, first thing in the morning* 54
Maxine Chernoff, *Again* ... 55
Kara Jackson, *walking down milwaukee avenue* 56
Cynthia Gallaher, *Making Books at Hull House* 57
Laura Letinsky, *Time's Assignation (photo)* 59
Emily Jungmin Yoon, *Field* .. 60
Rey Andújar, *Musa Paradisiaca (Avondale by the River)* 62
Chuck Walker, *Sunday at The Green Line (artwork)* 64

Table of Contents

Sterling Plumpp, *Language* ..65
Reginald Gibbons, *Mekong Restaurant, 1986*66
Aimee Nezhukumatathil, *When I Am Six*68
Patricia Smith, *The West Side* ..69
David Trinidad, *Tiny Moon Notebook*70
Vidura Jang Bahadur, *Untitled, from the series "Rolling with the Punches," 2016 (photo)* ...77
Kay Ulanday Barrett, *Albany Park/Logan Square 1993-2000, Chicago, IL*78
Jennifer Steele, *In Search of Butterflies*81
Kelly Norman Ellis, *Saturday Class: The Rat*82
Campbell McGrath, *The Sun* ...83
Ana Castillo, *Chi-Town Born and Bred, Twentieth Century Girl Propelled
 With Flare into the Third Millennium (c.1999)*85
Phillip B. Williams, *Homan and Chicago Ave.*90
Tonika Lewis Johnson, *6329 S. Paulina from Folded Map Project (photo)*91
Heidy Steidlmayer, *Two Women in a Revolving Door at Water Tower*92
Chris Solis Green, *In The Blue Stairwell*93
Vida Cross, *Bronzeville at Night* ...95
Nicolás de Jesús, *En El Tren (artwork)*97
Elizabeth Alexander, *Blues* ..98
Marvin Tate, *Memories of a Dance Floor*100
Rachel Jamison Webster, *Our Lady of The Underpass*101
Reggie Scott Young, *Crime in Bluesville*102
Tyehimba Jess, *Long Live the Checkerboard Lounge,*103
Daniel McGee, *55th St. Underpass*104
Frank Spidale, *North Ave. Bridge (artwork)*105
Edward Hirsch, *I Missed The Demonstration*106
Joanne Diaz, *A Thousand Flowers*108
Quraysh Ali Lansana, *conundrum*110
Aviya Kushner, *Night On Wellington Avenue, Chicago*111
Sun Yung Shin, *Abracadabra, or A Spell for The Disappearance of Chicago's 한인마을* ..112
Haki R. Madhubuti, *Chicago Is Illinois Country*113
Rosellen Brown, *Lake Loving* ..114
Marianne Boruch, *Once At Berghoff's*115
Priscilla Huang, *Andersonville (artwork)*116
Sandra Cisneros, *Good Hotdogs* ...117
Tara Betts, *Donny & Minnie on the 72 Bus*118
Mike Puican, *Tequila and Steve* ..119
Krista Franklin, *In a condo on the southside of Chicago*121
Ira Sukrungruang, *There Is Nothing Else to Talk About*122

Table of Contents

Janet Ruth Heller, *At Miller's Pub* .. 123
Rachel Galvin, *Here in Chicago* .. 124
Paul D'Amato, *Open Pump, Pilsen 1993 (photo)* 125
Li-Young Lee, *The Cleaving* .. 126
Achy Obejas, *On The Shores of Lake Michigan* 134
Aleksandar Hemon, *International Experience* 135
Dwight Okita, *Notes For A Poem On Being Asian American* 136
Jac Jemc, *Dermestidae* ... 138
John Guzlowski, *Looking for Work in Chicago* 139
Ugochi Nwaogwugwu, *Lost and Found (The Soul of this Town)* 142
Marta Collazo, *Cullom Street* ... 144
Raych Jackson, *Sunrise* ... 145
Leopold Segedin, *Three Men with Microphone (c.1945) (artwork)* 146
Marc Kelly Smith, *Sandburg to Smith* ... 147
Jerome Sala, *Hercules vs. the Tyrants of Babylon* 150
Jan Bottiglieri, *Inauguration Day, 2009* 151
Richard Jones, *Walking the Dog* ... 153
Rose Maria Woodson, *Lawndale* .. 154
Edgar Garcia, *The Planetarium* .. 156
Nina Corwin, *Whose Law?* .. 158
Kerry James Marshall, *Untitled (policeman), 2015 (artwork)* 161
Juana Iris Goergen, *Reconquest* .. 162
 Translated by Silvia Tandeciarz
Barry Gifford, *The Season of Truth* ... 165
Christina Pugh, *Windy City* ... 166
P. Hertel, *untitled (photo)* .. 167
Arthur Ade Amaker, *Clive Jackson – What it is about Chicago...* 168
Kathleen Rooney, *Pastoral* .. 170
Useni Eugene Perkins, *Bronzeville Poet* 171
Johanny Vázquez Paz, *A World of Our Own* 173
Frank Varela, *The Raccoons of Humboldt Park...* 174
Alma Domínguez, *We Are Here to Stay (artwork)* 176
Julie Parson Nesbitt, *Ferris Wheel at Navy Pier* 177
Duriel E. Harris, *A Secret, Fatal Line* .. 178
Robbie Q. Telfer, *Chicago Wilderness* .. 179
Luisa A. Igloria, *Dear Epictetus, this is to you attributed:* 181
Marty McConnell, *the fidelity of disagreement* 182
avery r. young, *base(d) on a prompt from Phillip B. Williams* 184
Virginia Bell, *The Father* .. 185

Table of Contents

Angela Davis Fegan, *Letterpress posters at the Empty Bottle (artwork)*186
Tom Mandel, *Remedial Memorabilia,* .187
Dipika Mukherjee, *Printers Row, Chicago* .190
Tony Trigilio, *In the Intersection, Jackson and State* .191
Calvin Forbes, *State Street That Great Street* .192
Mary Kinzie, *The Mary Chapel* .193
Mohja Kahf, *I Cried for You in Chicago* .197
Raúl Niño, *February on Eighteenth Street* .198
Maureen Seaton, *Woman Circling Lake* .201
Mary Livoni, *Ashland #8 (photo)* .202
Albert DeGenova, *The Bus Stop* .203
Keith S. Wilson, *53rd street* .204
Patricia McMillen, *Yang* .206
Olivia Maciel Edelman, *Dear Lisi:* .207
Lasana D. Kazembe, *Chicago* .208
Amanda Williams, *Cadastral Shakings (Chicago v1), 2019 (artwork)*211
Vincent Francone, *Ashland Avenue* .212
Faisal Mohyuddin, *A Shared Oneness (artwork)* .220
Susan Yount, *Chicago 2004* .221
Carlos Cumpián, *La Décima Musa* .222
Peter Kahn, *Upstairs at Ronny's Steakhouse* .223
Robin Metz, *Midtown Lowdown* .224
Vincent Romero, *A Chicago Street* .225
Maya Marshall, *Montrose Beach, Before the Funeral* .226
Rashayla Marie Brown, *Chocolate City (Chicago: Johnson Publishing Co) (photo)* .227
Yolanda Nieves, *Remembering the Division Street Riots* .228
Grady Chambers, *Infinite Jest* .231
Emily Thornton Calvo, *My Chicago* .232
Bob Chicoine, *The Quincy Stop* .234
Monica Berlin, *Triple Elegy* .235
Eduardo Arocho, *Rainbow Shoes* .236
Sara Salgado, *The Last Poem About My Neighborhood* .237
Terry Evans, *Summer Bur Oak, Jackson Park (photo)* .238
Barry Silesky, *Tree of Heaven* .239
Jeffery Renard Allen, *Hush Arbor* .242
Simone Muench and Philip Jenks, *Dear Chicago –* .246
Beatriz Badikian-Gartler, *How to make a fire (a sonnet)* .247
C. Russell Price, *Gay $* .248

Table of Contents

Mary Phelan, *Catching The Sun (photo)*250
James McManus, *Smash and Scatteration*251
Diana Solís, *Entrance to Central Barberia, 18th and Laflin Street (photo)*260
Susan Hahn, *Anna of Devon Avenue*261
Michael Warr, *Hallucinating at the Velvet Lounge*262
Angela Narciso Torres, *September, Chicago*263
Larry Janowski, *Brotherkeeper* ..264
Jayne Hileman, *Beverly to Calumet markers, Calumet area map (Mapping Beverly
 to Blue Island Series) (artwork)*266
Gwendolyn A. Mitchell, *Remaking Maps in Chicago*267
Paul Martínez Pompa, *How to Hear Chicago*268
Viola Lee, *Wild Abandon* ...269
Paul Hoover, *The Angel Guardian Orphanage Florist*270
Luis Alberto Urrea, *The Signal-to-Noise Ratio: Chicago Haiku*272
José Olivarez, *wherever i'm at that land is Chicago*275
Santiago Weksler, *untitled (photo)*276
Mark Turcotte, *Hawk Hour* ...277

Contributor Notes ...279

Acknowledgments ..310

John Brzezinski

untitled

Foreword

> *It's hard to reconstruct*
> *how history catches us*
> *in its grip*
> *or passes us by*

That's Edward Hirsch, musing on arriving too late for an antiwar rally on the steps of the Art Institute many long years ago. In this case, history means, on the grand scale, the war in Vietnam and the generational clash that supercharged the domestic struggle over it. History also means, on the intimate scale of personal experience, the job at the railyard that kept the narrator from making it to the protest on time, the remembered smell of tear gas in Grant Park, the beef he got into

> *with a pimply-faced teenager*
> *from Cicero*
> *who had enlisted*
> *in the Marine Corps*
> *so he could be shipped*
> *to Vietnam or Cambodia,*
> *he didn't care which,*
> *he wanted to fight,*

And history, in this book, always and everywhere means the people, the work and play, the bungalows and courtyard buildings, the music and noise, the midcontinent flatland light and air, the human and material *stuff* of Chicago. Putting the label "Chicago literature" on a body of writing seems useful to me mainly as an invitation to consider how writers have explored the possibilities for making meaning and beauty and truth out of the raw material provided to them by the infinitely onion-layered fact of the city itself.

Treating the history of Chicago as the substrate of the city's literature allows me to take a pass on arguing for a Chicago school or schools of poetry in the formal sense. I mean, yes, in this collection you can certainly pick out lineages and circles of trailblazers and successors, mentors and mentees. And I'd argue that Gwendolyn Brooks emerges here as the presiding figure of Chicago's poetic tradition, the generative standard and model for turning your street, your neighborhood, your Chicago into lasting art. But I don't detect in the dizzying range of styles and sensibilities of the poems in this collection some essential shared aesthetic or ethic or theme of Chicagoness. I'm

Foreword

suspicious of that kind of thing, which leads too often to the usual big-shouldered suspects, a canon of overfamiliar local-color gestures that lazy overuse has robbed most of the capacity they once had to convey something meaningful about the city. You know the drill: *I'll have a Deep-Dish Windy Capone with a Sweet Home chaser, and stack some wheat and hogs on that jagoff.*

Now, I do recognize some hometown sensibilities and turns of phrase in this anthology. For example, José Olivarez speaks my inmost South Side self in his poem "wherever i'm at that land is Chicago":

> *i'm always out south*
> *of somewhere. i know the sun rises*
> *in Lake Michigan and sets out west.*

But if place names were redacted or swapped out could you really tell a Chicago poet apart from, say, a Detroit or a Cleveland poet?

So I will stick to thinking of "Chicago literature" as an invitation to consider how writers have exploited the artistic opportunities created by the flows of people and power and money and ideas and natural forces that have shaped Chicago's history on both the grand and intimate scales. It was, I think, decisively wise of the editors to choose to fill this anthology with poems explicitly about Chicago, not merely written there or by people from there. That policy makes it much easier to see how the work engages the city. Some of the subject matter that inspires the writers gathered here may resemble what you'd find in Dayton or New York or Shanghai, but some of it is uniquely Chicago-shaped.

We can plot the poems, and the Chicago-shaped rush of insight and feeling each inspires, on the map of the city. There's a Homan and Chicago Ave. poem, a Jackson and State poem, a poem about a young daredevil climbing a railroad bridge over the Chicago Sanitary and Ship Canal, several Lake Michigan poems, a poem about the open-air gallery of DIY art incised in stone up and down the lakefront, at least one poem about Midwestern resentment and envy of coastal cosmopolitanism, many poems about the old neighborhood and the new neighborhood and how one became the other. And there are a couple of railroad viaducts represented here. Any anthology of Chicago poetry should have viaducts, those everyday displacement-portals through which you pass to find the light, the world, and perhaps yourself just a little different on the other side. Vincent Francone paints one's portrait:

Foreword

> *...parting neighborhoods*
> *like the Red Sea,*
> *the midday steam and hiss*
> *of train cars marooned . . .*

There are also a lot of public transportation poems, which strikes me as fitting, since what is a collection of poetry if not a conveyance to transport the public? One thing I learned from reading this book – or maybe it confirmed a long-held suspicion – is that an army of poets rides the buses and trains of Chicago. They sit alone, for the most part, looking out the window, apparently lost in thought and not doing much of anything. But they're hard at work turning their experience of the city into its literature. And when they do that, their experience becomes our experience of the city, vitally extending and expanding the ways in which we know the place and invest it with sense and feeling.

To the imprint left on my being by childhood rides on the Jeffery 6, when upon boarding I would automatically check the back for aspiring bad boys and then the front for a suitably formidable church lady in whose lee I might dock to forestall them, I can now add the experience of riding an eastbound 72 bus, courtesy of Tara Betts. We listen to Donny Hathaway and Minnie Riperton on headphones as her narrator meditates on the procedures of transport:

> *When you count the breaths to your stop, wondering*
> *why you love the route & find yourself silently pleading*
> *to stay. You lean deep into your seat, press repeat since*
> *nostalgia becomes a contradiction of armor & comfort.*

To my vivid sense-memories of the old IC stations along 71st Street, with their splintery gray floorboards and radiator piss-smell, I can now add Albert DeGenova's meditation on a bus stop on 55th Street. There his speaker "saw Gina DiDomenico every morning," which led to asking her out, then months of necking in the rearmost seats of what they (and also the people I grew up with) called "the green limousine," then prom, then marriage. The onion layers peel away:

> *Years earlier, my mother waited on the same corner, met my*
> *father on the Archer bus, he would get on at Lockwood Ave,*
> *they'd ride downtown together – Mom was a ticket girl at the*
> *Chicago Theatre, Dad worked at the Palmer House Hotel.*
> *They divorced too.*

Not much comfort there, and the stab of recall goes right through whatever armor he's managed to piece together for himself, but the corner and the bus route and the

Foreword

landscape of neighborhood and downtown still pulse with the vitality of memory.

A whole lot of people put a whole lot of good work into this book. I can find my Chicago in it, accruing in a slow steady tidal surge of recognition punctuated by lightning-strike flashes of revelation, but the collection's deeper value to me lies in finding all these many poets' Chicagos in it. Their Chicagos enlarge and enliven mine, giving it depth and dimension I could never find on my own, just as the city, in return, enlarges and enlivens and enables their poetry. It's hard to reconstruct how history catches us in its grip or passes us by, and even harder to plumb the depths of what it meant and how it felt to live the consequences of the catching or the passing by, but that's part of what Chicago's poets do for us. Reading their work here in the strange old ungridded city by the salt sea where I live now, I pass through a viaduct of the mind and come out in Chicago, a miraculous act of transport for which I am grateful in ways I find it difficult to put into words.

Fortunately, we've got poets for that.

– Carlo Rotella
April 25, 2022

Introduction

People not from here sometimes ask, "What is Chicago like?"

Chicago is like nothing. It's like everything. There is no universally correct or incorrect answer, only a whole string of correct and incorrect answers.

People not from here ask, "What is your favorite restaurant?"

To reduce to one the gluttony of options would pay disrespect to all those other tremendous places, to rank a swank spot over a delightful dive, or a five-star chef over a street corner vendor. In Chicago you get to experiment and indulge.

People not from here say, "Chicagoans are so friendly!!!"

Meet enough Chicagoans and you'll find plenty of ornery, petty, vindictive, rude and selfish people, often standing shoulder-to-shoulder with the friendly people, of which, yes, there are a lot.

Chicago is 234 square miles, and that doesn't count when you tip over into Evanston or Oak Park, zig into Elmwood Park or zag over to Berwyn, venture to Westmont or Barrington or Harvey, meander into any of those places that aren't but are Chicago.

Around three million people live in Chicago, and the population triples when you calculate the near and near-enough suburbs that constitute "metro" Chicago. Tourists and even some scholars want to reduce Chicago to cliché. *Chicago is a tough town. Chicago is the capital of corruption. Chicagoans get things done. Chicago is a blue-collar city.* When we leave it to others, Chicago becomes a place where we eat deep-dish pizza and Italian beef sandwiches. We talk like fat Bears fans in an SNL skit. The lake. The el trains. The blues. Violence. There are those who visit Chicago – some over and over – who never make it past Harrison Street to the south, Lake Street to the north, State Street to the west, or the Oak Street beach to the east. Hollywood establishes that we are in Chicago with shots of tall buildings (Willis Tower or the John Hancock, either will do), a looping overhead train, lions outside the Art Institute or the Picasso statue in the Daley Plaza or the marquee outside Wrigley (all, if you can make the cuts quick enough), and of course glittering Lake Michigan.

Those things: all true. All false. Believe me when I say that some of us go long, long stretches without bumping into the Picasso statue or climbing the 94 floors to get a view from the Hancock. We eat pizza and beef sandwiches only as much as pad thai and tacos.

We hunker down in our own neighborhoods, or go to a friend's. We wear out a

Introduction

path between work and home. We return to our favorite places. We try new ones. Sometimes, we are tourists in our own city, packing up a bag, consulting a map, and finding an attraction or experience or neighborhood that heretofore we'd somehow avoided. We do things indoors and outdoors, alone and in huge crowds, out of duty and pleasure.

Chicago does toddle, but only if you're in the right place at the right time with the right people.

Poets, the good ones, explode small moments and details; they use the particular to get at the large. Poets know that it's what is here, sure, but it's also what happens here, how the urban landscape empowers or oppresses, heightens or suppresses, how a city not only makes you feel but how you feel inside that city. Rather than reducing Chicago to a cliché, they strike at its essence.

It was in Chicago that I first met Robin Metz, himself an extraordinary poet. We were at the launch of a literary journal, a reading in which virtually nobody turned up to play the role of audience. This was at the original Open Books store in River North, on Institute Place. We wound up in a circle, just sitting around talking until it seemed okay to end the charade, and then we went forth looking for alcohol.

Before we'd finished our last beer, we were friends, and being friends with Robin meant I'd hear about, and eventually get involved in, his schemes. And he in mine. Over the next almost decade, until he died, Robin grew to be one of my favorite people and a constant inspiration. He wanted things, for himself, for me, for his wife and children, for his students – for humanity – and he worked every angle to get them. His charm derived from a gilded tongue – he was witty, urbane, sophisticated, and at the same time exuded the grit and street smarts of somebody who'd been on both sides of a grift. He was funny. Loving. Honest. It did not surprise you to know he'd been a professor for five decades, nor that he built his Ferryville, Wisconsin, dream home, two-by-four by two-by-four, with his own hands. He delighted in words, in music, in games, in travel – in life – and he unabashedly supported those and that in which he believed.

The project Robin shared with me, the one he kept circling back to, was this Chicago poetry anthology. Chicagoland, then. Robin and his collaborator, Nina Corwin, started collecting poems back in 2009, through a *Poets & Writers* call for submissions. They solicited friends and strangers. They read and reread poems. They evaluated each piece. They brokered a handshake publishing deal and worked to win satisfactory terms. I heard about this early on – all excitement. All optimism. At first, Robin just wanted recommendations – he knew I knew Chicago writers and wanted to know what I knew. I tossed him some names and forgot about it. But every six months or so, the topic would resurface. Robin was thinking about how to make this anthology great,

Introduction

talking aloud about all that he needed to still do, regretting that his busy schedule had not allowed him to put in the time. At some point, Robin got stuck. He couldn't get unstuck. Nina dropped out of the project, frustrated with Robin's end of the deal. The project became dormant, the pearly white hope of it all turning gray, then close to black. Robin's greatest asset was also his biggest flaw: he was generous. He said yes to everybody and everything. Yes, yes, yes. Ultimately, his ever-growing To-Do list would defeat him.

Not the anthology, though. Long after everybody else had forgotten the project ever existed, Robin continued to feel obliged to see it live. He was a beloved man. And he earned every bit of adoration he received. In this case, I sensed that Robin felt a debt: to the poets, to Nina, to poetry at large, to this shred of shame hovering over his otherwise sterling reputation. Suffering from a relapse of pancreatic cancer, Robin accepted his doctors' assurances that his time was almost up. On my last visit to Buck Creek Road, Robin greeted me in the long, gravel driveway, his signature silver ponytail gone, his paunch popped, his body caving in on itself. He must have been in agony. I'd driven the four-plus hours north to spend a few days hashing out the project: what was done, what remained. Despite Robin's health – he was just a few months from passing – he blocked out hours at a time for us to work. He wanted me to see like he saw why this was so important, not so much what it was but what it could be.

It was clear to me, almost immediately, that the work Robin had collected was *ALL* outdated – most of the poems surely had already been published and the contact information expired. His assessment of the work was vague, much of it indecipherable. The publisher he'd secured was remote, their deal tenuous. I knew what we were talking about was, basically, starting over, or, rather, working a cold case in which there were valuable clues but each and every one in need of rechecking, bringing up to date, being chased down alleys. All in the hopes that there were more clues yet to surface. The sheer magnitude of unfinished work that had caused Robin to extend this book project a full decade should also have caused me to kindly disassociate myself from the cause.

I said, "Sure, I'll do it."

Robin and me, we were alike in that way – say yes first and sort it out later. What Robin knew, what he always knew, was that I would do this for him, but I would also do it for myself. It was my kind of thing. I soon saw what Robin saw: this could be a fantastic book. There were several hundred poems and more than a hundred authors, many of whom I knew or at least recognized. I knew that there were many essential poets on my own list, which was at least as long as his own. I listened and tried to understand Robin's vision, and there in his glorious handmade home, we hurriedly – because there was no time to dawdle – hashed out a collaborative framework. He had

Introduction

done what he had done, but we both knew it would now be mine.

In order to include as many poets as possible, I suggested to Robin that we limit contributions to one poem per poet. I also shared my instinct to insist upon the poems being about Chicago. Robin pushed back on some of my suggestions, we brainstormed some ideas, we dreamed of the possibilities.

For those couple of hours, I almost forgot Robin was sick. He was exhilarated. Hungry for this creation. We were laughing. Our tangents veered toward the Cubs and Cuba and Donald Trump, to those things we loved and hated, or just puzzled over. Collaborations like this, in my life and I know in Robin's, were partly just an excuse to enjoy friendships. But in the midst of it all, Robin, without ado, nodded off on the couch. I knew, then, that I would feel a kind of sadness in doing this alone, and that turned out to be true. Before I'd even had time to do the initial reading, Robin passed away, and it took many months after that before I convinced myself that I needed to continue, for his sake, for mine, and for our imagined readers.

Ultimately, though, Robin was there. I was not alone. I am hardly a mystical or spiritual sort, and if anything my world view excludes much sentimentality. I am not suggesting that the ghost of Robin Metz appeared to me, or that I spoke to him like an apparition friend hanging around the material world for my benefit. Not that. More, I included Robin in the process. Each poem I read, I thought about from my point of view and then his. Sometimes, the old files ended the speculation, as he'd stamped, "No" on the submission. Other times, I guessed that Robin would be unenthusiastic about a silly poem I favored, or all for one that I found too esoteric. I let Robin win some of the battles and vetoed him on others.

So many times throughout this process, I wanted to share progress. "Edward Hirsch, Robin! He's giving us a poem." Or get his opinion. "Exactly the kind of poem we want here, but not a great poem?" Maybe get his assurance. "We've already got 107 poems, but, man, how could we not?"

Ultimately, I think Robin would have been proud of what we assembled here. I hope so, because nothing would satisfy me more than to add one more substantial accomplishment to Robin's extraordinary legacy. Robin was a community builder like no other, and as I reached out to poet after poet after poet, and those poets recommended other poets who recommended still more poets, it became increasingly clear that this anthology acted as the ultimate vehicle for community building. I wanted the poems, as a collection, to reflect the Chicago we know, a Chicago that is different things to different people at different times, with all these diverse worlds colliding or at least brushing up against one another to form a greater whole.

This is a world-class assemblage of poets, all with strong connections to Chicago. Among the 134 authors, there are Pulitzer Prize and National Book Award

Introduction

winners, several former Illinois Youth Poet Laureates and the current Illinois Poet Laureate, McArthur Foundation "genius grant" recipients, Cave Canem fellows, Gwendolyn Brooks Award honorees…the accolades are exhaustive. But it's not just that these poets (many, at least) are decorated. Their own Chicago experiences reflect the city, in all its glory and grime. These poets made their way up through academia, but also the slam scene. Their parents were poor, and rich. They were born here or migrated here. Some date their Chicago roots back to the early settlers, some to the Great Migration; some came here to escape violence in their homelands, others came here to take a lucrative job. Some passed through on their way to other places (in fact, several went on to become poet laureates of other cities and states). These poets have roots in Costa Rica, Pakistan, Japan, Bosnia, Mexico, Puerto Rico, Nigeria, Chile, Cuba, India, Korea. They are from Houston, Beckley, Philadelphia, Enid, and Montgomery, left here for Madison, West Lafayette, San Antonio, New York, and Los Angeles. They are Jewish, Muslim, Christian, Atheist, Buddhist, Hindu. These poets know the South Side and West Side, the North Side and the lakeshore, they know fancy and they know simple, they know tender and they know brutal. A large majority of these poets have been community and institution builders, a lot around their various poetry scenes but in every other imaginable way, as well.

These poets, no matter their circumstances or experiences, have this in common: they care. They care about their city and its people, they care about justice, they care about beauty, they care about decency and compassion, and they apply their considerable gifts in the advancement of their own truth.

What we have here, then, are a lot of truths. Chicago is a blend of all those truths, and the city is at its best when all our stories converge, when the audience is attentive and fascinated, when we glimpse the inner and outer lives of those around us. This anthology takes us to our legendary restaurants and our greatest museums. It views aspects of the city, like the lake, from myriad perspectives. It resurrects the ghosts of Carl Sandburg, Gwendolyn Brooks, Kent Foreman, and David Hernandez, as well as Ella Fitzgerald and Mahalia Jackson. These poems wander in time from Chicago as outpost to Chicago during the pandemic. It takes the CTA all around town, and pauses at notable monuments. These are magical poems, language poems, free verse poems, hip hop poems. These are odes, haikus, and sonnets.

These poets all lived and breathed the Chicago air. Regardless of when or where or how they experienced our city, it became, forever, a part of their identity.

What is Chicago like?

This is what it's like. And this. And this. And this.

And the other.

– Donald G. Evans
April 25, 2022

Xavier Nuez

Step Through the Light

Elise Paschen

Kitihawa

Monday May 10th 1790 Stopt at Point Sables anchord with the cannots & begun to hull Corn & bake Bread & arranged everything for next Morning.
 – Hugh Heward's Journal from Detroit to Illinois: 1790

My relatives guide fur traders between swamp
and bog, down age-old trails, under pine trees
and black oaks, navigating the tributaries,
the sweeps and turns. My husband and I

followed the river to its mouth, this spot
where the sun and the moon climb above
the rim of lake. I feed the traders hot
loaves from our Bakery, milk crocks from our Dairy.

Silent as fog rising from the marsh, I observe.
The traders barter canoes for our whitewood dugouts.
My husband broods at the prow of the long table,
candles sputtering, reflected between two mirrors.

Clearing the wooden plates, I question the way they shake hands.
I see blazing greed, our earth parched, my descendants gone.

Featured in the Floating Museum art installation (2019) called "Founders," honoring Kitihawa Point du Sable (Potawatomi) who, with her husband Jean Baptiste, established the first permanent settlement in Chicago.

Averill Curdy

In The Beginning

Was it only the mild indecision
to postpone lunch and turn,
planning to catch our breath
just as Lake Michigan's gilding
dulled to the shading of a moment –
unremarkable, transient, like
those stiflings of iridescence
when the hooked trout slacks?

A window instead, opening
to stir a mulberry black jam
of shadows thickened
with fried onion and fish,
and after what might have been
the day's one meal, this luxury:
a little music, a little sentiment
of the accordion. Notes faltering

over the sill waste in this air where
tempers of tundra and gulf meet,
vagrant as the cottonwood seeds
flagging the fidelity of sweet water,
though now through concrete courses
underground refreshing in secret

payday loans and pawn shops,
beauty salons and storefront evangels.
It isn't played for us. The hidden music
like a story, false yet necessary,
begins in accident, a phrase, the same
again, naïve, dispossessed, searching
the quiet between us. What was it
that we'd imagined, setting out?

The poem previously appeared in Zócalo.

Luis J. Rodriguez

A Hungry Song in the Shadows
(For Chicago)

When I think about Chicago's first settlers, migrants, jobseekers,
 who sought haven or the hope of one,

I think about a place fierce with wails, noises in all decibels,
 tongues from all reaches, and how this is not just a city,

but a dream state of brick and chain-link fences, where poetry clatters
 along with the El train on iron rails, where temples hold every

belief and street corners every color, a city that nourishes all palates,
 holds all thoughts, and still contains the seed of this vital idea:

in accord with nature, all is possible. This is a city that steam built.
 That muscle and sweat solidified into a church

of organized labor. Where a swampy onion field in a few generations
 could become home to the brightest and most jagged skyline,

where fossil fuels are holy water and smokestacks and silos remain
 as soot-stained monuments to industry – from horse-drawn plows,

to the foulest stockyards, the roar of combustion engines, the clang
 of metal-tipped tools, and smoke-curling big rigs streaming along

cluttered expressways and upturned streets. I came to this city on my knees,
 laden with heartaches, bitter in the shadows, seeking a thousand voices

that speak in one voice, where steel no longer reigns, but where open mics
 and poetry slams keep the steel in our verses, lamenting a life of work,

in a time of no work, and where the inventive and inspiring
 could finally burst through the cement viaducts and snowy terrains.

Now we are artists or we die. From the fractured neighborhoods where
 bootblacks and news hawking boys once held sway, to this daunting

Luis J. Rodriguez

gentrified metropolis of ghosts, toxic waste, and countless poor ripped
 from their housing projects, three-flat graystones, or trash-lined

bungalows, yet nothing can truly uproot the uprooted. The energy for what
 Chicago can become is buried inside people, in callings, passions,

and technologies, but only if this manufactured garden aligns
 with real nature, no longer limited, finite, fixed on scarcity, but abundant,

cooperative, regenerative, like a song across the lakeshore, blooming
 with lights, music, dance, banners, and words into a cornucopia

of potentials, possibilities, even the impossible. It's an imagination
 for the intrinsic beauty and bounty in all things.

Chicago. Clean. Just. Free. It's the city we've wept and bled to see.

"A Hungry Song in The Shadows" was commissioned in 2010 by the Jane Addams Hull House Museum. Poem appeared in Borrowed Bones, *published in 2016 by Curbstone Books/Northwestern University Press.*

When Winter Comes, 2030

It is not fortuitous that we met under the dying sun. Yet, we rise every day
to meet the heavens filled with nitrogen because someone must
cover the blackened streets with a flurry of dandruff until winter arrives.

This city once sprawled out like a virus taking over the bodies of our planet
instead of up reaching like a space elevator. Nobody asked what's wrong
with the sky?

Lake Michigan is dead. Even in Chicago a polite chill still fills us,

and it satisfies our addiction to seasons because if we invent it, it will come.
But one addict doesn't deserve another or at least that's what we learned
as children brushing away an invitation to glaze the windows with ice.

Angela Jackson

Summer and the City
(Chicago then, in memory of Robert Hayden)

Summer nights cool came down
Blotting heat like a kiss for colored children.
Heat surged
As we danced jagged up and down the street
Played hide and seek,
Last night, night before
Twenty-four robbers
At my door
I got up
Let em in
Hit em in the head
With rollin pin
All hid? Among the leaves
Of church hedges
We smelled
Something slow and splendid
In our sweat.

Our fathers we knew worked good
Jobs that required muscle.
Our mothers in day work
Used elbow grease and unwritten recipes
For smothered chicken and gravy
Caused white women to envy and delight.

Outside mothers waited for aid checks
And the long gone man, large women
On folding chairs
Ate chunks of Argo Starch.

Lean days, sugar sandwiches,
Ketchup, or mayonnaise.
Missing meat a vague notion.
Love, manna.

Angela Jackson

Twilight blessed the blocks,
Poured from a dark man's mouth
like a spout of Joe Louis milk,
Our champion toast.

Heralding the greatest arrival

However long the getting there
Slow rocking grandmothers
Spit out words into small cans
Held in their hands.

Their eyes trained on us
From Deep South porches
We never left behind

Never left us

Even after Exodus

Mouths wide open, we drank
The evening's pleasure.
Men, women who loved us more
Than what we could have known.
We were their quick, flashing hope-
 treasures
The memory of us
Their milk. Their honey.

First published in TriQuarterly Issue 143, Winter/Spring 2013.

Rachel DeWoskin

chance, chicago

what bagels and bouquets of kale do in a bath I'm
learning/dancing/half-dressed/mambo #5, my kitchen
designated tetris spaces: contamination station,
soap station, rinse station, dry station, every jam

jar sprayed, surface of each lettuce leaf clean, an outside
chance i know, but risk's expansive. is one sun hot enough
to burn this virus off, away from us? are we tough
or broken, are we what we eat, wash, shrink from, hide

inside ourselves? or safe? strange groceries stack and gather,
repeat, vanish, re-make patterns, re-make us, these new days
take tiny shapes, then slip and fall away, become ways
lives narrow into – stop. points of light on the lake. i'd rather

kiss you randomly, raise our arms in a stadium wave, take
the opposite of a distanced risk, touch everything, but now
chaos disorders wonder. letters, stanzas, rhyme somehow
let this city sparkle, please: at 8 each night, people make

a constellation, shining flashlights out our windows, some
solidarity in those bright dots, manmade stars: *hello
i see you.* we'd never have met, but here we are, a show
of company, south loop a momentary magical escape from

lonely. pilsen, bronzeville, hyde park, flashing *stand
with me for a second*, thinking: maybe we'll find something
unlike shared terror, past surviving all we clean, catch, bring.
chicago blinks in sync for a second. light carries, let it land –

Daniel Borzutzky

Lake Michigan, Scene 0

There are 7 of us in front of the mayor's house asking questions about the boy they shot 22 times

There are 7 of us in front of the mayor's house screaming about how the videotape of the shooting was covered up so that the mayor could get reelected

And a police officer says down there where they live there was a shooting you should be protesting that shooting a 9-year old boy was shot by a gangbanger why aren't you protesting that shooting why are you only protesting this shooting

Another police officer wants to know why we are protesting this shooting when just yesterday there was a drive-by shooting in Rogers Park and two innocent bystanders were shot and one of them died

We don't answer instead we do a die-in in front of the mayor's house and the camera crews from the nightly news stand above us as we lay stiff and motionless on the cold wet pavement

They shot the boy 22 times

They kept the video secret for a year and a few days after the video was released we took to the streets and didn't let anyone into the Disney Store

We blocked the doors to Brooks Brothers

We blocked the doors to Topman

The Disney Store was empty but for a few sales folk standing around some Stormtroopers

A guy who drove up from Indiana tried to get into the Disney Store and when we told him that nobody would be buying Stormtroopers today he spat on us and called us stupid assholes

This place is for kids Y'all are fucked up

Daniel Borzutzky

We didn't let anyone into the Apple Store

No one got into Banana Republic

A police officer pulled one of us out from in front of Banana Republic and asked us why we weren't protesting the other bodies that were shot by bodies that were not police officers

It was a strange line of questioning

But it kept happening

The cops kept asking why the body they shot was more important to us than the bodies shot by others

Because you took an oath to protect people we said not to kill them

Because you are paid to protect people not to shoot them

Then they filmed us and we were on the nightly news dying-in on the cold wet pavement

And the politicians called us anticapitalist terrorists who wanted to close down the city's access to commerce

Then the public forgot about the boy they shot 22 times and the mayor closed 50 public schools and replaced them with privately run charters

And the mayor said we must make our school system more robust we must make our schools more efficient we can no longer have empty schools we can no longer have failing schools we can no longer have public schools we can no longer have public bodies

And he proposed a plan for privatizing all of the bodies of all the residents of Chicago

And the City Council passed the proposal and we were given physical examinations injected with vaccines and told we had quite a bit to learn from those who devoted their lives to prayer meditation and nonviolent disobedience

Daniel Borzutzky

We had no choice

This was the dream they subjected us to

They took us to Lake Michigan to the prisons on the beach on the northern end of the city on the border with Evanston on the sand they imported from Indiana

The police build bonfires to remind us of the bodies they throw into them

They tell us cautionary tales about the secret prison on the West Side where once they killed a man by chaining him to a radiator that fell on his head

They tell us this and they expect us to hate them but when you are a decrepit privatized body who has not been fed for several days it's not always possible to feel something as violent as hatred

And they say why do you think you are here

And we say we exist in a historical continuum our comrades in the 16th century were also not told why they were imprisoned or tarred or killed

And they say we have video recordings of you torching your neighbors' garages

And they say we have video recordings of you hiding guns and money under the floorboards of your houses

And they say where in your heart is love

And we say it is everywhere it is all that we have there is nothing else to hang on to when you are in the back of a pickup truck handcuffed to other decrepit privatized bodies rolling around and your heads keep smashing other heads and your shoes keep kicking other faces and other shoes keep kicking your face and you are bleeding and you are terrified and you are blindfolded and you are in the back of a pickup truck and no one has given you enough time to call your father your friend your mother your brother your lover your x your y you are nothing but a rotten piece of meat they tell us as our broken bodies roll around the back of the truck

This is an attempt to provide context for the insignificant reality of our lives

Daniel Borzutzky

This is an attempt to provide context for the dreams we have in which we swallow the bodies of the police officers the prison guards the mayor the migra

These are our dreams we digest the bodies that destroy us

They throw us in the back of a wagon take us to a holding cell and when we are released we gather in front of the mayor's house

And the police officers say we have better things to do than stand here and make sure you don't burn down the mayor's house or shoot a journalist or go crazy and shoot yourselves

Then one of us puts a shoe on the mayor's lawn and they throw her to the ground put a knee to the back of her neck handcuff her tell her she is under arrest for trespassing

And we all step onto the mayor's lawn and the police officers throw us to the ground hold their sticks to our necks put their knees to our backs pull our hair handcuff us take us to a holding cell where we are separated one from the other and we cannot call our lawyers our friends our families and we scream from our cells until they tape our mouths shut

But who will document our deaths and disappearances we wonder

Who will inscribe our bodies into history

Who will know that at one point in this life we were something other than what the bureaucrats knew us to be

And we are alone for several hours until they bring us trays of stale food and dirty water

A few days pass we lose track of time we have no watches no phones no way of knowing where we are or what time it is then an authoritative voice says take these putrid bodies out to get some sunshine

And we go out into the grass and there is a lawyer and a psychologist and a bureaucrat waiting to interview us to ask us what it is that we want

We are silent

Daniel Borzutzky

So they beat us

And when we say please don't beat us they say finally you are getting the hang of it finally you are learning how to articulate your deepest dreams and desires

And they like this

So they beat us

And when they finish beating us they feed us

And when they finish feeding us they throw dollar bills on the floor and force us to play a game where we must beat each other in order to get the dollar bills and if we don't beat each other they beat us

Sing they say or we will beat you

And so we sing what they tell us to sing

We love you we sing

We love your money we sing

We love your food we sing

We love your guns boots and nightsticks

And they like this song so they beat us

They pay us and they love us and they beat us

Published in VQR: A National Journal of Literature & Discussion ISSUE: Fall 2017 Volume 93 # 4, *October 1, 2017.*

René Arceo

La Búsqueda

Elaine Equi

Ode to Chicago

In my city
dinosaurs are not extinct.
Evenings they stroll downtown
and their smooth bodies
from the fortieth floor
are often mistaken for golf courses.
Pterodactyls swoop
above our vegetarian restaurants
while in the park
the famous sea serpent
entices tourists with his lewd chatter,
his long neck.
Nowhere else will you find rocks that perspire,
trees that grow hair.
Here even the common criminal
loves to talk about his "primeval mother"
and although some refer to it as uncivilized,
in my city we know where we come from.
We remember our origins.

"Ode to Chicago" was published in The Corners of The Mouth *(Iridescence Press, 1986)*. Copyright © 1986 by Elaine Equi.

Charles Rossiter

Memorial Day

A hundred faces of my father
talked World War II on television
specials last night, big band sounds
in the background of rosie the riveter,
loose lips sink ships, jitterbug days
of rations and sacrifice, victory
garden and Times Square victory
celebrations when the Axis
got the ax.

Outside Myopic Books
on Milwaukee Avenue
an old black man, about the age
my father would be, moaned
like a Tuvan throat singer as he
preached and waved at his demons.
Wicker Park yuppie couples
lined up waiting to brunch
mostly looked the other way
but he was loud enough
to be heard in the back
of the history section.

Near the entrance to Humboldt Park
the ice cream wagon was already
in place, a pickup truck vendor
was hanging out his array of
Puerto Rican flags
in the drizzling rain.
Two men were taking huge
potted plants out of a green
dented van while their partner
put up a sign that said
"5 bucks a piece."

A t-shirted young man
leaned slumped asleep
on a nearby bench
with his arms folded
much the way Mike and I

Charles Rossiter

slept out on park benches
in downtown Baltimore,
Mike who joined the army
to get out of the factory
went to Alaska, then went
to college and disappeared
so thoroughly not even a friend
with all the megahertz in heaven
can find him.

Five teenage boys with nowhere to go
were hanging on the corner
slouched in various poses of casual disrespect
repeating history the way we relived
zoot suits and peg pants, ducktails and goatees
hollering "go" and burning to get out
to what we knew was waiting for us
anywhere but here.

It's Memorial Day and all over
America people are wearing poppies
putting wreaths on graves
and giving thanks that the fuhrer
got what he deserved and democracy
was preserved and that the millions
of fathers dead and undead didn't fight
or die in vain.

Here in Chicago, a slow rain
glosses over buildings and streets
with a silvery sheen and I
get the feeling
the world looks so fresh
and new washed it's age
doesn't show — as if
it's barely been lived in and
hasn't been through
what it's been through
swept so clean we could almost
start over again.

First appeared in After Hours #2, Winter 2001.

Faisal Mohyuddin

Ella Fitzgerald, Entering Chicago by Train, Remembers Her Mother's Voice

Mother kept church
Songs tucked inside her
Brassière, warmed
By the bursting fullness
Of her bosom, and
Like candied wishes
She popped them,
One after another, in her
Mouth, and despite
The shyness we shared
Like blood and that
Forgotten history
Of our ancestors, she
Sang open the too-small
August mornings
Of Yonkers while doing
The laundry of olive-
Skinned strangers whose
Worn undergarments,
Ferried here from
Unremembered Italian
Villages, held the grime
And loss of a new life
Not much better
Than ours. But her voice,
Honeyed by the sweet
Black Southern earth,
Which she'd forsaken
For new love and another
New beginning, clutched
Within it a divine
Light so impossibly rich
It rendered my music-
Wild daydreams delicious,
Pure enough to pursue
Like God Himself in

Faisal Mohyuddin

The dreadful crush of days
After the crashing
Suddenness of her death.

Now, after eons of
Starlit darkness west
Of New York, as we bend
Up along the sweep of
This city's golden coast,
Feeling in the sway
Of this steel body
The winds shoving across
Lake Michigan, I feel
A warm cleansing
Trepidation of the new,
Just as Mother must have
Felt coming North
To see with a child's
Eyes the perfect beauty
Of her Blackness
As it unfolded against
A freshly painted sky.
Longingly I see her now –
A holy radiance glowing
Above the big-shouldered
Metropolis where,
Tomorrow night, against
The shimmering rush
Of Rush Street, I will sing
Her back to life, and,
In the crystalline
Stillness of Mister Kelly's,
Climb up to her in heaven
On the silver rungs
Of her favorite songs.

From The Displaced Children of Displaced Children *(Eyewear Publishing, 2018).*

cin salach

construction

When the men leave there's a giant hole in the street which honestly doesn't surprise me. They tear it up then surround it with yellow "caution caution caution" tape which you know the wind is gonna blow off soon enough and then if you're not careful you could fall in or pop your tire or damage your suspension rods. It's true. A friend of mine had to get a whole new car because she drove into a hole in the street.

The workers leave one man behind on a folding chair holding a flip phone and sipping from a blue thermos. It's his job to watch the hole until the other men come back, or until the city sends further instruction, or until the hole miraculously fills itself back in. But really it's until someone calls him home for dinner and he can fold things up and drive away, his honest days work done.

And who am I to make assumptions? Maybe he's going home to a sick mother. Maybe this is his first real job after months of unemployment. Maybe this is just the way streets get fixed in Chicago or sewers or whatever runs under these roads I think are so solid and apparently are not. Look at that hole. Drill a little ways down and it's all up for grabs. It's all open space and random construction and here I am driving around thinking it's all solid under there, but really it's air. I might as well be driving in the sky.

Previously published in Brute Neighbors: Urban Nature Poetry, Prose and Photography, *edited by Chris Solis Green and Liam Heneghan.*

Ed Roberson

What Are We Drinking Here

in Chicago the *X* – say The Gage –
serves a Manhattan that would have you
showing up in the East River by tonight
we take it serious here

the sophistication
of our cocktails our day night life
we have you
covered in. no time

the city's board of travel wouldn't have
this as an advertisement says. too fast
to show where on the map of things we are –

meanwhile our cabaret plays the country
into the ground so the blues of its jones
raises the dust of that song up your nose.

LA long little finger fingernail
style with bling ring pinkie doesn't play blues
key here. maybe back up-south but not South-
side city muddy lake shore water blues

delta damn. –
up off the ground street.
up your ass as well as down
the throat of your bespoken word language

this tailored by happening couture worn
to A after Y (any shooting police/ drive by/ line of fire/ innocent
to B after Z bystander/ hospital/ funeral)

Ed Roberson

after C grows its hawk.
claw wind tearing off –
the face of the lake. in it: in whatever key.

 Chicago in it even if it's not in
 actual music

whatever twisty whiskey and song –
women and wine gone on earlier
younger more lulled up in the curation
of tradition –

here now more simply the burn aging
drunken after 2 am music chasing it.
barreled into the night
flavors. the vapors.

caught.
with your eyes dying up her –
skirt. she finally owned her big hips out of –

the church. *she walked out on*
the stage back of the *yards* *of pearls, emerging*
the great migration *feathered, beaded satin smile and*
 swallowing with a 'sippi sings *Chicago.*
 blues.

 Chicago in it even if it's not in
 actual music

Michael Anania

Steal Away

"the dead are caretakers" – Jeffery Allen

in the end, at the ending
everything retreats; farewell
daylight and all your objects;

the Jeffery bus rocks around
the curve below my window
its cabinet of artificial light;

sing the lionheaded storefront
lost to discount gas pumps,
barbershop – Leon!—whispered

away; who died here, shanked
on his way to play the blues,
Sterling? chorus gone silent;

I remember Curtis rounding
his round face with a smile,
Super Fly, can you see him

outlined in the plaster clinging
to an exposed brick wall,
the remnants of one house

illustrating another, stained
wallpaper fresco, its sainthood,
a dream grown arms, legs,

dance step in silhouette;
are they sad, then, sad captains
of sad songs? "can you," he says,

"can you dig it," or will you
(it no longer seems to be
a question); Sonny Boy

Michael Anania

and Curtis, each smile
peaked church roof prisms
the distance; south, you say,

on Indiana, toward Theresa's,
pigs' ears on Wonder Bread,
"a slice of life, honey," the lines

in her palms like squid ink
drawn across parchment, sepia,
of course, no more, no less;

who was it, then, the sodium lights
yellowing toward evening; looks
can be deceiving; the stroll, not

so much as raised his hand
or dipped his head to say hello,
calluses zinging across strings,

blind, perhaps, or playing,
someone said, just like a blind
man, or learned to play watching

a blind man play, blind lemon
branching from a blind tree,
Leon, and so seems that way,

all sound without sight,
without sight reading, the exact
dip of head and shoulders,

stroll just past where the El
screeches out his name; can you
(the question is its own answer)

see him, Sonny Boy gone
to shadows, Superfly, can you
reach into the moist coil

Michael Anania

the song leaves turning
in the night air, its bright
scales chilling your fingers,

uncoils, then recoils,
tongue flicking the lilt
things sometimes take,

names passing by, arms
shoo-bopping, heel cleats
drag out the beat, coils

in the night's ear, song;
can you see, just there
like a paper cut-out;

Little Walter going this way,
Blind Lemon, that? St.James'
steeple and Olivet's stone face;

Eunice said, look here,
it doesn't matter what you
think or who you think you are;

there's man crouched behind
a bureau with two children
and a loaded gun thinks

you're the way back from
too far and all that matters
is that he thinks you are;

at some point in our lives
we might each of us be called
upon to be what we seem;

Superfly, accidental saint
suspended above churchfronts
and on-coming headlights,

Michael Anania

say what it is that's
rung out track after track,
the brightness steel work

leaves across steel, names,
or how too far's edge draws
us along like a third rail,

its sparks opening quick
constellations, their sudden
horoscopes etched into

the backs of our eyes, lines,
names like hands raised in song,
moist sepia drawing in the half-light,

stroll, Oliver, Hines, Armstrong,
One Hundred and One Changes
down the line, names, how

they ring, Superfly, can you
see him, Sonny Boy, Sterling,
the chord dead fingers clutch

at in the summer air, moist
as song and sacrament, Leon,
the figure in paper and plaster,

can you see him in flight
or the body, hand stretching
toward song, folded into a doorway?

listen up, listen up! too far
is a song and dance, is hands
raised, is coil and rail returning

"Steal Away" from Heat Lines *(Asphodel, 2006).*

Dmitry Samarov

Inside/Outside

Kristiana Rae Colón

where fun comes to die

Maroons like to run naked.
Every winter, a squadron of nerds disrobes
to jog bare buttocks through Hyde Park snow, showing off their pale pimpled backs,
pink with sweat and February frost, glossed with the jittery intent of a Boston native
majoring in Arabic, prep school prom queens burning
off the tension of cramming OChem. Past the Bartlett quad,

across University Avenue, dazzling sleepy studiers dragging themselves to the Regenstein
A-level with their flapping breasts and astoundingly white asses. Finals week, another

platoon of nude runners whoops through the library, slowly enough to notice that still, no
one is hot enough to justify wasting your Blackberry's photo memory, quickly enough

that it might have just been a mirage induced by Adderall and espresso and reading that same
sentence from "Discipline and Punish" for the eighteenth straight time. This is the place

where fun comes to die. It's a concentration camp for fun, an awkward first-year might say, and
wait for a laugh.

In Southern Sudan, one tribe commonly names their sons for the historical events during which
they were born. There are many sons of Sudan named Domaac,
bullet.

Days before the 2007 Polar Bear Run, the University
of Chicago President released a statement explaining
why the institution would not divest from Sudan,
but would start a $200,000 fund toward scholarly works
studying the effect of corporate divestment from genocidal conflicts.

Days after the 2010 Polar Bear Run, the University Police brutalized and arrested a Black undergrad
on the A-Level of the Regenstein Library for trespassing.

A child too weak to walk another hundred miles is easy prey for lions.

Twenty-six thousand bird-ribbed boys march away orphans. They know the forest better

Kristiana Rae Colón

than the northern militia; their sisters
are no longer virgins, their mothers have been stoned.

When the Ethiopian tanks chase them to the River Gilo thousands die in the spray of bullets, thousands more
in the jaws of crocodiles, others simply drown, feathering
the surface current with their hollow bodies like browning leaves.

The rest run naked toward Kenya, bullets whizzing at their backs, the whir of mosquitoes
prickling their wounds. This is where

fun comes to die, where children dig each other's graves.
This is a concentration camp for fun, where dorm-debutants
run naked except for gloved hands, where a lost boy's hands
flap away from the machete, where chemists who row crew
jog through Chicago slush wearing only Crocs, where crocs snap

the naked heels of boys who run like bullets.

Lake Michigan

No clam's bubbles to step on the lake beach.
Waves just come and go, no seaweed,
 no fisherman's nets.
Plastic caps tumble,
 but no bead coral.
Lifeguard's freckled shoulders. Nobody screams, "Jellyfish!"
Wind tosses my hair across my mouth. I taste
nothing like standing by the seashore near a beach house – rusted roofs.
You sweated and wanted to name the baby, *"Yume."*
I said, *"Dream?"* and I did not like it. Too ephemeral white.
 Clouds stretch.
Maybe you knew – first breath, almost.

Previously published as a graphic poem in Poetry *(October, 2019).*

Stuart Dybek

Daredevil

Here's what we've come to see: a boy
in greasy jeans, t-shirt plastered
to his ribs by a wind that doesn't blow
on those of us sweltering below.
He's scaling a railroad bridge
above the open sewer that in the 'hood
we call the Chicago Insanitary Canal,

swinging between girders, the kid
who couldn't heave a pass or hit
a ball if his life depended on it,
a wuss, too chicken to punch back,
transformed before our eyes
into an acrobat without a net,
exhilarated by the proximity of death.

One misstep from dashing out
his brains, and suddenly assured
as that ultimate athlete, a cat,
he balances along a ledge and shimmies
a high-voltage pole, ignoring signs
that picture skulls, and promise
both DANGER and PELIGROSO.

He's learned the edge is theater
and mounts the stage, not a star,
but some rogue artist of the strange,
a Fool who turns us into uncrowned
kings, craning our necks as he ascends
a rusted drainpipe, and outlined
against cinematic sky, leaps the streak

of blue between the roofs. Look,
three stories high, he's clawed the bricks
to Rita Robles' bedroom sill, peeping in
while she gets dressed for Sunday school.
Hey, we know a dare's not about being
brave, but being crazy, which is as close
as some guys come to being cool.

Regie Gibson

It's a Teenage Thang
(Or, Sneaking out to go to house music clubs in Chicago when your parents think you are asleep in bed. Circa 1980's)

bass slides in on all fours – rabid with a feral look in its eyes
bodies twist themselves into blasphemous angles of rebellion & defiance
something smelling like jail-time cuts across the air
like handfuls of cubic zirconium scratching up a plexiglass sky

a cue-ball's psychotic smack breaks up a tribe of stripes & solids on a squared field of
green – the black 8 sinks through the smoky haze of *Aww, mans! & Damns!*
as 10-spots reluctantly ruffle their ways out of pissed off pockets

now the dj (who we call the priest) sits in the pulpit in all transcendent splendor
jacking the sounds spinning the rhythms in thirty-three & a third sermons
preaching the sound of our new gospel as the church's hands fly high
bearing our palms to the angels in hopes of catching a holy hand slap
from whatever god is working the night-shift

tonight we are young, virile, sweated with passions you've got to experience in order to understand

we don't give a damn about tympanic cartilaginous erosion of our inner ears
weakened by way too many weekends of butt-bumping woofing & tweeting
we don't give a damn about that ass kicking we're going to get when our parents find out
we snuck out to come to this party (ok, a little)

but what we care about right now is that ass-kicking only bass & drum can give
that ass kicking that only bass & drum can heal

you see, tonight we live

we live
	for strobe lights that burn our vision & bring new sight
we live
	for dance floors moaning beneath the weight of our young flippant attitudes
we live
	for glasses that mumble the speech of stolen kisses
	& for a sky that explode with the funk of our flirting smiles

we live to kill our burdens – shoot them in the back of the head
& watch them give up their ghosts between the etched grooves of waxed plates.

Regie Gibson

We live for the bodega crew coming up from Humboldt & Pilsen
bringing supple-brown morenas with hips like congas bumping 6/8 rhythms
from the front door to the dance floor – hips that got you tonguing a language you
ain't never languaged before like:

miro momi passi pora key por un mon potato po fayvaay (or something like that)

big red manzana lips that part ever so slightly revealing a sliver of pink tongue
that rolls itself like scarlet smoke off the roof of latina mouths

we live for south & west-side sisters: blue-blacks & honey-browns –
heavenly ebonies getting down on legs shaped like mama's soul food
calves carved out of hams & hocks with asses big & round
as grand mamas home-made biscuits

they're hair: slicked & tricked out into an asymmetrical isosceles rhomboid parallelogram & a few other shapes that defy geometric explanation

tonight we are young, virile, sweated with passions you've got to experience in order to understand

tonight is our night to hold somebody's body close & firm
to feel the thin wispy fingers of their breath invade our ears
like well-trained mercenaries
hold them close & firm on a slow jam
heaving against the mask of teenage knowing & adolescent pretense
something deep inside our loins that used to draw on the walls
of caves 40,000 years ago understands

understands that this moment belongs to us
 this moment will never come again
 this moment contains a forever

& forevers are strung together one dance floor at a time

tonight we are young, virile, sweated with passions you've got to experience in order to understand

& we don't care or give a damn
that our parents don't want to understand
that sweat is a friend of ours

& tonight we've got to get real real friendly

Coya Paz

list of wishes, first thing in the morning

quiero mas café
quiero desayuno
quiero paz
I want a dress that always makes me feel pretty
I want fewer sides to the story
I want to know who did it y
quiero saber si lo hizo a proposito
quiero un pintalabio rosado just right to match my hair
quiero noticias que me hacen sentir que todio podria estar bien if we tried harder
quiero tener fe
I want someone to kiss me and mean it
I want self-tanner that doesn't leave streaks
I want someone to tell me the truth about what happened
I want to look out the window and never see my neighbor shoot my neighbor
I want to look out the window and see houses people can afford to live in
I want to turn on the news and hear about a mayor who loves teachers
I want the teacher's union to be carried on our shoulders like we carry hockey trophies, so much love, so much joy, que suerte to be the shining home of este equipo, este sindicato
I want Chicago to be run by people who love Chicago, love the people, not the real estate possibilities
y tu, no se
quiero que me entiendas y tambien
quiero olvidarte
quiero olvidarlo
I want a coconut paleta y quiero que tu me lo compres
y luego quiero que me dejes en el parque
just leave me there
quiero un fin
pero actually quiero un time machine para volver a 2019 when looking for an alligator in Humboldt Park era toda una fiesta, a total vibe, remember the whole city out there, in love with the park and with each other
I want the word sigh to sound more like a sigh and insert it here, the sigh, el suspiro
quiero algo que tu no me puedes dar but I want you to give it to me anyway
I want you to tell me this isn't too much to ask, que lo quiero todo.
I want all of it.
this is what I want.

Again

On Chicago Skyway's vast, welcoming bridge, you drive to dream's remembered peak. There, you exchange words for sentence, meaning's unholy cargo of wished endings seen on a boat in the lake. There you are, colored by moonlit lights that float like lemons on water. You with your silence and breath. Snow forms words in the house of language, all seasons imagined as one. You imagine one summer at The Point, shirtless drummers, whiffs of maryjane, Hyde Park splendor. A tablecloth is laid on the rocks with pears and apples, fulfillment a theory of attention.

Kara Jackson

walking down milwaukee avenue

first a black woman wins over her car motor
a game of who can make the most noise.
then pigeons ask the sky for lunch.
they do not know where bread comes from
just that it comes like rain. there are windows on the highest floor
where a man slices the ac and prepares to make it behave
little boys make an alphabet of their sweat
fighting words are ponds under their shirts
and didn't danny say this is where he is moving?
or maybe a little farther down where a dog falls
for the trick of his tail and gets spit everywhere.
teenage girls read their fingernails for filth,
pick at the frayed parts of themselves in the shopping glass.
home is always what's unbearable to someone else
isn't that why morrison made milkman travel to virginia?
and why that couple doesn't seem to mind the heat
though it threatens the clasp of their hands.
I am waiting to feel terrible
in this sun. thought the fire would take me
but fire was taking a stroll too.

Cynthia Gallaher

Making Books at Hull House

Glue with muscle, flat bone sticks,
a cake of beeswax,
thick cotton thread,
pulled and pushed
in and out from paper pages,
making books.

Windows swing open,
summer streams in,
as jazz from our radio throbs out,
we jam with our books' blank folios,
and they become
jazz books.

Young mother in the corner
speaks of how her child died,
cries through lessons,
watermarks pages with tears as she works,
her book becomes a book
of sorrow and forgetting.

And the old woman across the table
finishes her first binding,
asks in a child-like crackle,
"What shall I fill it with?"
Flipping through choices
is a new happiness, finally up to her.

There are different women's circles
filling charted canvasses with nostalgia,
others' suggestions of "what is art,"
looped together in matched dye lots,
but the classmate next to me
looks at the stitches of her binding,

Cynthia Gallaher

Lumpy as stray sax riffs, some pages
sticking out ever so slightly from the rest,
and says, "The only thing perfect is God,"
holds her book like a prayer book,
offers the flawed volume as she does
her wayward rhythms.

In this room,
what new things we create
are joyfully incomplete,
paper vessels for musical fragments we hear,
drifts of clarinet, piano, pain,
some hot nights of love we play over and over.

Someone opens a book,
begins to write,
"If everyone made books this slowly,
imagine how many trees
would still
be standing."

"Making Books" has been previously published in the periodical, Panoply, a Literary Zine, Issue No. 15, "Paper"-themed issue, Pensacola, Florida, as well as in Gallaher's collection of poems about Chicago, Swimmer's Prayer (Missing Spoke Press, 1999).

Laura Letinsky

Time's Assignation (from the To Say It Isn't So series)

Emily Jungmin Yoon

Field

All my friends who loved trees are now dead,
my grandmother said, and now she is.

She had a green thumb. She loved medical shows.
How can you see all that blood, all that cutting? I asked.

She said, *I wanted to become a doctor.*

She wanted to travel the world. She taped the world
map on her table, drew a line from Chicago to Busan.

She loved me. She was tired of living.

I wanted to pretend. Be protected from her death.

In the Field Museum, I stroll among *Birds of America,*
life-size paintings of specimens doing what they do:

a pair of long-billed curlews, standing next to tall grass.
A roseate spoonbill, twisting toward water.

Audubon went through great troubles, observing them flying
and looking after their young, then somehow,

killing these birds. Now here I am, observing the pretend-
portraits, protected from the blood, the cutting.

Walking through the taxidermy wing, I see more animals
who loved trees, who died to pretend.

Just last month, taking turns pouring dirt over her coffin,
her children commented how she chose the perfect day to go:

a warm Saturday with blue skies, too warm, in fact, for January.

Emily Jungmin Yoon

She is so good at forecasting the weather, my uncle praised,
as if she was just in another wing.

Her grave is contracted for 50 years, another thing I learned then —

where our bodies lie are temporary exhibits.
In the Intensive Care Unit before her death,

I was annoyed at how beautiful the nurse was, standing
next to my grandmother's swollen hands and feet,

at her foundation, curly eyelashes, roseate blush,
her life painted into display.

Then, I was ashamed.

After my grandmother died, my mother entered the morgue,
the only one out of her children.

She watched the body getting cleaned and dressed.
She observed the blues and greens

of a dead body, its cold limbs twisting out.

She curled out my grandmother's dried lips,

then, with her makeup, started painting her.

"Field" originally appeared in Pleiades 40.2.

Rey Andújar

Musa Paradisiaca (Avondale by the River)

I

Before the end of the world
We dreamed an afternoon
Seated in front of
One modest branch of
The Chicago River

The beer made sweet our lips
We held hands and promised
To keep it a secret
To remember the sun forever
The shining light of august

>My body trembling by your side
>Like a Musa Paradisiaca under the rain

I had induced the truth of the memory
The noise
The used inventory of souls and things
I sold, left or stole
To move to this city
To become one of her winds

Chicago
Truth, memory, and reality in the same emotion and contradiction
Where the Caribbean grows and runs freely inside of me
>Like a river
>Like a portrait of superimpositions
>Caught between verb and essence

II

Our song started as a mistake
On Bucktown
Under signs that read
Black Lives Do Matter
Nelson Algren lives here
Ni cojo - Ni fío - Ni presto

We made jokes around the ghost of Richard Brautigan
We felt sorry for Sylvia Plath and her filth of life duties

Rey Andújar

You fell out of love behind a rock
Dancing was the command
But we wanted more beer and more books and records
That is how we ended up going to The Bucket of Blood
On California and Milwaukee
Near my house

You let the August light hit your face
I followed you like a sinner monk
The clerk at The Bucket didn't laugh at our jokes
But with her blessing, we crossed the street
And got semi wrecked at the Beer Temple

As you know, the end of the world is near my dear
So we went out to get some food
I am Mexican, don't feed me Mexican, you said
A little happy
A lot of drunk
With your Passion Fruit smile
Your Caribe
Your Malecón
You ended up loving Las Traspasadas and their black salsa
We rocked and rolled the streets of my neighborhood
And past Washtenaw we found another brewery
And the bench in front
Of a modest branch of the Chicago River

III

Of all the elements that rule
It is water that calls my name

We are quiet by the river
No need for metaphor
For that, good or bad, we will write a poem later on
For now
I will concentrate on us
And by us I mean
The absolute excellence of a fantasy
A praxis
A city
Three kisses
A river
And some kind of blissful eroticism

Chuck Walker

Sunday at The Green Line

Sterling Plumpp

Language
for Reginald Gibbons

In my loneliness I sometimes
 Wander to Forrestville.
Order me a Sweetie Pie
 Omelet of spirituality.

Sit alone lamenting
 chaos in life
ornate cement one prances
 before overhead shadows
find comfort in twelve bar riffs.

I chant in the red, red Clay
 Evans motif of moans
Ushered by his merry go round
 table of dialects

I inherit.
When he pulpits
 his implementation of libraries

He deciphers diasporic journeys.

 To say masks
for tomorrow and tomorrows
 I journey
quilting identity from my silences.

Originally appeared in Chicago Review, Summer/Fall 2019.

Reginald Gibbons

Mekong Restaurant, 1986

What's the half-life of a city?
 Elsewhere, far away, green shoots of rice as new as creation, a soft harmless color, rippling, shimmering, in a breeze over the flat surface of water, outside a village of frail huts with talk in them, under trees of a green hot place drenched by rain, in a country of rain clouds and smoke clouds and fire clouds.
 A menu in Vietnamese and English.
 A dozen immigrants waiting among native and naturalized citizens for their boxes and bags inside a terminal at O'Hare. Refugees streamed back the way that long war had come to them – into the very country that had turned guns and poured fire on them. The immigrants have brought their children and their names with them. Some of their children; some of their parents and uncles and aunts; names that must struggle to be pronounced inside unfamiliar mouths.
 But along these streets ice-winds race. And in summer the raw weedy vacant lots show a jewel glitter sparkling like sequins on fields of ragged green and crumbly gray – innumerable bits of shattered glass under the half-open windows of apartment buildings and ramshackle three-flats, a few with new paint and siding. Up and down the busy street there are shops – Viet Hoa Market, Nha Trang Restaurant, Video King, White Hen, Viet Mien Restaurant, McDonalds, Dr. Ngo Phung Dentist, Nguyen Quang Attorney at Law, Viet My Department Store, Casino Tours. High and far as mountains beyond and above the roofs of this street the winter gray-on-white cityscape wears banners of steam flapping straight sideways in the bitter wind. If you stare at the big buildings long enough you might begin to sense a foundational anxiety in the balanced masses of stone and you might wonder why they don't just fall. Fall!
 Go out into a vacant lot, or even into a park, and hide under a weed.
 Same moon. Not the same moon. After danger and escapes, after straining so intensely to survive – living in this place makes some feel they have come to their own funeral. To live away from your own place, far away, and to think you will never return, is to be condemned to have been saved one time too many, some will feel. When meteor showers fall in winter and summer you won't see them because the underbelly of the sky is lit orange all night in every season. But the children grow accustomed.
 An immigrant boy of fourteen wearing black trousers and a white shirt and a thin jacket is standing with his immigrant parents at the counter of

the high school office, waiting to be called in to be registered; the two clerks are busy, giving the immigrants only a glance, and the mother and father and boy are waiting. At this school the students speak twenty-nine languages, or forty-one, or sixty-three.

The year lasts longer here. It's a proven fact of quantum longing – that time passes more slowly when the air is cold than when it is warm, and that snow and bright street lights are emotionally radioactive. Not so far away is a famous atom smasher that generates twirling nanosecond particles, and around itself it pays for wide reaches of lovely restored native prairie.

In this place are two zoos, many banks, millions of persons, and the inland sea, frozen this year near the shore, and perhaps for the last time in years to come. From wave water splashed into the air, where it freezes, crumbly hills of ice have risen along the beaches, and beside the lake-front roads blackened piles and heaps of soft-hard decayed slush. The fast traffic rolls and rolls.

A menu in English and Vietnamese.

It's late, he's looking out through the kitchen pick-up window at three American strangers, still in their overcoats, who have come in, who are looking around, who are sitting down at a table.

What is the half-life of a city?

Previously published in An Orchard in the Street *(BOA Editions, 2017).*

Aimee Nezhukumatathil

When I Am Six
Chicago, IL

My mother waters the tomato & pepper plants. I steal drinks from the penny-taste of the garden hose. It is my favorite drink. I am six & think to cross the street by myself from time to time, but never do. I am six, my sister is five, & we hide inside clothing racks at the store just to feel the black-sick fill our round bellies when we get lost, lost, lost from our mother. I am six & I am laughing with a mouthful of cashews. I think nuts is the funniest word I have ever heard. I am six & I break all of my mother's lipsticks & glue them together & put them back in her bathroom drawer. She'll never notice. Sometimes I find sad envelopes, the ones with red and blue stripes, meaning these envelopes fly, meaning thin feathers, meaning bird with a little worm in the beak. Envelopes from her father, I think – she snatches them from my hand & says, No, no, where did you get these? Now put them back.

Originally published in OCEANIC *(Copper Canyon Press, 2018).*

Patricia Smith

The West Side

is where I arced toward the idea of bloom,
under the city's most siphoned and skeptical
sun as it spit dutifully toward rows of threadbare
commerce and tilted storefront churches, toward
fish shacks gnawed shaky by grease and gossip
(and that crippled mouse crowing wretched blue
note beneath the stove), toward the Pilgrim Rest
Missionary Baptist, toward my gold-toothed
mama, toward my doomed daddy, and finally
toward me, word drunk, scrawny and luminous
with Vaseline, braids tugged stiff, my scalp roaring.

The West Side is where I licked the grey slick
of dubious swine and sucked marrow from stew
bones, accepting murder as nurture. It's where
I jammed plump peppermint sticks straight into
the pungent guts of hot pickles and chomped
until I was marked holy with stink and stain.
West Side girls have always been enthralled
by the failed muscle of everything tasked
with ending us. Look how our butts and bellies
travel, smooth as silver on water, how we got
a million answers to the hisses from the doors

of Lake Street taverns, a million ways to eat
chicken, and a million languages no damned
body knows. We are, all of us, the daughters
of Gwen, baby girls of bowleg and explosive nap,
our stout legs etched glorious by switch-whuppin'
and doubledutch scars. Tell us how little we're
worth, how ugly we are, how our double-negatives
scar the air. Tell us that our bodies are clogged
with cheap meat. Say we'll never be southside.
Tell us how lucky we are that Chicago chose
to own us, to dress us in unraveling thread
and show us off in its dark rooms of whizzing
bullets. We'll just keep on with this beauteous,
standing wide like a wall, and wearing all that
wounding atop our gilded nappy, like a crown.

David Trinidad

Tiny Moon Notebook
for Tony Trigilio

A perfect half
moon. Walking
Byron. Hot
breezy night.

•

Above the roof of
the building across
the street: a bright
gibbous moon in a
nest of silvery clouds.

•

Corner of Hollywood
and Glenwood.
Above trees: moon,
just about full, obscured
by small puffy clouds.
First hint of fall.

•

Full moon, moonlit-
clouds – through
trees.

•

Clouds moving
across the round
moon. The night
Jim died.

•

David Trinidad

Walking down Clark
St. with Doug. The
moon, waning, against
a black backdrop,
above Alamo Shoes.

•

Leaving Jim's place
with Priscilla: a
gibbous moon, lightly
smeared, between
telephone wires.

•

Doug and I walking
out of Whole Foods in
Evanston: gibbous moon
on a clean blackboard.
Doug eating a cookie;
me, a Rice Krispie treat.

•

The moon, almost full,
glowing a little, but alone
in the sky. A yellow
leaf fell in front of me.

•

Radiant and
full, the moon,
alone in the
sky.

•

Walking Byron
(with Doug) on

David Trinidad

Hollywood Ave.—
whiteness through
the trees.

•

Hollywood and Ridge:
waning gibbous,
out of focus.
Beneath it: a
bluish wisp.

•

Outside Ebenezer Church:
the moon, shy of
half, and fast-moving
gray streaks.

•

Glenwood and Hollywood.
Everything pointing up:
steeple of Edgewater Baptist
Church, trees – one stripped
clean, one hanging on to half
its yellow leaves. The tip
of the latter touching the sharp
point of the half moon.
It looked like a blade.

•

Half moon on its
back, quickly enveloped
by orangish-gray gauze,
through wind-tossed
trees.

•

Gibbous moon in
the thicket of an

David Trinidad

almost bare tree.
Halloween.

•

Day moon over
the Art Institute.
How did it get
so big?

•

Moon – removing
her gray veil.

•

Not yet dark, the moon,
nearly full, with nimbus,
in a net of bare branches.

•

Gibbous moon
in black branches,
burning through
swiftly moving mist.

•

Hopping out of a
cab at Hollywood
and Clark: gibbous
moon in a cloudless
sky.

•

First Christmas
lights. No moon
for the longest time.

•

David Trinidad

Crescent moon.
Then: a low plane.

•

Half moon, hazy,
directly over
the clock tower
at Dearborn Station.

•

Half moon, white
as a tooth, through
a mass of bare
swaying branches.
Shroud-like clouds
moving across.

•

Clear, icy
night. Gibbous
moon – white
and gleaming.

•

Byron sniffing
shoveled snow.
The moon, not
quite full, free
of branches by
the end of the block.

•

Same moon,
high in the sky,
lighting the ice-
tipped branches.

•

David Trinidad

The moon – as full
as it can be and not
be full. Do the craters
make any shapes?

•

Full, horror film
moon, complete
with clinging branches,
shredded clouds.

•

A small faint dot,
barely burning through.

•

Waning, bright
and white.
Wintery.

•

Morning moon
in a slate blue sky.
Some of it was
eaten away
in the night.

•

Moon over
Manhattan.
It too is
far from home.

•

Quarter after midnight,
with Jeffery and Soraya,

David Trinidad

corner of 9th St. and 6th Ave.,
the moon, its top
sheared off, above the building
where Balducci's used to be.

•

2:30 a.m., in Marcie's
kitchen window:
a crescent Cheshire
cat grin, rising
fast, above Denver's
twinkling lights.

•

I thought it was
the moon, but it
was a clock at the top
of a cell phone
tower.

•

The day after
Christmas. Home
from O'Hare.
Hello Byron!
Hello (half) moon!

•

Through the overcast:
a wedge of light
glowing, then dimming,
almost disappearing, then
glowing again.

•

A waxing, afternoon
moon.

"Tiny Moon Notebook" from Dear Prudence: New and Selected Poems *(Turtle Point Press, 2011), © 2011 by David Trinidad. Reprinted by permission of the author.*

Vidura Jang Bahadur

Untitled, from the series "Rolling with the Punches," 2016

Kay Ulanday Barrett

Albany Park/Logan Square 1993-2000, Chicago, IL

Accents, hard A's ascending on the roof of the mouth, angry and anticipated, assembled by the air they miss all over.

Boys brandish harsh syllables, *Don't be so bakla!*
They berate. They break. They belittle until the
bright light would go barren black.
Brraaap braaap baraaap making fake
bullets into one another's brows.

Crips and Disciples. Color-clad, do's and don'ts on your clothing. Categorize blocks a careful cartography. Caution Caution can be cutting (among other things) come childhood.

Did I mention Deep fryer sizzle as shrimp heads popPOP a firework dance with scallions, garlic browning, adobo peppercorns flicker the oil like summer afternoon jump rope sessions. Dinner is a dervish of dancing dishes among cousins on tip-toes for our turn.

Elegance is a dozen expectant elders roving through a bbq,
 for balut, halo halo brazenly melted onto their soft oblong
 palms which is basically as good as prayer.

The Filipino's first call and response:
 Kain na tayo! Time to eat! Food is ready! Get your asses ovah here, na!

Guaranteed commentary by a gaggle of aunties—*Ganda, no?!* gasped over the grass grooves. Simultaneously, ghosts on ghosts in prayers gaping on the maws of lolas gesturing rosaries.

A metallic harmony. Look, to the plastic bags heaped in hands, *can you hold this for me, child?*

Inquiries like furtive urban inquisition:
 So when are you going to college?
 Where is your boyfriend?
 Did you know – insert name – is pregnant?
 going to the army?
 ran away?
 was locked up?

Jackfruit in spoonfuls. Jaded by the roomfuls. Jalopy speakers croon choruses of Sharon Cuneta.

Kay Ulanday Barrett

Kids linked together summer nights like sutures trying to let their insides spill, sanctify the sidewalk. Kindred, feet-first,

Lolo: *Hold still will you? Look, take these flowers to your mama. Say they are from the both of us.* Leaf cutter takes a liking to the lilacs. Left languid long sprays of the hose as the old man's labor never goes unnoticed.

Miscreant: noun, [mis-kree-uh nt]
 (Migrant. Misplaced. Mapping. Misunderstood. Melancholy.)

Naturally, the bone cracks are from neighbors rushing to their night shifts or narrowly missing sunrise, packed lunches in knapsacks as they stand in the slough of gravel, a nest for feet that can never truly fly away.

Once, okay more than once / I captured glow bugs / butts blinking / in the jar a surreptitious serenade. It was like a curated collection of cosmos with a humsong, and a lid, *Hoy! What you doing?! You cannot keep creatures too long contained, they'll lose their shine!!*

P.s. did I mention? I would eat icecream for breakfast. PPAAHHLLLLEEET-TAAAA! Pulp packed on popsicle sticks, papaya, pinya,

Quezon City twang, left somewhere silky on street corners and cigarette butts, from cool kids and quips.

Roosters as alarm clocks, rake the sky with scrawled chords, loud, unforgiving.

Stoop stunners, all of us. Family be like, sacred sacred songs sung from old homelands that need salvaging. Soiled work lapels sweat ordained slack of backs hunched solemn like. Sand daydreams in order to stay alive here in this country.

"Till tomorrow, I'll be holding you tight
And there's nowhere in the world I'd rather be
Than here in my room dreaming about you and me."
– Selena.

Upswing.
Upset.
(young mamas unimpressed by stained shirts and blurt uncomfortable internalized racisms, licking their thumbs to coat a cheek clean until it floats.)

Kay Ulanday Barrett

Vexed making porches something perplex, another police officer too pleased to pound the

hips of doors til they drill whatever out of you.

Was that Tita Yoly yanking up the weeds on the corner of Albany and Waveland, in her tropical flower moomoo? Callous knees make green collisions, (she was a collector) roots yelping. It wasn't the kang kong of her riverbed, but it will have to do.

Exhaustion, for instance.

Yawning young ones. Crust-laden lids and
half-dream yammering crossing the street,
Careful careful now. You got your homework?

Sometimes indistinguishable with "S"
as in *selos* (said like *zelos*),
as in jealousy.
as in what's supposed to consume you
 when you grow up from nothing.

Previously published in More Than Organs *(Sibling Rivalry Press, 2020).*

Jennifer Steele

In Search of Butterflies

After your first day of 1st grade at a new school
we start the 20-minute walk from work to the car:
 Harold Washington Library
 then down Plymouth Ct.
 and through Cotton Tail Park
to spare the costs to park any closer.

I tell you the time will go by quickly
if we share stories about your day,
I-Spy morning glory after morning glory
adorning rod iron fences of homes
that I wish to plant next Spring
outside our southside building
so you can also see this kind of beauty
everyday outside our door.

I tell you there will be butterflies
like the ones you raised and set free
at your old school with your old teacher
and hope this will be enough.
When you are not with me and I take this walk alone
I call out *Painted Lady!* or *Monarch!* as you do
in delight, so that you are.

But right now you are six and tired
and done with the length and labor of this trek
until we finally see one butterfly

and then another

and another

and we count more as we go,
never attempting to catch them.
Just call out their names
and watch them fly on, unafraid
of never seeing them again.

Kelly Norman Ellis

Saturday Class: The Rat

I say
Explain how Native Son is the blues.
Student says
I used to be Bigger
Bored and crazy
Dried up like in that poem
You made us read.
It's called Harlem I say
He says *yeah. Except this called*
The west side.

I know Bigger supposed to be the rat
And America got the frying pan
Beating us to death so
That's the blues

But look at the definition Ellison gave us I say
Ragged wound. Transcending brutal experience
I point to the words on the white board.

Did you transcend? I ask
He says
Yeah,
I ain't no rat.

Campbell McGrath

The Sun

Sound of the coming rain, sound of the commuter train percussive as ten penny nails,
 sound of the electric fan, sound of thunder booming out, very close indeed.

Sound of my voice echoing in the snail-shell byways of my skull, my secret voice, introit,
 talismanic, my snail-song voice.

Sound of the downpour like a shovel in gravel, like sand thrown against a doorway,
 lightning flashes suddenly with the sound of a padlock snapping open, sound of a car
 motor cranking, sound of the El slowing to a halt at the station, sound of the trees,
 the grass, tomato plants growing along the side of the house, thirsty roots thankful
 for water.

Sound of fat droplets downgrading to a drizzle, sound of a bird or cricket, some squeaking
 creature like a faucet dripping lemon juice, sound of a drape cord ticking in the
 breeze, sound of thunder retreating like footsteps descending into the basement.

Sound of the city resuming its floor show, sound of the clouds building their castles,
 sound of the rain stopping now.

Now we exist in the present, rain-glazed, wet, wetter than before, glazed with water-
 that-was-rain, remembering that this too is the Now-Which-Has-Already-Passed,
 the Now which is happenstance, is the shell, is fallen petals, smoke, the Tenebrous
 Fire-Touched Unrecoverable Now.

Now I see in the air a spirit – is it my own gold-battered soul or sunlight in the crown of
 the elm tree, hovering?

Now the sun is out, in which we enter used bookstores and discover a line from Walter
 Benjamin or a T'ang dynasty poem that changes our life or more probably doesn't
 but makes us think, at least for a moment, about changing our lives,

the sun in which workmen align wooden planks on scaffolds, in which a baby sleeps
 snugly in its gentrified papoose, in which old women come out from beneath their
 umbrellas and young couples walk into diners to eat omelets and bowls of
 asparagus soup.

Campbell McGrath

The sun, a great place not to visit.

The sun which shines upon the transit buses up and down Stony Island Avenue no matter how intense the shit becomes.

The sun whose light as it filters through the trees is elegant and lovely, infused with grace, it is good to be alive in young-leafed summer.

The sun in which I pass an ancient closed-down Woolworth's remembering the pleasure of the bygone pet department there, how the green parakeets would fly loose and perch squawking on top of the light fixtures and merchandise –

once, long ago, I asked the saleswoman how it happened and she said, touching my arm, deeply moved, thoughtless people leave the cages open.

Ana Castillo

Chi-Town Born and Bred, Twentieth Century Girl Propelled With Flare into the Third Millennium (c.1999)
(For Nelson and Simone)

I'll turn into an 8
If I am late! Said the Mad Hatter
Of Chicago, City on the Make
that got put through Rehab, a Twelve Step Program or two,
send the Mayor's brother to Washington to give the party a
 hand,
gutted out warehouses, tore up factories,
and leveled down docks.

It's a truly *beau-ti-ful* town now.
Clean as polished chrome if not always sober.
Although debauchery is not tolerated, not even at Wrigley
 Field
When the Cubs lose again despite Sammy Sosa,
Or at the United Center after a Blackhawks game, not even
 When
The Bulls won their sixth championship.
Not an odoriferous trace of the fish market or
of the stockyards that once were our trademark.
The river beats the Seine for clarity, and the Lake
is not just a lake but a Mediterranean Lite.
The Buckingham Fountain still infuses June nights at Grant
 Park
For free music lovers and lovers of every other kind.
Yes, it's a pretty city if you're not down on your luck
or being relocated from Cabrini Green
to something else like it or you're not locked up in County Jail
or sleeping on cardboard in the Jewel's parking lot.
No clotheslines-on-porches views from the El Train
anymore, but flower boxes and portable barbecues.
Every window from North to South and even on State Street
right downtown is to a condo, a computer hack's office,
an architect's studio ringside seat of the winning skyline to
 heave
that all of Asia cannot beat.

Ana Castillo

Don't get me wrong.
The American Dream stories that this city was known for
one hundred years ago more than still abound
right here in Uptown. Across the street Africans pray
on Sunday morning for asylum, Salvadoran refugees and
 Mexican
Illegals lie low waiting for appointments with the Immigration
 Service.
D.P.s (displaced persons) are dark-skinned now; seem less hopeful than the Europeans I
Grew up around on Maxwell Street:
Italian markets with dry bacalao hanging outside and snails crawl out of tall baskets,
Jews in doorways with their fine tailoring and pawnshops,
Irish cops, mafia bosses and Greek diners along Halsted Street.
Gypsy fortune teller and no-name drunk derelicts loitering on Madison –
Everything so unapologetically ethnically and economically divided. All this
 I saw
Growing up as Mary Ann,
little Mexican girl who attended at Jane Addams' charitable mansion
to learn to cook and stitch and stay off the streets.

My mother named me Ana María, which got purposely turned around
at the hospital like everything an Indian woman said and did
 got turned around.
In public school I was renamed Marie like a missionary's
 Convert
and back to Mary Ann, but at home I was Anita.
To my father: Anna Magnani – the movie star.
He was born in Chicago too. I went to the same grammar school
He had but not the same high school because by then it was
 1968:
The Democratic Convention, Martin Luther King came around
And racial intolerance was going every which way
with brown people kept in between.
If you're white, you're all right.
If you're brown stick around.
If you're black – step back, step back, step back. But
If you were brown in the white part of town or wandered to
 the South Side,
which was black then, you'd better run and run fast.
The man I called my father was a tough young lad on the
 fence.

Ana Castillo

Between a pun and a respectable head of the family.
After a while he straightened up.
He didn't believe in upward mobility – or even lateral mobility.
He liked things to stay the same. The city came and moved us
When it was time to bulldoze our neighborhood near little Italy
To build a university.
He worked on and off in factories and smoked a lot of cigarettes.
The last company closed down and packed off to Southeast Asia.
He died, one winter night, unemployed.

His mother got to Chicago chasing a son
who'd taken off with Pancho Villa, but all that – as they say – is
 history.
She was Pentecostal and a *curandera*,
Penniless as they get.
I wish she'd been a bootlegger, or that she married a crook police chief
And left me a lot of money hidden in an old trunk.
Instead, she left the legacy of being Mexican
This far north where it was not just bean and tortillas
all day, all night, Mary Ann,
and not just English lilts but a tilted Spanish too.
The eradicable accent which came from being the child of
 factory workers,
field workers, railroad workers, and related to every kind of
 labor work
in the Midwest is all your people ever knew.

One day after my son was born I took my name back and left.
We lived all over the country.
We saw the big cities and stayed in a lot of small towns.
We went to corn dances at Laguna Pueblo
And learned to eat lobster in Gloucester.
We sat by the seashore in California and got the grand tour of
 Texas.
We came back unimpressed and stayed.
Now my son is a bona-fide Chicagoan, product of his generation
or maybe mine, the free-lovin' seventies, when
reading and travels opened our imagination,
which is to say he's proud to be a mutt-boy like all his friends.
They're not brown or black or white or even Cantonese
like the food in Chinatown but a true *molcajete* grind.

Ana Castillo

They hustle homemade CD mixes on the street.
They have the blues in beats, tag lampposts and trains,
rhyme and scratch my dad's old LPs. Late into the night
on the landline, they plan the revolution. (As far as I can tell,
not one can say of what.) Pros at video games but none
would carry a real gun – or would they? So, all this is to say,
just maybe my hometown won't be shot to hell by 2001.

What's gone for certain are candy stores,
No more corner taverns with pee smell and beer stained floors,
fathers whose kids went in to drag them home for dinner,
hot dog/beef stands left but commerce in fast food is booming,
an amped imitation of what once was on a local scale.
New bars, boutiques, cinema multiplexes, the same you'd find
From Canada to Mexico! Forget about it! What, with the Free
 Trade Agreement
in full swing, it'll all soon be one big theme park. One day
it'll look like Orlando.
All that'll be missing are the palm-tree-lined boulevards.
Ethnics have taken over the burbs.
Children of the White Flight have returned to roost on the Gold Coast.
Raised on liberals' Pablum they believe they have no prejudices.
 Heck,
they don't scorn foreigners. They're not against bilingual education.
Some even speak Spanish as well as their Nicaraguan nannies.
It's the Age of Investments and Portfolios
(but they don't like the word capitalist, which rings of Republican
and falls hard on the ear of a Democratic town.
(But if Colin Powel decides to run no one will be sure which
party is which.)

Nostalgia's the trend. Sinatra's "Chicago" plays throughout the Loop.
How can newcomers in jeeps and scuba-diving gear on on-line reading,
Starbucks coffee and microbeer savoir-faire, whose convo is about
Kangaroo hunts organized by Safaris Are Us and stay bronze all year 'round
With tanning booths in the basement, lay claimed to this
 Town?
The truth is they don't even want it or much else for very long.
You try what's new and then, move on, move on, move on.

Ana Castillo

I'll turn into an 8 if I'm late,
traded in my hat for a hundred pairs of imported shoes,
not beating the pavement but for show.
The world is oyster on a pizza, you know, said the mad shoe repair man.
This place don't matter, or San Francisco gone million dollar Silicon
or B and T Burroughs of New York, New Orleans became Capital of Honduras,
except three days for tourists. It doesn't matter times change,
looking so much easier but just as tricky. Chicago will still eat you alive.
You'll remain anonymous, even in an obituary.
Big Brother is not a threat now.
You can get a talk show and talk trash about your grandma,
Take a job as a cook and tomorrow call yourself a chef,
Start a digital movie company right at home, never mind Hollywood.
Do whatever you want.
 Fame
in 1999 is the only game in town.
Don't hold back your best. Keep vanity in check.
Chicago doesn't forget. It'll show you the way down
On the Willis Tower elevator express.
Next winter wind chill factor will feel colder than before
and like any back room craps player senses,
humming Over the Rainbow, there's no place like
Home Sweet Home Chicago where you are on top
of the world.

From I Ask The Impossible *(Anchor Books, 2001).*

Phillip B. Williams

Homan and Chicago Ave.

Cross the blood
that quilts your busted lip
with the tender tip
of your tongue. That lip's
blood is brackish and white
meat flares from the black
swell. You crossed your mama's
mind so call her sometimes.
She dreams your dead daddy
still puts his hands on her
waist. She calls his name
then crosses herself, calls
the police then crosses
her fingers. Cross me
and get cut across your cheek,
its fat bag full of bad words
and cheap liquor you hide
from your badass kids. Make
a wish for bad weather
when the hoodlums get to shooting
in a good summer's heat.
Cross the territory between
two gangs and feel eyes stare
and cross in a blur of crosshairs.
When a shot man lands
in the garden of trash the block
flares up like an appetite
spurred on by the sight
of prey, by the slurred
prayer of a man so death-close
he sees buzzards burrow
their bladed beaks into
his entry wound. Tune
the trumpets. Make way through
dusk's clutter. After death
the dead cross over into song,
their bones tuning-forked
into vibrancy. Cross your lips,
mutiny against all speech
when a corpse starts singing
despite its leaded larynx. Don't
say miracle when butterflies
break from a death-gaped skull,
rout the sky, and scatter.

First published in Poetry.

Tonika Lewis Johnson

6329 S. Paulina from Folded Map Project

Heidy Steidlmayer

Two Women in a Revolving Door at Water Tower

My mother digresses
into doors that keep repeating

the same story over.
I am ushered into a hush

which echoes my fear of turning
into her, an old woman

occluding the doors before me,
whose voice is my voice

when I say behind her back
this is not my story —

and push her out of the way.

First published in Humanitas (Vol. 2, 1996).

Chris Solis Green

In The Blue Stairwell
"Windows into the Body" exhibit: Chicago Museum of Science and Industry

They cut him in horizontals –
half-inch sections
with a power saw
from ear to ear and down across his neck, torso, arms, thighs, knees, shins,
to his smallest toe
As if you could see through someone from above or below
He is arranged
like dozens of unframed paintings of steak
His mosaic a rusted flat yellow heart grey flap of lung
its specks of blue tar like squinting stars
bulb of penis
wrists like an agate slice you might buy
in the gift shop hang from a
key chain

She, more whole – four vertical pieces of herself (each a half-inch thick) from crown down
through her pelvis
Her long panels are displayed like four pages opening and spining out from
the wall
You can stand as if inside her,
see her full profile on your right and left
 And like Blake's shapeless souls descending to hell,
her selves slouch thin but heavy, unforgiven in their bag of skin
Her outline, almost human:
her few electric strands of pubic hair the amber impression of a
nipple her breast's receding beach the peek at a
small piece of lip a small breathless nostril her last loyal eyelash
a bit of ear

Inside, her parts are arrowed with words, her heart is labeled
heart, her ribs marked *true* and *false*

This Woman looks blind and sideways at herself;
This Man, like a deck of cards unshuffled, looks up and down for
what he was

Chris Solis Green

Our heavy creative brain floats in a pool, its waves stimulate
the whole enormous Tongue, our throat's muscular yet sensitive heart,
which leads Blake to say,

As a man is, so he sees
From the subterraneous Mouth and precarious Teeth, the earth is declared a perfect Eye or
the eye a perfect Earth, from its aqueous ocean to its lit pupil, it
can detect a lighted candle 1 mile away, can see up to 10,000 colors

The Heart, like us, beats its fist but works only as much as it has to:
in an average life between beats it rests for 40 years

Between the lost and found and the coat check, near the restrooms and the public phone,
between the Main Floor and the Balcony, near the baby chick hatchery, the fairy castle,
Petrochemicals, Polymers and You,
past the kids petting plastic cows, behind How to Ship Spent Nuclear Fuel,
before you Enter the Internet, below Virtual Embryo,

not the sold-out Titanic exhibit, not an actual locomotive, not the line for the flight simulator,
nor the combine ride
The sign says, *Basic Science: The Head, The Heart*

Not on the map of Special Exhibits, two bodies in pieces in the Blue stairwell on the landing between
the coal mine and the Nazi submarine
Anonymous as anyone, this man, this woman died in 1940, were frozen, then sliced

First published in the Cream City Review.

Vida Cross

Bronzeville at Night
After Archibald J. Motley Jr.'s "Bronzeville at Night"

1.
Front Yard

In city summers
we wait for the breeze
from trains
rain
or slammed doors

Summer turns the war
sheer curtains are drawn
tulips parade

Touch the rose
the pain will repeat itself
repeat the healing

Showing off
one bud
rounding pink petals
turned from Sunday dresses

Flower beds greeted me

Furnished rooms overwhelmed me

I lie flowered to rest

2.
State Street

Spotting the woman's round rear in the window
Jack's Chicken Shack
the blue nights glow
the full street

Vida Cross

a couple of red dresses and two stop lights
Mr. Archibald J. Motley stood on the corner of 35th Street

The fat man dropped his head

I snuck onto the front stoop

Mr. Motley sketched dark lines

The fat man whistled the tune of
"Heads snappin'
shoe heels tappin'
bent knees flappin'"

I sat still
hoping Mr. Mot would sketch me too

3.
Juke Joint

Night calls
men away
night answers
the two meet
shaking up the joint

Bodies throb
jumping the rip
strip/whip of music

If you believe death
the crow has fallen
relieved of our city life

First published in Bronzeville at Night:1949 *(Awst Press, 2017).*

Nicolás de Jesús

En El Tren

Elizabeth Alexander

Blues

I am lazy, the laziest
girl in the world. I sleep during
the day when I want to, 'til
my face is creased and swollen,
'til my lips are dry and hot. I
eat as I please: cookies and milk
after lunch, butter and sour cream
on my baked potato, foods that
slothful people eat, that turn
yellow and opaque beneath the skin.
Sometimes come dinnertime Sunday
I am still in my nightgown, the one
with the lace trim listing because
I have not mended it. Many days
I do not exercise, only
consider it, then rub my curdy
belly and lie down. Even
my poems are lazy. I use
syllabics instead of iambs,
prefer slant- to the gong of full rhyme,
write briefly while others go
for pages. And yesterday,
for example, I did not work at all!
I got in my car and I drove
to factory outlet stores, purchased
stockings and panties and socks
with my father's money.

To think, in childhood I missed only
one day of school per year. I went
to ballet class four days a week
at four-forty-five and on
Saturdays, beginning always
with plie, ending with curtsy.
To think, I knew only industry,
the industry of my race

Elizabeth Alexander

and of immigrants, the radio
tuned always to the station
that said, Line up your summer
job months in advance. Work hard
and do not shame your family,
who worked hard to give you what you have.
There is no sin but sloth. Burn
to a wick and keep moving.

I avoided sleep for years,
up at night replaying
evening news stories about
nearby jailbreaks, fat people
who ate fried chicken and woke up
dead. In sleep I am looking
for poems in the shape of open
V's of birds flying in formation,
or open arms saying, I forgive you, all.

First published in Body of Life, *(Tia Chucha Press, 1996).*

Marvin Tate

Memories of a Dance Floor
The Smart Bar 1987

Feet stomp,
knee deep grooves vibrating
 into century old hardwood,
imprints of when we danced.
Shape shifting algorithms,
overflowing in and out of safe spaces
seeking solace with self.
We only came here to dance,
to be in the moment, westside, House,
 Blueline, wha'cha look'n at?
 rainstorm, they and dem and pookie an'nem.
We only came here, to dance.
The DJ knows this and feeds us,
a plethora of beats. We be slaphappy,
awoke, unpremeditated glampires
ridding away layers of the ev'day;
the petrichor beckons our senses
while we remain present in our body-glitter.
Sweaty, soaked shadows, disengaged in the hearsay
of they said, dem did, they said, them did
they said, dem did. We here for the beats,
that only the flowers can hear
We only came here, to dance.....

Rachel Jamison Webster

Our Lady of The Underpass

A shape on an underpass wall of the Kennedy Expressway attracted hundreds Monday who wanted to see for themselves if it really looked like the Virgin Mary. The image drew Mexican immigrants who said it looked like Our Lady of Guadalupe, the patron saint of Mexico. Polish immigrants thought it might be connected with the death of the Polish-born Pope John Paul II.
 —Chicago Sun-Times, April 19, 2005

To see it was to see the others
seeing it – their placid faces
and worksplit hands
holding roses in cones of cellophane,
hoisting babies and
guiding grandmothers
over the piss-darkened curb
to those already waiting.
To see it was to see the mass
of candles – lit wicks darting quick
then reversing like a shoal of small bright fish
trapped in the tides of traffic and greed.
To see it was to see a break
in the unending blank
cement. To see it was to see
the old echoing shape
of a mother broken open under
her veils like the stains
of receding waves, salt-furred
and roughed as that cut
we come from, bloodied, bloodying.
To see it was to see the child
say beso and press his finger
where her mouth would be.
To see it was to wonder
where you were
in the dimming folds of time,
what in you had not been born
or what had not yet died.

Reggie Scott Young

Crime in Bluesville

On the West Side,
no one complains about
the heat: there
isn't any; but
folks do be trying to grab
a little warmth.

People naturally
don't want to freeze,
but sometimes
that's a little more
than they can afford.

Sometimes,
we light the oven,
those of us with gas,
or turn on an old electric heater
after running an extension cord
next door,
we even burn old wooden chairs
in the tub, or
bring a garbage can in and
let it be our fireplace.

We know not to relax in-
to comfort in
the winter of the night,
we might get drowsy and
go to sleep.

Too often
we are the burning story in
the morning news.

"Crime in Bluesville" was originally published in Yardbirds Squawking at the Moon *(Louisiana Literature Press, 2015).*

Tyehimba Jess

Long Live the Checkerboard Lounge,

Slow steeped in Buddy Guy's Stratocaster
callused fingertips conjured
from collard green Mississippi
choruses. Checkerboard, you scotch
and whiskeyed a razor cut
funk into my bony youth,
anointed me your high heeled
sneakered sneer, pushed
my head into the diatonic
mouth of hungered harmonica
hole, birthed this Motown child
into a cauldron of jook,
spread my legs akimbo
with shuffle, coated my tongue
with Southside pavement.
Checkerboard, transom door
to Eshu's greedy workshop
of gyrated hip, cellar beneath
the gospel moan of Thomas Dorsey's
precious hands on tattered keyboard,
you bore me to strummed, sacred
wattage near the intersection
of Martin Luther King Drive
and Muddy Waters Drive.
I still savor each holler you spat
into my mouth, the humbucked
feedback you lesioned into my brain,
dear Checkerboard,
University of Carnal Capacity,
delivered unto metal and smoke,
you rode me into Chicago's gunshot
dawn with lopsided grin on my hips.
I stride stagger your neon
corpuscles through every
door I wander.

Daniel McGee

55th St. Underpass

I.

In this tunnel of ramblings, no voice overshadows
the vibration of drumsticks speaking to gallon buckets,
the steady cadence of tapered trills and head turns
from the four Chicago Bucket Boys drumming away.

Walking past, I meet one's eyes, seeing within his irises,
tiny drummers thumping a calming melody on both pupils.
They vary the rhythm with rim taps and stick twirls,
even looking away from the drum to prove their practice.

II.

Pieces of the city find their way in like undertones:
the occasional riff of pocket change bolting around,
a light splash of parading feet both coming and going:
everything attracted to the sound of their drums.

The crowds revolve with the changing streetlight colors
leaving just the mural of onlookers to listen to their beats
and a boy in the back tapping his hand to the melody
as his pupils slowly become a thing of percussion.

Frank Spidale

North Ave. Bridge

Edward Hirsch

I Missed The Demonstration

I was late getting away
from my shift at the rail-yard
and missed the rally
on the steps of the Art Institute
where two college kids
from Normal
burnt their draft cards
and stomped on the flag
in front of the stone lions,
I missed the demonstration
but I could still smell
the tear gas in Grant Park
where I met a couple
headed off
to join a commune
in northwestern Canada,
and got in an argument
with a pimply-faced teenager
from Cicero
who had enlisted
in the Marine Corps
so he could be shipped
to Vietnam or Cambodia,
he didn't care which,
he wanted to fight,
we were all moving
so fast then
it's hard to reconstruct
how history catches us
in its grip
or passes us by,
I missed the demonstration
and brooded about it
on the way home

Edward Hirsch

since there are no accidents,
or so Freud believed,
though I almost corkscrewed
my first car
when a motorcycle
skittered on the gravel
and veered
toward oncoming traffic.

Joanne Diaz

A Thousand Flowers
Arthur Rubloff Collection of Paperweights, Art Institute of Chicago

The history of America
 is the history of the blowtorch

and the propane gas
 that molds the skyscrapers

that rise on the hottest days
 of summer. It is the hubris

that coats the plain façade
 of the Page Brothers Building,

built just one year
 after the great fire that melted

cast iron buildings
 into mountains of lava

so hot and fast
 that the people's only refuge

was to run to the lake
 and stand in its waters

until the land had cooled.
 It is the stubbornness

that it takes to forge
 from that same material

even when you know
 its brittleness, even when

the city is a testament
 to ruin. It is the need

for open windows
 on those insufferable top floors,

and then another need
 for glass paperweights

Joanne Diaz

on every desk covered
 with piles of papers –

for pigs, for cows, for dairy,
 for trains, for more

skyscrapers – about to be
 blown and scattered

across the desolation
 of the prairie. It is

the thousand glass flowers
 that fix all of those papers

in place: cross-sections
 of bundled roses, fruits,

and snakes, bullets
 of color, the heft

of lead glass, the illusion
 of depth; and sometimes,

it is a glass salamander
 luxuriating on the top

of the paperweight
 like a rotten weed

born of fire, a black slick
 glistening,

waiting for its prey;
 a messenger

carrying the ash
 of the spent world.

First appeared in River Styx.

Quraysh Ali Lansana

conundrum

after another afternoon of attempted guidance of urban undergraduates i approach the house in my teenage jeep. the block is benetton: continental african and arab medical students, european undergrads, working class blacks and three generations of mexican immigrants, all kinfolk, in the two buildings south of mine and almost completely inhabiting my side of the street to the north. martinez tradition demands, for the menchildren, high school rotc training, then either active duty or the family business. these pursuits serve one another. vicente, early twenties, a spit of black grizzle on his thin face, leans out the screenless window of the rust brick three flat. porcelain virgin mary presides to his right front on manicured dirt, the walkway lined in rock potpourri from gate to stair. he is reliving last night's transaction with hector, his slightly older cousin, wearing a navy blue hoodie, back to street, as i park. as i open my door, vicente recounts "…yeah, i had to tell my niggas that black nigga was the one…". we lock eyes as i emerge, his rouge from smoke, mine from sleep deprivation and the peculiar beatdown suffered at public universities. he nods at me, a grand but simple act of acknowledgement, acceptance. then continues recounting his night. though i have lived here two years, i am new to the block. in this time i have seen as many of the men of vicente and hector's generation go to prison as go to war. they call me "mister Q" and play soccer with my oldest sons. we talk futbol and football. they have little idea what i do. sometimes i hang, drink a beer. say something stupid. i have seen their uncle's tattoo. i know who they are. they look after mine. i must pass hector to get to my gate. it feels rude to walk in front of him, between the conversation. he stands near edge of sidewalk, where concrete meets freshly swept front yard. i tell my youngest daily to stay on the walkway. their dirt is impeccable. hood up, engrossed in vicente's story, he doesn't hear or see me coming. "excuse me, hector." he jumps. puts right hand on jacket pocket. reaches in. the outline and angles clear. unlike his hand, he moves his head slowly toward me. exhales. "shit, sorry man. you scared me."

Aviya Kushner

Night On Wellington Avenue, Chicago

To Germany,
from its German citizens, 1913. Another night
and I am a walker
in the night, a wanderer reading.

The Jewish neighborhood is graced by that odd monument,
and the night is laced with Isaiah, with the juxtaposition
of horrifying prophecy and soft wind.

Is it all exile, all the cities of earth awake
and all the lovers of inexplicable cities walking,
thinking if they just keep moving
it will all be calm,

just keep moving and the body and the mind will exhaust
into sleep.

And I watch as
men hold hands with men outside a bar,
and women hope for salvation, their whole bodies
one big ear, listening,
asking always, that awful phrase
Do you love me? Do you love me?

And as the wind winds
down and the bartender yells last call
I wonder if anyone is really in or if all of us
are always out, out, out, wanderers like
an unwanted prophet, an old man raving.

Sun Yung Shin

Abracadabra, or A Spell for The Disappearance of Chicago's 한인마을*

KOREATOWN EXIT 84
KOREATOWN EXIT 8
KOREATOWN EXIT
KOREATOWN EXI
KOREATOWN EX
KOREATOWN E
KOREATOWN
KOREATOW
KOREATO
KOREAT
KOREA
KORE
KOR
KO
K
G
GR
GRO
GROC
GROCE
GROCERY
GROCERYR
GROCERYRE
GROCERYRES
GROCERYREST
GROCERYRESTA
GROCERYRESTAU
GROCERYRESTAUR
GROCERYRESTAURAN
GROCERYRESTAURANT

*Little Korea or Little Seoul = Koreatown

Haki R. Madhubuti

Chicago Is Illinois Country

we are the breast and chest of this nation,
four seasons on the shores of hope
where ideas and fresh water feed
hearts and land in this century's city,
all aware that we can be illumination,
velocity, bread, breath and motion.

we, the carriers of deep earth, sun, snow, desert
and red clay, collided in search of soul and finality.

there are recent padlocks on our memories.
neither infidels or unbelievers we are loosely
camouflaged and choreographed dancers.
out of necessity and accelerated foresight,
we arrived as unsettled bones and motion.

calm we are not
satisfied we are not

our music is the accretion of
multiple tongues into one language
the indomitable spirit harmonizing in
must do theaters where second as in city or state
is absent from our vocabulary and intentions.

we, carriers of all cultures,
invented untried futures
gathered the sane vitality of distant spheres
to narrate an illuminated vision and motion
in this city,
in this state,
in the breast and chest of this nation.

Illinois Humanities Council established the Studs Terkel Humanities Service Award, November 6, 2002. Haki R. Madhubuti was a recipient of the award in its inaugural year.

Rosellen Brown

Lake Loving

From my window:

• Soft green – not Mediterranean aqua, more the rubbed matte pastel of sea glass, gentle, as if a deeper color were being restrained.

• It's steaming! The freeze must be withdrawing and it's smoking out there. It's still a vast snow-field, but to see what's boiling off it you'd think there were dozens of ice fishermen lighting bonfires to keep warm.

• Bruised purple stripe along the horizon. How strange that there are no clouds to account for it. Strict straight-edge at the horizon line, sometimes thin, sometimes wide – totally inexplicable. Dark, irregular patches hover over the water like the shadows clouds make on a meadow, but no, the sky is utterly clear. A mystery.

• Tropical blue – looks like an invitation to snorkel for gaudy fish amidst the coral. Implausible, frivolous, hard to associate it with our city grit.

• White water shattering against the rocks of the Point, all broken edges, tossed twenty, thirty feet into the air. Tide coming in, weirdly, on the diagonal. The City of Chicago phones to say to beware the swamping of the Drive.

• Sails have massed like dozens of gulls, though no one seems to be moving.

• Pure Japanese. Through one little rent in the mist, a red sun burns without heat. And it's all one, lake and sky, unbroken.

• I woke to the most peculiar moment I've seen yet: Thunderstorm, the sky a menacing thick gray, lake exactly the same color, but between them a wide belt of light so even that its edges, upper and lower, look ruled. Pure abstraction, more rigid than a Rothko. More like Albers, color against color. In ten minutes it's breaking up, dissipating, and the day can start again.

• And on my daily morning walk along the shore, a wild spray of water drops, frozen as they've hit the ground, has left the winter-dead grass covered with a vast, unbroken carpet of shiny glass knobs lit by the sun. Winter must not prevail: I picked my way across them like an ancient crone.

"Lake Loving" is excerpted from City 2000, *ed. Teri Boyd (3 Books Publishing, 2006).*

Marianne Boruch

Once At Berghoff's

So forty years later, I cross autumn
as usual, its elegant distortion of fact –
that window, Chicago's old downtown, a girl
and her mother at lunch in that understated
stately place. Which is to say, cloth napkins.
Which is to say, the sky darkened, made
lamplight by buildings. Exactly
as my mother dreamed.

Not without a scene, of course. A linen dress
I didn't want, its overwrought embroidery,
flowers weeping their tiny
busy opera. Finally, I liked the waiter
– you like the waiter, don't you? my mother said –
the way he held himself so secret
in a hoarse ironic whisper.
I hadn't thought intelligence that austere.

Rain, it seemed, for weeks,
and then the day before, it cleared.
That was autumn too, and city apartments
lived in years, buildings mortgaged
and double mortgaged, windows that launched us
into streets staggered with leaves, piled high
by boys who worked by the hour, or cousins,
brothers, because they were told.
Leaves by the curb crested on sidewalks,
on fenders. And fathers coming out of kitchens
with matches, then the smoldering fragrant
eclipsing smoke. Everything lit
and sending up signals.

Coming home, my mother stepped off the bus
so gracefully that afternoon. Our real street
flared up, all red leaf and haze, kids
somewhere shouting. Forty years now,
forty years – I watch her turn
and speak politely as a stranger
to thank the driver.

Marianne Boruch's "Once at Berghoff's" first appeared in her Poems: New and Selected, *copyright © 2004 by Marianne Boruch. Reprinted by permission of Oberlin College Press and the author.*

Priscilla Huang

Andersonville

Sandra Cisneros

Good Hotdogs
for Kiki

Fifty cents apiece
To eat our lunch
We'd run
Straight from school
Instead of home
Two blocks
Then the store
That smelled like steam
You ordered
Because you had the money
Two hotdogs and two pops for here
Everything on the hotdogs
Except pickle lily
Dash those hotdogs
Into buns and splash on
All that good stuff
Yellow mustard and onions
And French fries piled on top all
Rolled up in a piece of wax
Paper for us to hold hot
In our hands
Quarters on the counter
Sit down
Good hotdogs
We'd eat
Fast till there was nothing left
But salt and poppy seeds even
The little burnt tips
Of French fries
We'd eat
You humming
And me swinging my legs

From MY WICKED WICKED WAYS. *Copyright © 1987 by Sandra Cisneros. By special arrangement with Third Woman Press. Published by Vintage Books in paperback and ebook, in hardcover by Alfred A. Knopf, and originally by Third Woman Press. By permission of Susan Bergholz Literary Services, New York, NY and Lamy, NM. All rights reserved.*

Tara Betts

Donny & Minnie on the 72 Bus

Some of the best things in Chicago
seem almost mythic in existence.
The Water Tower surviving cow & flame,
the steely limbs of Picasso's sculpture
allowing humans to sit at its feet,
the blues clubs still stuffed with juke,
smoke, slow grind & knife fight, even
Donny Hathaway & Minnie Riperton's
voices on rainy days ring in headphones,
pulsing stars from happier nights. You are
on the 72 bus again, east from K-town –
Karlov, Kedvale, Keeler, Keystone, Kilbourn,
Kildare, Kolmar, Kostner, Kilpatrick, avenues
with reputations fit to kill, but still all history.

You think of George's Music Room, how
the owner once touched the throat that sung
"Loving You," the throat clenched by deadly
cells that possessed the flesh of Minnie's notes.
You think of applejack hats, how Donny's voice
kept telling you we'll all be free, your anthem so
you and your brothers could shake-a-hand-shake-
a-hand every Christmas, and this Christmas too.
As the buildings outside the bus windows blur
from speed, drops & fog steaming the windows,
you wonder if the ghetto made Donny try flying
more than depression swelling into that fatal leap.

When you count the breaths to your stop, wondering
why you love the route & find yourself silently pleading
to stay. You lean deep into your seat, press repeat since
nostalgia becomes a contradiction of armor & comfort.

Previously published in Crab Orchard Review, Vol. 15 No. 2, Summer/Fall 2010.

Mike Puican

Tequila and Steve

After all the bars on Broadway
closed, they walked outside.

He was the Butter Man, also
known as Steve; she was

Susan but on weekends
went by Tequila. Above them,

the sky reared, flame-
edged, over the fire pit

called Chicago.
What time was it?

It was Saturday and the
heat had just begun to arrive.

As they walked, he felt
his heart sprint ahead.

She was the one
who asked the time

but the clock was them.
The sun ignited a marble bust

ringed by sugar maples,
a family pushing an elote cart

down the street, a tiny spider
dangling above her doorway.

Mike Puican

In her kitchen, a pan
sizzled with oil while faint notes

rose from a piano downstairs.
The scents of fried eggs

and just-cut lilacs filled
the air while the back

of her neck and a can of beer
created a near-perfect tranquility.

First published in After Hours #21, Summer 2010.

Krista Franklin

In a condo on the southside of Chicago

The living room is a museum of blk art
that negroes too simple to know
is a fortune. *They broke in three times,*
he says, *and didn't take anything off the
walls. Just DVD players, VCR, a black
& white television.* We laugh because
it's not funny, giggly off greens, wings,
wine. The watercolor eyes watch us, run
into their frames, not amused, and call
me between conversations that build
like tiny windstorms from the crowd-
ed corners. One of the guests is rich
mahogany, kills two bowls of *dulce
de leche* cake leaning up next to butter
pecan *Breyers* and talks only when
he's done, his spoon clinks against
the side of fine ceramic to punctuate
the jokes of his friends. Talks turn
to points of origin, his Mississippi
boyhood when he stoked the family
fires at 5am, ventured out to corral
cows who roamed off to greener
pastures, worked the fields of neighbors
and took cotton to the gin. He laughs,
says, *We were the machines*, & the industry
in all that country splits my head
like a pig slaughter in November, and every
acrylic eye stares blankly from their canvas
whispering *timeless timeless timeless…*

Previously published in Killing Floor *by Krista Franklin, a limited edition letterpress chapbook (Amparan, 2015).*

Ira Sukrungruang

There Is Nothing Else to Talk About

We start conversations the same way: *How is the weather where you are?* During the Chicago winter, I say, *The snow is trying to eat the dogs.* She always says, *Thailand is so, so hot.* There are things we keep to ourselves. I do not tell her that sometimes – always in the morning – I feel lost, a boy wandering a mega mall searching for familiarity, ultimately carried out into a white sea. I do not tell her the obvious: since she's moved back, I have no family besides my wife, who smells like the rich earth of central Illinois and the musk of Morgan horses, who despite her kindness would never understand what the mosquitoes sing across the ocean before they drink. I do not tell her I stare out the front window on most mornings, at the spruce cowed by the weight of the snow, bent like a dancer taking a bow or a monk praying at the foot of Buddha. I do not tell her I am beginning to understand the meaning of the word "immigrant," and I no longer believe in the American Dream because there is nothing American about success and there is nothing American about dreams, and mine in the last month have woken me up in the middle of the night, images slipping quickly away, sensations lingering – a heavy chest, shortness of breath, longing tightening my throat. Our talks are ten minutes at most. In those minutes spanning eight thousand miles, in the whispering snow and under the breathing sun, we say what we both want to hear: *I am still here.*

Janet Ruth Heller

At Miller's Pub

Nestled in the heart
of the Chicago Loop,
Miller's Pub has served meals
and beer since 1935.
Visitors leave autographed pictures
above the tables full of beef, salads,
seafood, pies, and sausage.

Patti Page gazes wistfully at diners
from a gilt-edged frame
while Fred Waring smiles benignly nearby.
But most of the photos capture
little-known actors or singers,
brave local legends
who lost the high-stakes game
in New York or Hollywood.

As they strut in spangled costumes,
the starlets appeal
to hungry business groups,
tourists, and shoppers
for a moment of homage.

"At Miller's Pub" first published in Knot Magazine (Fall/Winter 2020).

Rachel Galvin

Here in Chicago

It's cold in Chicago, cold on the sidewalks
Bitter cold outside on the sidewalks of Chicago
It's a cold that stings, a cold that flays, it's bitter cold by the lakeside
There's music on the sidewalks of Chicago in the snow
People grow numb tonight on the sidewalks of Chicago
People outside in the cold, on the north side
on the south side, on the west side of Chicago
Here in Chicago there are people outside watching people inside
People grow numb tonight on the sidewalks of Chicago
There are people inside, inside from the cold
watching the stride of Chicago
There are people striving inside and people striding outside
saying Buy me a sandwich
There's music on the sidewalks of Chicago in the snow
There's music on the sidewalks as people run for the El
and a man with two teeth says I'm hungry
People grow numb tonight on the sidewalks of Chicago
A man blasts jazz as he bikes in the snow
There's music in the city of Chicago
there's music in the city, there's music in Chicago
There's music on the sidewalks of Chicago in the snow
There's music on the sidewalks of Chicago in the snow
Banks flash low rates, blue neon on the snow
People grow numb tonight on the sidewalks of Chicago
Numb tonight on the sidewalks of Chicago

Paul D'Amato

Open Pump, Pilsen 1993

Li-Young Lee

The Cleaving

He gossips like my grandmother, this man
with my face, and I could stand
amused all afternoon
in the Hon Kee Grocery,
amid hanging meats he
chops: roast pork cut
from a hog hung
by nose and shoulders,
her entire skin burnt
crisp, flesh I know
to be sweet,
her shining
face grinning
up at ducks
dangling single file,
each pierced by black
hooks through breast, bill,
and steaming from a hole
stitched shut at the ass.
I step to the counter, recite,
and he, without even slightly
varying the rhythm of his current confession or harangue,
scribbles my order on a greasy receipt,
and chops it up quick.

Such a sorrowful Chinese face,
nomad, Gobi, Northern
in its boniness
clear from the high
warlike forehead
to the sheer edge of the jaw.
He could be my brother, but finer,
and, except for his left forearm, which is engorged,
sinewy from his daily grip and
wield of a two-pound tool,
he's delicate, narrow-
waisted, his frame
so slight a lover, some
rough other

might break it down
its smooth, oily length.
In his light-handed calligraphy
on receipts and in his
moodiness, he is
a Southerner from a river-province;
suited for scholarship, his face poised
above an open book, he'd mumble
his favorite passages.
He could be my grandfather;
come to America to get a Western education
in 1917, but too homesick to study,
he sits in the park all day, reading poems
and writing letters to his mother.

He lops the head off, chops
the neck of the duck
into six, slits
the body
open, groin
to breast, and drains
the scalding juices,
then quarters the carcass
with two fast hacks of the cleaver,
old blade that has worn
into the surface of the round
foot-thick chop-block
a scoop that cradles precisely the curved steel.

The head, flung from the body, opens
down the middle where the butcher
cleanly halved it between
the eyes, and I
see, foetal-crouched
inside the skull, the homunculus,
gray brain grainy
to eat.
Did this animal, after all, at the moment
its neck broke,
image the way his executioner
shrinks from his own death?
Is this how
I, too, recoil from my day?

Li-Young Lee

See how this shape
hordes itself, see how
little it is.
See its grease on the blade.
Is this how I'll be found
when judgement is passed, when names
are called, when crimes are tallied?
This is also how I looked before I tore my mother open.
Is this how I presided over my century, is this how
I regarded the murders?
This is also how I prayed.
Was it me in the Other
I prayed to when I prayed?
This too was how I slept, clutching my wife.
Was it me in the other I loved
when I loved another?
The butcher sees me eye this delicacy.
With a finger, he picks it
out of the skull-cradle
and offers it to me.
I take it gingerly between my fingers
and suck it down.
I eat my man.

The noise the body makes
when the body meets
the soul over the soul's ocean and penumbra
is the old sound of up-and-down, in-and-out,
a lump of muscle chug-chugging blood
into the ear; a lover's
heart-shaped tongue;
flesh rocking flesh until flesh comes;
the butcher working
at his block and blade to marry their shapes
by violence and time;
an engine crossing,
re-crossing salt water, hauling
immigrants and the junk
of the poor. These
are the faces I love, the bodies
and scents of bodies
for which I long
in various ways, at various times,
thirteen gathered around the redwood,
happy, talkative, voracious

Li-Young Lee

at day's end,
eager to eat
four kinds of meat
prepared four different ways,
numerous plates and bowls of rice and vegetables,
each made by distinct affections
and brought to table by many hands.

Brothers and sisters by blood and design,
who sit in separate bodies of varied shapes,
we constitute a many-membered
body of love.
In a world of shapes
of my desires, each one here
is a shape of one of my desires, and each
is known to me and dear by virtue
of each one's unique corruption
of those texts, the face, the body:
that jut jaw
to gnash tendon;
that wide nose to meet the blows
a face like that invites;
those long eyes closing on the seen;
those thick lips
to suck the meat of animals
or recite 300 poems of the T'ang;
these teeth to bite my monosyllables;
these cheekbones to make
those syllables sing the soul.
Puffed or sunken
according to the life,
dark or light according
to the birth, straight
or humped, whole, manqué, quasi, each pleases, verging
on utter grotesquery.
All are beautiful by variety.
The soul too
is a debasement
of a text, but, thus, it
acquires salience, although a
human salience, but
inimitable, and, hence, memorable.
God is the text.
The soul is a corruption
and a mnemonic.

Li-Young Lee

A bright moment,
I hold up an old head
from the sea and admire the haughty
down-curved mouth
that seems to disdain
all the eyes are blind to,
including me, the eater.
Whole unto itself, complete
without me, yet its
shape complements the shape of my mind.
I take it as text and evidence
of the world's love for me,
and I feel urged to utterance,
urged to read the body of the world, urged
to say it
in human terms,
my reading a kind of eating, my eating
a kind of reading,
my saying a diminishment, my noise
a love-in-answer.
What is it in me would
devour the world to utter it?
What is it in me will not let
the world be, would eat
not just this fish,
but the one who killed it,
the butcher who cleaned it.
I would eat the way he
squats, the way he
reaches into the plastic tubs
and pulls out a fish, clubs it, takes it
to the sink, guts it, drops it on the weighing pan.
I would eat that thrash
and plunge of the watery body
in the water, that liquid violence
between the man's hands,
I would eat
the gutless twitching on the scales,
three pounds of dumb
nerve and pulse, I would eat it all
to utter it.
The deaths at the sinks, those bodies prepared
for eating, I would eat,
and the standing deaths
at the counters, in the aisles,

Li-Young Lee

the walking deaths in the streets,
the death-far-from-home, the death-
in-a-strange-land, these Chinatown
deaths, these American deaths.
I would devour this race to sing it,
this race that according to Emerson
managed to preserve to a hair
for three or four thousand years
the ugliest features in the world.
I would eat these features, eat
the last three or four thousand years, every hair.
And I would eat Emerson, his transparent soul, his
soporific transcendence.
I would eat this head,
glazed in pepper-speckled sauce,
the cooked eyes opaque in their sockets.
I bring it to my mouth and –
the way I was taught, the way I've watched
others before me do –
with a stiff tongue lick out
the cheek-meat and the meat
over the armored jaw, my eating,
its sensual, salient nowness,
punctuating the void
from which such hunger springs and to which it proceeds.

And what
is this
I excavate
with my mouth?
What is this
plated, ribbed, hinged
architecture, this *carp head*,
but one more
articulation of a single nothing
severally manifested?
What is my eating,
rapt as it is,
but another
shape of going,
my immaculate expiration?

O, nothing is so
steadfast it won't go
the way the body goes.

Li-Young Lee

The body goes.
The body's grave,
so serious
in its dying,
arduous as martyrs
in that task and as
glorious. It goes
empty always
and announces its going
by spasms and groans, farts and sweats.

What I thought were the arms
aching *cleave*, were the knees trembling *leave*.
What I thought were the muscles
insisting *resist, persist, exist*,
were the pores
hissing *mist* and *waste*.
What I thought was the body humming *reside, reside*,
was the body sighing *revise, revise*.
O, the murderous deletions, the keening
down to nothing, the cleaving.
All of the body's revisions end
in death.
All of the body's revisions end.

Bodies eating bodies, heads eating heads,
we are nothing eating nothing,
and though we feast,
are filled, overfilled,
we go famished.
We gang the doors of death.
That is, our deaths are fed
that we may continue our daily dying,
our bodies going
down, while the plates-soon-empty
are passed around, that true
direction of our true prayers,
while the butcher spells
his message, manifold,
in the mortal air.
He coaxes, cleaves, brings change
before our very eyes, and at every
moment of our being.
As we eat we're eaten.
Else what is this

Li-Young Lee

violence, this salt, this
passion, this heaven?

I thought the soul an airy thing.
I did not know the soul
is cleaved so that the soul might be restored.
Live wood hewn,
its sap springs from a sticky wound.
No seed, no egg has he
whose business calls for an axe.
In the trade of my soul's shaping,
he traffics in hews and hacks.

No easy thing, violence.
One of its names? Change. Change
resides in the embrace
of the effaced and the effacer,
in the covenant of the opened and the opener;
the axe accomplishes it on the soul's axis.
What then may I do
but cleave to what cleaves me.
I kiss the blade and eat my meat.
I thank the wielder and receive,
while terror spirits
my change, sorrow also.
The terror the butcher
scripts in the unhealed
air, the sorrow of his Shang
dynasty face,
African face with slit eyes. He is
my sister, this
beautiful Bedouin, this Shulamite,
keeper of sabbaths, diviner
of holy texts, this dark
dancer, this Jew, this Asian, this one
with the Cambodian face, Vietnamese face, this Chinese
I daily face,
this immigrant,
this man with my own face.

From The City In Which I Love You *(BOA Editions, 1990).*

Achy Obejas

On The Shores of Lake Michigan

Here, on the shores of Lake Michigan,
where we often believe we've avoided
the curse of the coasts,
sometimes I think even the alewives
die with more dignity,
entombed like silver in the sand.

There are more empty shells piled up on the shore
than anyone will ever count now –
not the pretty pink conches birthed by salt,
but the single white slivers of fresh water.

Years later I still resent the intrusions –
the beepers going off every hour or so,
pockets full of pills, the constancy of
new experts on seroconversions,
metasizing cancers, t-cell counts and drug trials.

I'd rather spend this time meaninglessly,
talking about the weather,
about the strips of dull green color
where the sky and the lake meet.

Nothing heals here, certainly not
whatever's picked up from the alewives
rotting under our feet.
Even the waves, refusing to freeze,
also refuse to fully bury them, or take them back.
Sometimes in the middle of winter
I look out on the ice and see only light.

It's no consolation to know
this will all melt away in the spring.
No matter how often they come again,
on time and perfect, each season is different,
conspicuous by who's not here, scarred
by the knowledge of those already marked
for future absence.

Aleksandar Hemon

International Experience

The company was up in Six Corners. I counted only five
and was lost right from the start. Nicely dressed youngsters were already
in the room, all of them smiling, for the first thing he did was sketch
a downturned-mouth face on the dirty chalk board, cross it off, draw
a smiley one, declaring: You are happy now! He was pink-white,
wore a lawn-green suit, had a mullet, floral tie, big gold pinkie
ring, a minor star in the field of Chicago hustling written
all over him. He called himself Johnny O. It was the early
summer of ninety-ninety-four. *The Chicago Tribune* before
me had a map of Bosnia on its front, the tiny fires
marking the cities under siege, including the one I love.
Put that shit away, he ordered with a head shake. News only make
you sad. He did not know where I might be from, or that such a place
as Sarajevo existed, nor did he care. The future was
the only thing that mattered, we all had to understand, right there.

He moved like a ballroom dancer, shoulders and hips first, expertly
winking at the cross-legged women in the front row. Who wants
to make money? he shouted. Half of the people raised their hands.
It was clear to me they were all plants, experienced at hustling
for him, pursuing his American dream. I too – broke, sleeping
on the floor – raised my hand. Ask yourselves: What can you offer to this
company? Care for our customers and their needs, they rushed
to say, making this business all it could be. Immediately
I thought, I do not want to be here, but I have no place to go.
I've nothing to offer, to this company or any other,
and I never will. I strive to stay alive as long as I
can, love some, be loved a bit, and that's it. His smiling crew is
still staring at me, eager to hear me say something. But nothing
comes out. My international experience is in the silence.

Dwight Okita

Notes For A Poem On Being Asian American

As a child, I was a fussy eater
and I would separate the yolk from the egg white
as I now try to sort out what is Asian
in me from what is American –
the east from the west, the dreamer from the dream.
But countries are not
like eggs – except in the fragileness
of their shells – and eggs resemble countries
only in that when you crack one open and look inside,
you know even less than when you started.

And so I crack open the egg,
and this is what I see:
two moments from my past that strike me
as being uniquely Asian American.

In the first, I'm walking down Michigan Avenue
one day – a man comes up to me out of the blue and says:
"I just wanted to tell you…I was on the plane that
bombed Hiroshima. And I just wanted you to know that
what we did was for the good of everyone." And it
seems as if he's asking for my forgiveness. It's 1983,
there's a sale on Marimekko sheets at the Crate &
Barrel, it's a beautiful summer day and I'm talking to
a man I've never seen before and will probably never
see again. His statement has no connection to me –
and has every connection in the world. But it's not
for me to forgive him. He must forgive himself.

"It must have been a very difficult decision to do what
you did," I say and I mention the sale on Marimekko
sheets across the street, comforters, and how the
pillowcases have the pattern of wheat printed on them,
and how some nights if you hold them before an open
window to the breeze, they might seem like flags –

like someone surrendering after a great while, or
celebrating, or simply cooling themselves in the summer
breeze as best they can.

In the second moment – I'm in a taxi and the Iranian
cabdriver looking into the rearview mirror notices my
Asian eyes, those almond shapes, reflected in the glass
and says, "Can you really tell the difference between
a Chinese and a Japanese?"

And I look at his 3rd World face, his photo I.D. pinned
to the dashboard like a medal, and I think of the eggs
we try to separate, the miles from home he is and the
minutes from home I am, and I want to say: "I think
it's more important to find the similarities between
people than the differences." But instead I simply
look into the mirror, into his beautiful 3rd World
eyes, and say, "Mr. Cabdriver, I can barely tell the
difference between you and me."

First published in Crossing with the Light *(Tia Chucha Press, 1992).*

Jac Jemc

Dermestidae

At The Field Museum they don't reveal
 the bugs sicced on skeletons in back rooms:
 hungry swarms staffed to hide the meat in their bellies.
The food chain of exhibition is easy to conceal –
 when a fresh specimen arrives, the feast resumes,
 in a tight tank furious with famine.

The same beetles attack violin bows,
 leave silence where sinew once rang.

It was the insects who showed me you were too many grooms
 to be fed by me, a singular bride.
 I know too well how easily
 the soft tissue of me
 divides from the bone.

John Guzlowski

Looking for Work in Chicago

1. What He Brought with Him

He knew death the way a blind man
knows his mother's voice. He had walked
through villages in Poland and Germany

where only the old were left to search
for oats in the fields or beg the soldiers
for a cup of milk. He knew the dead,

the way they smelled and their dark full faces,
the clack of their teeth when they were desperate
to tell you of their lives. Once he watched

a woman in the moments before she died
take a stick and try to write her name
in the mud where she lay. He'd buried

children too, and he knew he could do any kind
of work a man could ask him to do.
He knew there was only work or death.

He could dig up beets and drag fallen trees
without bread or hope. The war taught him how.
He came to America with this and his tools,

hands that had worked bricks and frozen mud
and knew the language the shit bosses spoke.

*2. I Dream of My Father as He Was When He
First Came Here Looking for Work*

I wake up at the Greyhound Station
in Chicago, and my father stands there,
strong and brave, the young man of my poems,

John Guzlowski

a man who can eat bark and take a blow
to the head and ask you if you have more.

In each hand he holds a wooden suitcase
and I ask him if they are heavy.

He smiles, "Well, yes, naturally. They're made
of wood," but he doesn't put them down.
Then he tells me he has come from the war
but remembers little, only one story:

Somewhere in a gray garden he once watched
a German sergeant chop a chicken up
for soup and place the pieces in a pot,
everything, even the head and meatless feet.
Then he ate all the soup and wrapped the bones
in cloth for later. My father tells me,
"Remember this: this is what war is.

One man has a chicken, and another doesn't.
One man is hungry and another isn't.
One man is alive and another is dead."

I say, there must be more, and he says,
"No, that's all there is. Everything else
is the fancy clothes they put on the corpse."

3. *His First Job in America*

That first winter
working construction
west of Chicago
he loved the houses,
how fragile they looked,
the walls made of thin layers
of brick, the floors
just a single planking
of plywood.

John Guzlowski

A fussy, sleepy child
could destroy such a home.
It wasn't meant to witness
bombing or the work of snipers
or German 88s.

He worked there
until the cold and wind
cut him, and he found himself
thinking for hours of the way
he stacked bricks in the ruins
of Magdeburg and Berlin.

Finally, he quit
not because he was afraid
but because he knew
he could without fear

his shovel left
standing at an angle
in a pile of sand.

The poem "Looking for Work in Chicago" appeared in the poet's book about his parents and their coming to America as refugees after the war: Echoes of Tattered Tongues *(Aquila Polonia, 2016).*

Ugochi Nwaogwugwu

Lost and Found (The Soul of this Town)

I.

Rain strikes stained window pane
like a frenzied drum solo at Constellation
Chicago. Attempting to cleanse
what remains of weathered
wood, brick and body

The bustling intersection
of 79th & Cottage Grove absorbs
energy whole; young and old
an intergenerational
non-discriminator
yanking souls out of skin
for the sin
of being
caught slipping

Avenues made from gravel and grit
smell blood spill and feast. Drink up
its warmth while dark matter splatters
in melodic syncopation to aggressive
downpour in vicinity of South Shore

It's Saturday Night
and the soul of this town chants
"Kitihawa Point du Sable!"
Thoroughfares bare invisible
resemblance to her non-existent
brown presence
Tuck her "pioneer" status
behind an unspoken veneer
a Hawk spirit. Her story bellows
in the city of wind as it spins
a destructive vortex

Violent rotating cycles of birth
and death around melanin, resurrect
essence of native woman return
in flesh. Stand. Heal feral homeland she plus
Haitian husband cultivated and settled
First. Bring it black in harmony
with universe, natural law

Ugochi Nwaogwugwu

II.
She folds into child pose. Alone.
In her sacred solitude summoning stillness
swarm her contorted form. Bury dead
in her head finally resting in placid peace

Beckons full face of illuminated
moon rise and fall on her body in waves
as it soothingly, synchronistic
caresses lake shore drive. Wash
over she like rugged rock stone, baptized
to polished perfection

Drown out rumble of El train or random police
sirens that incessantly wail and moan
their lingering lament. Singing
her into pseudo slumber. Lullabies that invade her
dreams. Disturb her awakening

She takes an intense inhale flaring nostrils to quiet
mind. Ignites tightly wound wand of white sage
copped from Culture Connection 360

It wafts room, filling cracks in low and high places
until consumed by thick smoke that suffocates
as it creates a safe container for she to reside and
hide from wrath released daily outside
on overactive corners of the southside

The soul of this town reflects
Jean Baptiste Point du Sable
A foreign king with no kingdom or court
Legislators have short term memory
Regarding sable-skinned citizens slain, so

she bends her frame to rhythm
of percussive rain drops.
Incant their names. Release
fervent prayers in direction of streets
smart light, LED opulent eyes
to deliver us from our shadow self

Marta Collazo

Cullom Street
for David Hernandez

He's come a long way
from Cullom street.
David and his famous dog, Lumpkin
standing like polished rice,
the mother of pearl,
the gold filling
in a Latino brother's mouth
paving Halsted street with paper hearts
all the way to the bank.
No longer compared to the Last Poets
or a sweet drug named heroin.
The Big Man in a little package
laughing at the moon,
standing on Chi-Town's shoulders;
the Batman of poetry,
this lullaby is a Cuban danza.
A Puerto Rican cuatro of cuentos,
Grapelli's gypsy violin, strong coffee, tobacco,
the morning news,
the night time blues,
he's come a long way from Cullom street
and noises in the street.
More like Hale Bopp,
the locust
and other assorted phenomenon
like the sighting of angels.
The Popular Culture Anthropologist
of real people behavior
whose words stink like sweat
or flesh.

Raych Jackson

Sunrise

Then a man invites me to watch the sunrise
like I haven't lived here my whole life.

Says it like he discovered air is what you need to breathe.
& I should be grateful that he put me on to inhaling.

Instead I go on my own.

My car is a shaky cavern of nerves that leads me east.
The silence is a welcomed sound in the darkness.

Being lonely in a large city is the only thing I do correctly.
I claim only good things for me this year.

The sun finally rises over the lake slowly.
Pushes through the pink fog to me, licks the water
and we stare at our reflection together.

What better mirror than Lake Michigan?
What better place to shine than Chicago?

Leopold Segedin

Three Men with Microphone (c.1945)

Marc Kelly Smith

Sandburg to Smith

Once you were the Hog Butcher for the world.
Elmo from Dakota stuck those pigs
Because it was a job nobody wanted
And he had to take it.
The blood came over his heels
And the pigs squealed.
And every time a street car turned a corner
Those squeals came back to him.
Bloodthirsty men.
Hogs to kill.

Once the tools were made here.
Are they now?
Buy 'em at Sears.
Buy everything at Sears.
Buy the whole god damn world
And cram it all into a thirty foot lot.
Renovate it. Rejuvenate it.
Hire a Polish immigrant to point the bricks.
A Czech to polish the floors.
Make the tools with Japanese steel.

"Stacker of Wheat" he called you.
Well, it must move through here somewhere.
Piled onto a boxcar.
Piped down into a ship's hold.
Stored in a concrete silo.
But where?

Louie Gomez quit school at sixteen to shovel grain off the
slip docks of the Calumet Harbor. It was hard fuckin' work,
but he had to take it. Now, a Champaign Biz-Grad, who builds
his body with free weights and cleans his Caribbean suntan
at the health club sauna, trades stacks of wheat we never see
making Louie's wages at sixteen (times) sixteen (times) the
years of inflation (times) the tick tick seconds of a Market

that closes at mid afternoon when and where Louis, now forty,
sweeps the floor.

Player with railroads, eh? Handler of freight to the nation?
There is no more romance to handle there now. No pride.
Just sleepy-eyed union stooges who walk the yards killing
time; pressing a button now and then. Robots, both mechanical
and in the flesh.

> Half hour coffee at ten.
> Gin mill at 12:15.
> Timetable says:
>
> City of Big Business Ventures
> (like the summer Olympics that didn't happen)
> And routine subsistence
> (like changing the sheets in the big hotels).

They told him you were wicked, hooked pin. He saw painted
women under the glass lamps luring the farm boys. I see hot
crack tricks prowling, almost naked on Dearborn, pulling
North Shore football heroes upstairs into fifty buck rooms
for thirty buck wipes of their runny noses.

> And they said to him:
> "You are crooked."
> And CROOKED STILL YOU ARE!

Crooked at the top. Crooked in the middle. Crooked at the
bottom – where maybe you should be crooked. Where maybe
there's an excuse for being crooked. Where gunmen still kill
and go free to kill again for those at the crooked top. For
those at the crooked middle, too moral to pull the triggers
themselves.

> Brutal? You bet, you're brutal.

On the faces of women and children I've seen the worn mask
of brutality, and I ask what's the use. What's the use in turning back
to these old pages of pride and optimism.
What's the use in throwing back the sneer saying:

Marc Kelly Smith

Come and show me another city with lifted head
 singing so proud to be
 alive and coarse and strong and cunning.
Flinging magnetic curses amid the toil of piling
 job on job.
Here is a tall bold slugger set vivid against
 the little soft cities;
 Fierce as a dog lapping for action,
Cunning as a savage pitted against the wilderness;
 Bareheaded,
 Shoveling,
 Wrecking,
 Planning,
 Building, breaking, rebuilding,
Under the smoke, dust all over its mouth,
 laughing with white teeth,
Under the terrible burden of destiny laughing,
 as a young man laughs,
Laughing even as an ignorant fighter laughs
 who has never lost a battle,
Bragging and laughing
 that under his wrist is the pulse,
 and under his ribs the heart of the people,
 Laughing!
Laughing the stormy, husky, brawling laughter of Youth,
 half-naked, sweating, proud to be ... proud to be

 ... proud to be ...

What's the use in being so proud when the things that change shouldn't and the things that should stay are fixed in the blind imbalance of Liberty that Hamlin, Masters, and Sandburg saw so long ago?

 Come show me now
 Hog Butcher, Tool Maker, Stacker of Wheat.
 Player with Railroads and Freight Handler to the Nation.
 Show me where we're going now.
 Show me our proud new destiny.

Previously published in Crowdpleaser *(Collage Press, 1996).*

Jerome Sala

Hercules vs. the Tyrants of Babylon
for Peter Schjeldahl

we here
 in the Midwest
sometimes see ourselves that way…

big dumb men and women
bludgeoning the style dragons of Europe and the coasts
so we can sit serene
entertained by the sad singers
in our Balkan restaurants

we hit the street
and hit it again and again
but there are just not enough people here
to appreciate how violent we really are

ahh – pass the bread and the cabbage rolls
and then let's all go down to buy English dance music
or get our hair cut
like they do out there –
beyond the sausage curtain

"Hercules vs. the Tyrants of Babylon" was published in The Trip *(The Highlander Press, 1987). Copyright 1987 © by Jerome Sala.*

Jan Bottiglieri

Inauguration Day, 2009

Barack: my mother died for you.

Because she was Chicago like you,
grew up on Armitage Avenue
in Depression years, poor
though she claims she didn't know it. First woman
at Waller High to be VP of her class.
Why not? She said. Like you,
what she didn't have
didn't teach her what she couldn't do.

Because she was Hyde Park like you,
at 81 driving her stricken son down to
U of C Hospital where twice they saved his life.
They're the best in the country she'd say,
wondering *what do other cities do?*
Turning right at the Fountain, that green glimpse
of what she always called Her Lake,
because it was true.

No lover of war, but when every able man she knew –
brother, lover, friends – joined the Good Fight,
she waved flags and made do. Immigrant's child
like you, no father at home, she carried that hope
colossal of the oceansick tossed toward Chicago;
she became the change they wanted for her.
Smart enough to run figures at the Met Lab,
didn't need to know for who.

Barack, my mother was America like you,
striver, happy in work, she taught me
diversity is strength, freedom thrives on tolerance.
She wrote one poem in her life
and it was about America.
She dreamed many things but the one she lived
was about America. She was Tess, Chicago girl,
an immigrant's daughter who knew

Jan Bottiglieri

when you said *your dreams do not have to come
at the expense of my dreams* you were talking
to her. When I tell you she died that September night
for you I don't mean like a martyr:
I mean *on your side*, like a mother, believing.
Of the thousand things I've been grieving
since she passed, one is this:
but she wanted to vote.

Now I watch you stand, hand raised to
the January wind, your own girls shivering
and shining there, and I see her – my mother, God,
how I miss her – her lake and her city, I swear they're there
too: the immigrant hustle and hope, the muscle memory
of Armitage to Lincoln Park, the world
my mother knew. Now the oath.
Now the change. The work to do.

An earlier version of "Inauguration Day, 2009" was first published in A Writers' Congress: Chicago Poets on Barack Obama's Inauguration, *ed. Chris Green, (DePaul Poetry Institute, 2009).*

Richard Jones

Walking the Dog

Blackdog and I, we've slowed down.
We take our evening walk down the alley leisurely,
having learned at last to go easy, to stop and smell
roses, or garbage cans, scents of the city.
It pains Blackdog to walk, arthritic hips gone awry,
and pains me to watch her hobble,
so we just go slow, old Labrador leading the way
or lagging behind, the two of us looking around
and finding ourselves in the last chapter
of our life together. It's always sad
to finish a long, well-written book,
pondering the last paragraphs,
the final few sentences,
then sighing
over the period
at the end of the story.
The leash now slack in my hand,
I admire Blackdog's eyes, sad and wise.
Our alley is beautiful with graffiti,
potholes, broken fences, that patch of sky
edged with clouds. At the alley's end,
we hesitate before turning back toward home.
Walking slowly, I tell Blackdog that when I finish a book,
I am a better person for having read every word.
I thank her for the treasure
she has buried like a bone in my heart.

"Walking the Dog" by Richard Jones is from Stranger on Earth *(Copper Canyon Press, 2018).*
Copyright 2018 by Richard Jones. Reprinted by permission of Copper Canyon Press.

Rose Maria Woodson

Lawndale

My old neighborhood.
A baker's dozen assortment of aromas:
deep-fried-cornmeal-rolled catfish, macaroni & cheese,
smothered pork chops, red beans & rice,
oxtail soup, collard greens & ham hocks,
black-eyed peas & fried chicken,
chocolate cake,
simmerin' chitlins, spaghetti & salt pork,
just-out-the-oven cornbread &
Lordhamercy barbeque.
Sweet-honey-hickory-secret-sauced ribs
smoke-signaled every cat-dog-man-child-woman alive
within a five mile radius.

Windows, like people, were open then.
Things drifted out. Things drifted in.

The store front church
two doors down
sold homemade, hand-cranked, vanilla ice cream
for a song
in the summer
after morning service.
I tasted sweet before I knew what sweet was.
The eggs nestled in the nest of my heart
were still whole then. Windows were open then.

My grandmother was always in a window,
watching us the way the shore watches the sea,
never losing sight of
where we were,
where we could be.

How could I know that sweet is
the voice that calls you, by name,
for dinner,

Rose Maria Woodson

for homework,
the voice that screams
when you play in the street.
How could I know that sweet is the dove
that flies from the open heart,
sent to find just you…
I tasted sweet before I knew what sweet was.

Now, windows hang around the necks of houses
like old lockets,
locked,
lost in dreams of a Grandmother,
cameo against the curtain,
calling cautionary tales as I disappear,
migrating along my own horizon.

Windows are closed now.
Aromas can't escape, can't dig their way out & run wild,
up & down the street, what with
hermetically sealed-air-conditioned kitchens.
Nobody knows, anymore, just
what anybody else needs to put inside them
to stay alive, to pause & taste the moment.

I promise myself this day, today,
that I will bake cookies,
chocolate chip cookies without nuts,
with milk chocolate chips, sweet butter,
the best vanilla extract & extra sugar. And then…
I'll open a window & set the captives free.

From the poet's chapbook, Skin Gin, *the 2017 winner in the QuillsEdge Press competition.*

Edgar Garcia

The Planetarium

Touching that, I saw it all – the spectrum,
The odd beauty of all things – the tormentation –
Abusive whimsicality, though felt
As true as the reappearances of a god,
Desire itself, embodied like a planet.

I'd seen the planets. Mercury was first.
Then that goddess of ambivalence,
Fertile with real clarity of purpose,
Inscrutable at times, because so sure,
That lovely Venus passed through my aching mind.

There is no touching such soft and tender disturbance
Without war – so Mars came after, and I,
As uninformed as I had been generated,
And gratified by military sport,
Thus died on drifting fields of winged dispatch.

And that was in my mind okay, not bad.
As you will know, I grew up on Earth, amidst
The worst of playful bellicosity
In masks of bellicose play – and ended my life,
In the truest sense of such words, in what gangs

That world could give. And that gift gave me the gains
Of Jupiter, highest of principals,
To guide and give form of worlds whose thunder speaks
Instrumentality, that ancient art
To hold when even what is visible

Is lost. And put such loss to work. And work,
That sacred rite we give for stalks of grain,
Is Saturn's home – the memory for which
We think extraordinary justice for all,
And order undivided, can be had.

Edgar Garcia

It is such strange and almost half-held –
Both here and utterly not – remembrance –
It slips into what hands Uranus has.
Originality, it could be called,
In forcing fondness from eccentricity.

This is the passageway to dreams as well,
To psychic receptivity, illusions,
Uncertainty of purpose, the brackish veils,
Which oracles still wear, in tacit fear,
Of Neptune, spinning past in liquid mirrors.

In going dark they gave the heaviest gift –
That gift that summons a person to inhume,
As I had done, so many times, such sand,
And dirt, once interspersed, intractable,
The diamonds in your hands – oh, Pluto's spoils.

Nina Corwin

Whose Law?
for Kent Foreman, Chicago poet (1935-2010)

i.

Ask the gravedigger, rusty spade cast down
 beside a pile of rock-bound clay:
 Why must fire always end in ash?
 What's that you say?
Everyone works, trades, pays and finally burns.

 Once upon a life, you wrote:
 it is the law.

ii.

Now, there's trades
 and then there's tradesmen.
And who better to dig?

Dig Max & Abbey & Oscar Brown, Jr.
 Outlive and live to dig some more. I mean *dig*
the dignity seniority accords. Dig Lorca, late night
 jazz & *Hot House* flowers:
 All fever and grace.

iii.

So, there's vocations. And paychecks.
And things we do without pay:
 Fashioning words into bridges and wings – a craft
 we wouldn't trade for anything.
 There is no price tag for this.

See, there's trades and there's tradeoffs.
 And in due course there's changes.
Colors change, loyalties change, finally
 the guard changes.
One stepping out as another steps in.

It's nothing we didn't already know:
 The victors have always taken
 history hostage, tortured it

into its present form. Lips sewn shut.
The law as rulers write it.

iv.
Think about it:
Cars break down on Route 94
hit the skids and collide
with each other.
Tickets are issued by officers of the law.

v.
But, why does fire always end in ash?
Ask the cigarette, its smoke rings rising
in a room that holds no truck with angels.
What's that, you say? Law
Of thermodynamics? Entropy? Extinction?

Damn, that's cold. But then,
it's winter in Chicago and it's cold all over.

vi.
I believe things come around or else they don't.
I believe in Stolen Moments and Great Balls of Fire.
Love's kindling: the hotter the better.

Once, I fell for a fiction, a fragrance, a fast ball. Hit by pitch.
The Bucktown pigeons saw me lame and pegged me. Twice.
But you? You called every day to see how
I was mending. Now I have fallen
for love with all its wrappings ripped off

And it is good. I believe
it's everything we burn
that gives us heat and light; so
if ash is what it all becomes well, that's life.
You don't have to dig graves to dig that.

vii.
So, my friend: foreman of gravel and clay –
How about we swap a song or two again? Dueling

in each other's duet.	For a minute.	A moment.
No answer.
It's late and there's a law.	No exceptions.

You hear that clock?	It's unrelenting,
wouldn't you say?	The works over-wound,
ticking faster than the fastest man.
How are we to count the hours?
And to what end?

viii.

Look:	there's a crimson-gold sun
burning off the clouds above Lake Michigan.
Whatever the hour, what counts is this:
You were radiant. Even now –
I can still see you glow.

First published in Sou'wester, *2013.*

Kerry James Marshall

Untitled (policeman), 2015
© *Kerry James Marshall. Courtesy the artist and Jack Shainman Gallery, New York.*

Juana Iris Goergen

Translated by Silvia Tandeciarz

Reconquest

When the trains
 rise up my throat
drowning a scream,
there is no machine, no method
noise invents time, Chicago
and what I write
in muted cry
in another tongue I unname myself
 "Oak Park" "Lincoln Park"
 "Logan Square"
 "Green Line" "Brown Line"
 "Tous Les Matins Du Monde"
screams someone out of context
and I
from so much not being
in two places
lose my center.

Unnamed
not even Walt Whitman
would dare try to recognize me
my name is a heap of bones
the weeping of masts
upon the shores
nothing contains the figure of a woman
colonized
an uncertain tenderness
a clock in shadow
an animal that thinks
an eye that glances
at the balcony of other eyes
that feeds of looks
of others looks
and turns back to you
Walt Whitman
and calls you once again
from emptiness to emptiness.

Juana Iris Goergen
Translated by Silvia Tandeciarz

Unnamed
tell me, tell me Walt Whitman
how old are these shores
that steal my body little by little?
and these hands
that are not awed
and these eyes
that topple to my feet
how old can they be?
Tell me, tell me yourself
Walt Whitman
who between the noise of Chicagoan trains
asks me
who dreamt this woman
polishing and sharpening
the threads of her broom?
this woman
that is water in motion
around an imaginary
island
who entered through the walls
recording her writing
in the windows
and asking herself
who dreamt you
Walt Whitman?
entering alone into the temple
of a transparent kingdom
that took away my country
my country
my country
that took away my country
that also asks itself
who dreamt this woman
who goes about changing the walls and the doors
and walks a dream
that the ancestors and the political status resent?

Poor us
poor you and I

Juana Iris Goergen
Translated by Silvia Tandeciarz

Walt Whitman
this clock has no pendulum to help
let me enjoy
this crisis
now that the Chicago morning is new
and a naked animal ties me
to the eyes of a diminutive girl
and you
who wanders in me from far away
beneath the voice
and I
in Winter's dark
I
screaming
devoured gropingly
by the seething eye that sings me
I do not exist
and in unnaming me
and in renaming you
Walt Whitman
I disappear intact
and exile myself
exile myself to a poem.

First published in Tameme New Writing from North America Volume 1 Issue 3, 2003, *selected by Tameme editor, CM Mayo, to be the poem that titled the volume.*

Barry Gifford

The Season of Truth

This is valuable experience,
lying in bed with the window open
on a cold, late October morning.
My father might not have understood it
but I have written some of my best poems
this way. Sunlight streams across the floor,
reminding me of my room at the back
of the house in Chicago.
It was always cold in there,
I liked it. I could scrape my name
in the ice on the window glass with my fingernail.
It was nicest when the sun shone on the snow
not hot enough to melt it,
but that was rare, usually the sky was gray,
and made me want to get away.
Born in Vienna, my father chose Chicago
to die in. Pigeons pecking in gutters,
frozen overcoats at bus stops.
The coast air is clear, I am happy here.
Chicago comes closest late in the afternoon,
when days are short. Winter, rain,
are more real than the rest. In truth,
that is when I am most relaxed and feel best.

Used by permission of Barry Gifford.

Christina Pugh

Windy City

They wrote all over the rocks, the ones
who came before and come still; choicer
than graffiti, the paint cubed and letters
blocked like epitaphs: *Acid* or *small groove*
or *baby cakes*. And primary colors whet
the schools of foam the lake makes,
its mobile cursive less serene, while the city
wells above that trace of sociability –
its steeples snuffed, or nearly, in the mist:
this could have been Christminster,
or these the moral rocks Tess read
on her journey home in terrible,
delicate boots: the shores mirror us
always, but the city transpires.

From Restoration *(Northwestern University Press, 2008).*

P. Hertel

untitled

Arthur Ade Amaker

Clive Jackson – What it is about Chicago…

When I came to this city, red dirt didn't run through my toes anymore. Hell, I aint never even seen any more of that; only green glass grey concrete blood on pebbles in these west side alleyways. Had to wear these scuffed up Florsheim shoes, walking down Madison when I first came. I was country clean. Now got me a pair of sneakers. Got used to wearing blue jeans in the winter. Wild cotton gloves, rubber boots for this snow. Long black trench coat. City clean.

No Magnolia trees here. No black-eyed susan vine, no candlestick plant. Whole nother type of tree in Chicago – buckthorn, black cherry, elm trees. I like them Mississippi trees better. They do better in the heat. Them wild magnolias put you some kinda where when you see them in bloom. But that's alright. Here is not Money, Mississippi. Thank God it not there. They treat colored better up here. Don't they?

When I first came here, I settled in with my cousin Mabel. Boy is she country. Walking around outside barefoot in the summer, pink handkerchief on her head, spitting chaw tobacco on the ground. Shoot she would walk barefoot in the snow if you let her. Still making corn liquor in mason jars. I tried to get away from that stuff, but boy it was hard. I miss home everyday. But now this is my new home. Met my wife here. She from Mississippi too. Greenville. She came here a little before I did.

This city, it's good but it's bad too. Like a real relationship, it make you fall in love and stumble out of it all at the same time. The stuff I love about this city – the lake, the skyline, the big pier where you can see them boats and watch those Fourth of July fireworks. The fountain in Grant Park. The Hancock Building built a few years ago. Took my son up there. We had the chance to look down at all the pretty lights of this city. Those pretty Chi-town lights.

The stuff I hate about this city – Cold weather. Can't go certain places without White folks having a fit. Try to run you out the neighborhood if you move in. Already seen a lot leave the west side. Lot of hate. Different than Mississippi, but hate still the same. They run like rabbits when they see us on the block.

Hard to get a job. Cops bust a Negro upside the head just for walking down the street. I used to think to myself – Did I really leave Mississippi? Really? I thought they liked us better up here. At least, that's what they told me.

Arthur Ade Amaker

The lights wasn't so pretty the night after Martin Luther King got shot in the head. It was on the news. Blood everywhere on that Memphis balcony. The only light we saw the night after came from the fires three blocks down from our two flat. Them type of lights ugly, real ugly. They burn everything in sight. Imperial theater, Rosenau Jewelers, Frank's Furniture House. Gone. Negros burned them down. Some say they going loot some more. Feel they got a right too. Need to be heard, they say. Crazy I say. Just crazy. Too much. Too much.

Police is everywhere. Guns out, they say there are snipers on the roof tops. We going to wait it out here. I got my rifle here just in case any of them want to get crazy with my family. We from Mississippi. We keep guns. Ain't scared of em. Ain't afraid to use em.

They say nine boys got killed. 300 people injured, 2000 arrested. Lot of blood. Lot of blood. They keep spilling our blood, so we keep burning. They spill some more; we burn some more. Man, when is it going to stop? Right now, I sure am missing home. But I don't think this is going to happen again. Negros mutinying like this. Not going to happen again. Ever.

Right? Right?

Kathleen Rooney

Pastoral

Lake Michigan churns like a washing machine today. Or so I imagine. Buckets of rain mean I remain indoors.

In the condo, the distant thunder of the toilet flushing. The sky out the window a moody adolescent.

When was the last time I just sat by a tree?

Why do the woods have a neck anyway?

A week past the vernal equinox, it stays too cold for green buds or bugs.

When it comes to alcohol and cookies, why are grasshoppers minty?

Convolvulus is a gnarly name for morning glory. Ranunculus same, but for buttercups.

In Chicago, we call plastic bags blowing across the sidewalk Jewel tumbleweeds.

The wind runs up the street on invisible feet. Its breath is the shepherd, the debris its sheep.

There won't be any sunset to speak of today, but all it would have said is *Et in Arcadia ego*.

Canada geese make a V in the sky, a reminder that in the end, victory shall be theirs. It practically glows.

Stare too long at a screen and the heart grows pathetic: misanthropic hamster, jogging on a wheel.

Can idle merriment, nymphs and swains, ever attain on purpose what nature achieves spontaneously?

When I can't visit nature, nature visits me: the fattest sparrow on the bare ash tree.

First published in Women's Review of Books Sept/Oct 2021.

Useni Eugene Perkins

Bronzeville Poet
for Gwendolyn Brooks

The streets of Bronzeville
seem more beautiful
because you gave them honesty.
Made Philistine experiences
more than monotonous copy
for obituary columns.
Helped black children
realize that filth and dilapidated houses aren't
the only world they have.
That blackness is more than
being able to recite black poetry
or wearing a voluminous natural.
You gave them fertile
soil from Africa to
scrub their faces.
Lifted their pregnable hearts
When racist institutions
branded their minds
with inferior images.
And the clumsy tongues of
button-down collar bureaucrats
told them that America
was the black man's salvation.
The streets of Bronzeville
seem more beautiful.
The blues at Pepper's Lounge
begin to take on
greater significance.
Muddy Waters becomes
a living legend and even
first graders admire Otis Redding.
The shadows under the "el" tracks
Along 63rd still hold fond memories,
of glittering neon lights
and mellifluous music.
And when we listen carefully

Useni Eugene Perkins

the buried sounds of the Savoy
Ballroom can be heard over the clamor
of screeching jitneys and street-
corner sermons.
And though Michigan Ave. has
lost its aristocracy,
a few buildings remain
that have survived "mecca's" fate.
And the dingy food shack
on 35th is not forgotten
amidst the neo technology
of industrialized war schools.
Its hickory aroma trickles to the corner
newsstand where two retired
postal workers see their dreams
absorbed by a dusty checker board.
And senile women with their
moth-eaten shopping bags,
searching for bargains at
the Catholic salvage store
aren't to be damned for blasphemy.
And the new black poets
begin to talk about
creating something
revolutionary…
black life styles/
and relevant dialogue/
They take a walk
through your Bronzeville
and begin to discover themselves.
See true images/the gut of life
silhouetted against the transparent
fabric of the black experience.
A Blues Singer greets them
And fiddles on his twelve string guitar,
while little Bronzeville children listen
and dance to your poetry.

Johanny Vázquez Paz

A World of Our Own
to the people of Humboldt Park

Between two flags we built
the past of an island exiled to memories.

We put up colonial balconies
and replaced the asphalt for paving stones,
the parks for plazas,
the supermarkets for *colmados,*
American coffee with *Café Yaucono,*
and hamburgers for the steak *jibaritos.*

We changed street names and words in Spanish:
from "desfile" to *parada,* from "patio" to *yarda,*
from "alfombra" to *carpeta,* from "mercado" to *marqueta,*
because we are bilingual *y podemos mezclarlas.*

We put flavor in the food, rhythm
to the music, murals on the walls,
accents on the words, heat to the cold.

We opened *botánicas,* cultural centers,
galleries, museums, restaurants
and anything else we needed
so our children could learn their heritage
of waves returned to shore
mixed with the blood of three races.

We built a world of our own between two flags.
A neighborhood with well know faces, familiar aromas
and noises kept company by the rumble of the drum.

Our homeland in exile that floats like a desert island
in the deep and vast sea of the city of Chicago.

First published in Streetwise Poems/Poemas callejeros *(Mayapple Press, 2007). Author retains reprint rights.*

Frank Varela

The Raccoons of Humboldt Park...

How out of place you seem
ambling down North Avenue,
are you lost or out to explore
dreaded city by the lake?
There's more found than lost in you.
That bandit's face harbors a sly,
impenetrable eclipsing moon.

Your rings remind me of the Cheshire Cat,
one instant there, next gone.
My wife's worry: dogs – mangy creatures.
The strays will get out of your way
than risk tooth and claw,
but I never thought raccoons favored Humboldt Park –
yes, Humboldt Park,
ten-city blocks set down on prairie open to the sky.

On Sundays, lovers wander serpentine paths,
when summer leaves or autumnal splendor
dress the trees in colors.
Only the public buildings betray the presence
of another power: graffiti's blasphemy.

Let's consider if raccoons favor Humboldt Park,
why not other animals?
Imagine bison thundering across the flatlands
as in the days before LaSalle, du Sable, and Father Marquette,
or spy stalking antelope, a golden shadow
lost among the whites of Queen Anne's lace.

Wouldn't be marvelous if in the lagoon,
beavers carved outlets for stagnant waters,
birthing mighty Humboldt River?
In one generation, time curves in on itself,
and the park spills beyond its borders.
Whitetails, alert-skittish, heads-up-down,

Frank Varela

nibble tender shoots,
while rusting automobiles
become ferny forlorn relics.

Funny how raccoons can change a city –
von Humboldt himself would never believe
ivy scaling up Sears Tower,
bachelor buttons carpeting the Kennedy
from Jefferson Park to Stony Island –
fauna and flora repossessing the earth
at the twilight of creation,
and while buses, cars
no longer rumble up Michigan Avenue,
manikins stare dumbly
at a sky never seen so blue.

"*The Raccoons of Humboldt Park,*" *from* Serpent Underfoot, *(MARCH/Abrazo Press, 1993).*

Alma Domínguez

We Are Here to Stay

Julie Parson Nesbitt

Ferris Wheel at Navy Pier
Modeled after the first Ferris wheel, which was built for Chicago's 1893 World's Columbian Exposition, the Navy Pier Ferris Wheel had 40 gondolas, each seating up to 6 passengers, until it was replaced in 2016 by the Centennial Wheel.

The old pier leans its narrow shoulder
against the shifting lake. From the pier's center
the Ferris Wheel rises: a strange flower

fifteen stories high, whose petals spin
down the slow drift of lake wind.
The Wheel curves to the sunlit east, bows

to the steel west where black slabs of buildings
stab the sky. Waves slap the pier:
a dealer shuffling his cards. Below,

a tide of lovers and children turns and flows.
In the Wheel's shadow, a girl presses herself
along the salt sweat of a boy's thigh.

The Ferris Wheel raises clapping hands to the sky.
Riders rise, crest, and descend; descend
and rise, while the sun spills down its silver coins.

Beautiful city, terrible dream.

Duriel E. Harris

Sonho meu sonho meu/ Vai buscar quem mora longe sonho meu
 – "Sonho Meu" (as performed by Maria Bethania and Gal Costa)

To be frank, I am holding her destiny in my hands and yet I am powerless to invent with any freedom: I follow a secret, fatal line. I am forced to seek a truth that transcends me.... But who can tell if she was not in need of dying?
 – Rodrigo S. M., writer and narrator speaks of his principal character
 Macabea Clarice Lispector's *The Hour of the Star*

A Secret, Fatal Line
(Ten Hundred Block of Racine Avenue, Chicago, IL)

want. unfurls from the spine.

trashy squat. folding
nylon lawn chairs. goodwill
card table, griddle plate,
sugar packets, ashtray. warped
plywood floor. soiled mattress
beneath a sill. something
turning sleep against the wall.

*the hand that feeds
smites and is done.*

the woman who stayed here:
hairless. not a single stringy strand. (except
stray eyelashes) she drew on
half-bird eyebrows to go out, and to church
of god militant pillar and ground of truth
she wore a ratty marcel wig. mahogany.
her soft stink waits on doorknobs and edges.

knew what she wanted. all the w's
sewn into her lining. soldier and willing.
eyes fixed on some point
beyond. no one will go
looking for her gnarled ash.
no one will go looking for a street
hype, homeless black hooker,
who worked her hustle like a wall
street broker. going broke for bulk.
rock smoke. gone in 15 min.

composition by field.
the crease her body made disappearing

Robbie Q. Telfer

Chicago Wilderness

Are people still leaving
Are they still stuck
What are they doing to our schools
Why isn't my recycling recycled
There was a skunk in my neighborhood
last week and I do truly
love their smell truly I do
It would be wrong to mail human shit
to Trump Tower
counterproductive
and yet
16 red stars between
two thin blue lines
Traffic report says
where the protest is at
The monarchs still pass through
en route to Canada and Mexico
they have many barriers to overcome
but a wall is not one of them
If we are to be saved
It'll be by
Chance
The Fort Dearborn Massacre
was ostensibly because
the white people destroyed
their guns on their way out of town
instead of giving
them to the Potawatomi
like they promised
What do you
call a gift white people
promise but never deliver
I can tell you where to find
the first wild turkey seen
in the city in decades

Robbie Q. Telfer

It's hanging out where
Aagje and Jan Ton hid freedom
seekers at their underground
railroad farm
en route to Canada
We are often noteworthy
only for those who pass
through
The only flower from Chicago
and found nowhere else on Earth
hasn't been seen
in over a century
only ever seen at 119th and Torrence
it's a tiny ghost named *Thismia americana*
and I know for a fact
it's still out there somewhere
hundreds, wild
I know they're still there
underground
waiting
till we again deserve them.

First published in Newcity, Summer 2019.

Luisa A. Igloria

Dear Epictetus, this is to you attributed:

Thou art a little soul bearing about a corpse.
And even then you were talking to all of us, weren't you:
ghostly presences in a future we now inhabit, tumbling
swiftly from one gate to another.

Last week, moments before the train departed the Jackson
Street station for O'Hare and a flight I had no idea would be
canceled three times before I could board: a woman got on,
breathless, asking passengers near the doors –

Chinatown? Chinatown? She had on a thin cloth coat,
and her short bob of greying hair was plastered
to her forehead. No one blinked. Perhaps they couldn't hear
from whatever was playing on their earphones, or maybe

they were tourists. Before the doors swung shut
I caught her eye and shook my head, yelled Red line,
Red line, and she darted off. I don't know if she ever
made it to her destination. Time is like a river

made up of the events which happen, and a violent stream:
for as soon as a thing has been seen, it is carried away,
and another comes in its place... Therefore, all that afternoon
into evening, as thin snow began to fall again

on the tarmac, streaking the windows,
chilling the glass, seats filled and emptied,
emptied and filled as though the blue light
flickering near the ceiling of the concourse

were that same river's garment. Anxious passengers
watched as TV monitors showed footage of town after town
hit by a single tornado – New Pekin, Henryville, Marysville,
Chelsea – before it crossed the Ohio River

into Kentucky. The hours stretched, and in their fluid arms
there might have been the call of the mourning dove,
there might have been a sparrow slight as the child borne
aloft before the dark column of air set her down in the field.

Marty McConnell

the fidelity of disagreement

Because there are seven kinds of loneliness
the receptionist keeps a basket of candy
by her desk. I keep my hair long
out of some poorly sublimated need

for tangible accomplishment. On Tuesdays,
the man under the El tracks calls me Miss America.
Most afternoons, the jobless gather in pockets

to shout compliments to each other across Sheridan.
It sounds a great deal like seagulls calling
other seagulls over the lake, or more
accurately, around the raw ascending buildings

where they screech directions, one
to the other, headed for water that is not
the river, past the bridge and the Picasso,

over the heads of the unlisteners, headphones
tucked into our ear-beds, and this is the first
loneliness. In the dream, I pull away slowly,
and you stand there, very still. When I turn

the corner, you are still there, and the next,
still there in the rearview, then it's not a car at all
but a movie, you're in an airport in San

Francisco, on an ex-lover's couch
in Seattle, it's unseasonably cold
for October, even for Chicago.
There's too much room on the mattress

and your shoes sit panting in the closet.
What do I know about loneliness.
You're on your way home to me

Marty McConnell

and a kitchen where the overhead light
sighs into a dim and the spoons tuck
their worn faces away. It's best
to argue in person, so you can see

where to aim the knives. This is the third.
I don't know what I would name a child. Four.
Across the train, a grown man memorizes the pattern

of a girl's school uniform skirt. A shirt button
is about to come undone. He leans forward
in his seat, our train a compression chamber
draining. Five. Somebody says, *you have*

*to show up early if you want to get
the chocolate.* I want to name this
something other than sorrow, tell you

I have a bird behind each knee. One
is always in a panic. The other, most often
asleep. I wish I could tell you that I know
what I'm doing. Was I ever a woman

who could shave her head without flinching?
I was. This is the sixth. We have time
for mistakes. The men on the street orbit

the employment office in a set rotation
I cannot translate. What loneliness
is left? You have the most beautiful face.

From Wine for a Shotgun *(EM press, 2012).*

avery r. young

base(d) on a prompt from Phillip B. Williams

a poem written in de voice of a parent Bunk 1973 -1994

inside co(r)ner sto(re) yo mama
profile erything right in stretch pant(s) actin
like her cuddnt reach a strawberry boones farm
from de cooler when her turnt tward(s) yourn(s) truly

& say hey

whatever yo name is

u tall enuf

get dis fo(r) me immediately i knew

i want(id)
a house of us & three baby(s)
wif my face punctuate(id) by her deep dimple(s)

me 19
in '91 inside co(r)ner sto(re)

all teef & cocoa butter

adidas track suit gold rope & joop

high top racin wif de sear(s) tower
to see what wud reach god firs(t)

dat day no blood or yourn(s) truly
to wipe off concrete

no officer briggins or meechie

dat day

no soun(d)
of her screamin on de new(s)

or picture of her in de paper

firs(t)

to keep yo mama from crossin yellow tape

reachin
to snatch me from gettin to god

The Father

I know. I know. I was not just a man who had nailed down horseshoes. Not just a man who traded in a welder's hide for a grocer's apron. Not just an alderman, but a town marshal, a treasurer. A man who counted. I know. *Where the sunshine does not enter in, the doctor does.*

And it is dark in Chicago. There is no sky out our window. There's grease again on my hands. The only sun is the before-and-after-work moon. I know too what Anna forgets. We might have starved in Michigan. Like in the old land. I tell her to stop acting the maggot. *You'll never plow a*

field by turning it over in your mind. And how it does rain in Chicago, turning to ice on the streets. I too miss the little lake where we used to skate. I taught Aggie and her sisters, steered them away from the edges, the invisible threat of thin-ice-skin. Anna taught them to jig. How to knot

a thread to mend your own skirt. *No man ever wore a scarf as warm as his daughter's arm around his neck.* Now I teach them to work hard. Harder than a body can stand. Still, I couldn't believe my eyes that night of the strike. Our little Aggie – two long braids down her back, her anemic

wheezing lungs – climbed onto the bandstand. Uninvited. Unplanned. A Spring crocus volunteering up through the cigar smoke. You could smell the sweat in the room. Like a hot hand on my neck. I know. I know. *Politics is a man's art.*

In 1897, Agnes Nestor moved with her family from rural Michigan to Chicago and began to work in a glove factory. She was 14 years old and quickly became a local activist and labor leader, and later, a national advocate for working women.

An earlier – and very different version – of the poem appeared in the online series escapeintolife.com. The whole "Aggie" series is also in a manuscript, titled (for now): All in the Air at Once.

Angela Davis Fegan

Letterpress posters (printed by Angela Davis Fegan) installed in public restroom for brunch at the Empty Bottle / Lavender Menace Occupation, March 2017. Photo by Jasmine Clark.

Tom Mandel

Remedial Memorabilia

 As I drive the mountainous spine
Of three states today on my way
 To an annual retreat of friends

 Memory's savoir faire sends me
The set Dexter Gordon played a
 Half century ago in my college

 Dorm, backed by a local quartet
With Ira Sullivan on trumpet (that
 Dejected idol of Crow-Jim

 Abstraction I'd so often heard Monday
Nights at the Gate of Horn's weekly
 Jam session, where he seemed to cut

 Everyone who came through town)
& the pianist Jodie Christian. As
 Dexter swapped quips with listeners

 Bassist Donald Garrett in his
Ala-Eckstine a capella way off-
 Tune baritone began to croon:

 "Imagination is silly
You go around willy-nilly
 For example I go around..."

 ...The car in front of me, crossing
The line after many feints, while
 I ponder memory's tonal

 Scale, the way time's shutter beckons
Thought away from the wheel to where
 Revealed or else re-veiled each part

Tom Mandel

 Of recollection folds through the
Shadowed rectangle of a truck I pass
 To maintain speed. Forested hills

 Flank the road. Sunlight flashes in
Picture windows while thin as the
 Devil's cigarillo Dexter

 Tears *Cherokee* to a storm of fragments
& legendary Chicago drummer
 Wilbur Campbell turns each moment

 Into music he cradles then returns.
Enormous suburban houses unroll
 Along the road – like CAD drawings

 Of mausoleums with driveways.
The other tunes Dexter played I
 Don't recall – bop classics, ballads,

 Some blues I imagine – yet riffs
From tenor solos roll through memory
 As if to fill out an experience

 That doesn't need the help. & now
(A different now I mean – as I write
 These lines) it's *Back Home Again*

 In Indiana that I find myself
Humming – a tune Dexter might have
 Called that day, confident it would

 Be in every player's repertoire.
So it is that each thing one knows
 May lead to another yet leave us

 Suspended in motion. Time, like
This simple drive, route & end-point known, seems
 Endless! Will I get there today

Tom Mandel

 I wonder… as out of nowhere
Another moment comes to mind, & I
 Hear my exiled Angolan friend

 Carlos recruit me to kill the
Enemy of his cause: "You fly to Rome,
 Someone puts a gun in your hand.

 In that moment disparaitre
The future you fear eludes or
 Excludes you," he goes on excitedly

 While I think "Is he nuts?" & fake
A chuckle as if we both know
 He's joking. Heady times – or so

 They seemed, that these days gather dust
On one of memory's neglected shelves,
 "*Unlike the vivid afternoon*

 I spent cross-legged on the floor
While Dexter played" I muse – but then
 As if to lift the aegis of

 Memory from this unending
Day, rush hour suddenly arrives!
 I hit my brakes & watch the Sun

 Into stalled traffic. "*This drive is*
Taking forever!" I hear myself shout. Back stiff
 From long hours behind the wheel,

 I need a place to stay the night.
& with that thought I am famished!
 I pull off the road & find a motel.

 I'll get there in the morning. But
Now, as dusk gathers outside my window
 I write down these lines from out of my past.

Dipika Mukherjee

Printers Row, Chicago

I come to Chicago
resisting assimilation.

From old cities in Europe
to the older ruins of Asia,
I have resisted the hyphenations
the identity reconstructions,
of tired-huddled-masses,
in this adulterated corner
of the globe.

Until, in Printer's Row
– in an antiquarian bookshop,
red-bricked from 1896 –
a man reads from the distressed
first edition of the *Rime*, hardcover
separated from spine, stark lines drawn
above an idle ship on a painted ocean;
He knows Tagore, and on his desktop
is the image of Waheeda,
incandescent beauty.

He talks about translators,
epics, New York broadsides.
In that tiny shop, lays bare the
nuances – the proclivity of
imagination – this audacious new world.

"Printers Row, Chicago" appears in East, West: Juxtapositions & Intersections, Earthen Lamp Journal (India), #3, 2013.

In the Intersection, Jackson and State

Without looking, I could cross Jackson
without getting struck, guided by voices, a hum
of tires on coarse pavement. I want to scale
one of those slopes, the blushed steel
of the CNA Building, grab the Monadnock's
frayed terra cotta drapery and climb.

Lakeside wind so loud it changes the subject.
In dreams, I lie too long on spring grass, pikes
still dead despite thaw. Ants crawl my arms,
bees swarm. Nature an antique, an abandoned
oak table behind glass, waiting for me
to test its legs, barter a price.

I'm afraid of nature. Orange, Brown Line
trains cross paths, the distant touch of negotiators.
Rivers changing course, office windows bound in mist.
Pavement accumulates, dismantles, rises; an array of noise
come again. One block east, a construction crew
is drilling, their hammers lift from State like smoke.

First published in The Lama's English Lessons *(Three Candles Press, 2006).*

Calvin Forbes

State Street That Great Street

You ran and then that cop shot you
You did nothing wrong so why'd you run

You think being right makes any difference
Maybe you figured being on the news

And on the front page of every newspaper
In Chicago makes you a star a legend

Instead of just another victim of a history
That's been around the block forever

All this anger's nothing but fool's gold
Your daddy can't spend on a good lawyer

Now you in the hospital instead of in the grave
You still figure running was the best option

What happened next was as predictable
As his finger on the trigger and the six bullets

He fired at you like you were a target
At the firing range and he took up the dare

The street corner isn't the amen corner
No man alive can outrun a bullet

Better to be arrested than to be dead
You are one lucky son of a very nice lady

Mary Kinzie

The Mary Chapel

Her arms pour down within her sleeves,
Her face bent so that she can look on all
The loosely gathered knots of supplicants.

Their skeletons seem to articulate
A blurring form of grief almost too abject
To be sculptural, or so riven by injustice
(What they suffered was so crazily *unfair*) that
Their bodies are distorted for a moment,
Caught out of time, but in the thick of motion
Like competing heroes in a peasant play:
Lear and Dis and Job, pelted by blows,
Gesticulating with a huge and narcissist
Disorder.

 One sees them, eddying in
To pray at St. Peter's in the Loop:
Types of mania or resignation
Self-knowledge briefly seizes or, perhaps,
A pang like recollection at the edge
Of antiseptic hours. This is what their mother
Would have liked to see them do –
Or what she was always doing, dropping one task
For another amid the clamor of her children
Till her sewing lay all about her,
Lank and ragged now her hand
No longer shaped each piece –
Or what they had never had a mother *for*:
To look on them with the mild silence
Of her disappointment, forgiving them
The pain they felt; how they felt it;
How they hated being trod on; how they turned.

•

The church must complement this panic
Orphaning that flares from soul to soul
By its clean chill of calm – nearly affectionate –
To rock complainants toward the Mary Chapel
Beneath the constant, air-conditioned nave.

Mary Kinzie

From a distance, what emerges is a period piece
Like a didactic painting of the Death of Cato
Or the grain exchange, as figures in scarlet drapery
Discourse from shared assumptions. However trivial
The allegory that one could put in words,
The comprehension of the image shows
Something lofty, proceeding from afar
To sweep us through the angle of beholding.

A figure who could be a servant bows
In a gloomy curve. A man, superbly dressed
And languorous, stands sideways listening…

But when I start to question what I see,
All the amplitude of a controlling vision,
And all the evocations of decorum, splinter.
Vanished any social warmth. The linkages
Of limbs and air jar with aversion.
Images of gargoyles tease thought over
Bundles of sub-humanizing sorrow
Heaped upon hassocks, like volcanic dross.

Even the auditory solace of the place
Begins to jive, and the frozen backs before me
Gulp and echo with the indistinguishable babble
Of their needs – remorse, ejaculation, plea –
All feeding on the golden atmosphere
Of answer but famished to an agitated
Subterranean shrilling as of organisms
Coursing through blind chambers:
A bent lady is pecking at her beads,
Her neck and spine as if held down
By an enormous hand – her entire person
Pent before the door of the confessional
Which an electric bulb admonishes
Is filled: Can she feel that closet
Dense with the burdens murmured in darkness
By some other to an unseen judge
(Knowing these are less serious than hers)?
She waits and waits. A restless icon
Of the rash of numbers, boiling with specifics –

Like the sideways man, fixed before the Station
Of the second fall of Jesus crowned with thorns,
Who can't catch the words he cocks his head to follow –
But he can't move the head at all; it grows there –

So he hearkens twisted to the twisted Via
Dolorosa with its grueling clues: He thinks he knows that
That is what Christ must think up to his maker
In the garden, that none of this was
Real, not blood pressed out of every pore, not
What was coming (briar; metal), not these fell
Accidents to body. He registers the message
With his crippled neck.

I try to turn the corner into
Common sense – the thought that we're all
Normal – some, sure, a bit wearied out
By life, but on the whole coherent
More or less – as if the myriad oddnesses
Could boil down to the average and subside.

It is a way of loosening oneself
Upon the lie,
 for something is not right.
This peppering of torsos in the clean blond pews
Cannot relax its arbitrariness –
As if the hull to which whole colonies
Found themselves fastened, held them fast, too –
Framed a descent that every person helped
To make a bit more solid, and time became
A staying-fastened over time,
Memory a jumble selvaged and precise
Like a deceptive jigsaw made of many – almost
Matching – broken sets.

 In the medieval
Theatre of levels would be a place for each
– Dante could place them – but here they grow unclean

•

Outside, the hectic throng
Even mid-morning pours along the streets
Presses together bodies who pivot and veer off
From obstacles you can't see until they're on you
In a shroud of smell and fiery rags:

Attention or face consequences please

Squeaks a line of type on the pamphlet

A fierce foreigner presses into my hand.

Mary Kinzie

Leave the poor to die

 cautions the mimeograph
Attributed to a rejected sage
Above the dotted scrolls of alphabet.
The text throws forth the errant English phrase,

log book…dehydration…ghost…co-driver

And the imprecations, alien and scary, about sex
And punctured valves, and suddenly, a sweet promise
That makes me look around,

 When needed
Heavenly spirits borrow human bodies…

But he is gone, part of the weave of bodies
Through which I keep passing. And I feel
The hectic tempo of trying to thrust
Something from the person of my body.

God at some time must have felt like this,
Unwilling to be touched, unwashed, unwanted,
Hunted, unrevered, his fanatic friends
Too small, even his mother vaporous with weakness
Beneath the corrugated wheel of power
That required him for its shining path.

•

If I am saved for now, it's only for a little.
I can go home to my daughter
And have dinner with my friends, delight
In the last taste of summer basil
Rioting to flowers, which I cut up into the pasta too,

But after the summer, pleasure will diminish
And the vine redden and die back;
And what was always out there, at a distance,
Will come nearer as it takes a form
Too much like the background, fending off
Reverberation and intelligence: The law
With its dark finish and low wavelength waits
To exert unmanageable force –
 Itself a common thought
Without much nuance, except in the event.

Mohja Kahf

I Cried for You in Chicago

I cried for you in Chicago
because you were such a broad-shouldered city
What a Lake Shore Drive was your writing arm,
girding the great rush of cars,
this ache in the side of the world

I cried for you in Chicago
You were such a Michigan Avenue,
magnificent, open, high, glittering to the skies
husky, brawling, full of painted women
and sneering boys

I cried for you in Chicago,
you boulevard wide like my heart for you,
you mad feast of human-folk
Come to me, come to me,
like the beautiful cruel city

Raúl Niño

February on Eighteenth Street

1.
You told me about your father
his wonderful way of telling a story
You weren't too bad yourself
your whispers and your eyes

Do you remember
when the breeze
surprised us
with color and winter warmth?

That afternoon's generosity
gave us gold prisms from the sun
we paid in kind
with silver from our breaths

From east to west
on eighteenth street
no one measured
our steps

Daylight was short
after all it was February
still we made our way
slowly

While silhouettes of buildings
crossed the street
you said "look!"
we stopped as you pointed

2.
San José del Cabo
on the tip of your tongue
growing before us
populating between each sentence

We stared at ourselves
two darkening reflections

Raúl Niño

in a pane of glass
behind it a map of México

I watched your face
your lips began a story
your voice took my hand
a reflection grew in your eyes

There we materialized
baja desert behind us
an ocean at our toes
the odor of waves filled us

I realized then
our lives have a smell
our past a lingering taste
like a guest moved in for good

Then you said
that things there had changed
"San José was not the same"
still you hoped to visit soon

3.
Our walk in that amber hour
lead us west where we found a church
framed between the cavity of two buildings
a massive Polish grey pointing skyward

Auspicious hands figured its belfry
over an immigrant community
when the Slavic language
was as far away as home

We saw its fading frescos
its wooden doors locked to evening
Saturday's approaching dusk
a separate solitude invading

Our distant gaze would not penetrate
those forest gates of religion
sealed from our innocence
as it was to our abandoned history

Raúl Niño

Yet you and I were still alive!
palms together our fingers embroidered
two strangers in unison
one body in prayer

Was it the texture of light
or lack of any familiar sounds
that seized us into becoming
pawns in a mean chronology?

4.
Beneath memories of spring
the day retreated
into a slumbering earth
only then did I notice the ice

Cold chandeliers pointing down
a delicate suspension
clear stalactites from every light post
roof edges held their solid frailty

Christmas and New Years still
lingering in shop windows
scanty unwinding
those familiar dramas ending

Ours was a "promenade"
that was your word
what we began that afternoon
went against the current of dying

Near us obstinate shadows battled
I could feel them gaining
still we walked
our communion was living!

A threshold was just entering us
it was all a beginning then
we were warm within the chill
changing inside that season of ice

From Breathing Light, *(MARCH/Abrazo Press 1991).*

Maureen Seaton

Woman Circling Lake

Oh transcendent, this aqua blue and all these health nuts
running back and forth hold nothing – no sea gnome,
no salt to scour your bones clean – only placidity
and motionlessness, no dark fugues or phosphorescence.
It's your turn to stir the waters. Don't
back away from brittle plains and dry wheat saying
you're too far above us for encumbrances. This
is your place, your time: Chicago, gate of a millennium.
Your fainthearted sallies fall deep into space, closer
to no one who knows you. See, cloudling, how the collie pup
chases the gray squirrel up bare sleeping trees. How
old snow banks the blue-green line of Michigan.
The collie is so happy and powerful. The squirrel
steals from ash to oak as if possessed by abandon,
rising higher into sky than any jubilant unchained creature.
You are the end of winter, sea light. Little star eater,
come back, it's not your turn to die.

From Little Ice Age *(Invisible Cities Press, 2001). Appeared originally in* The Paris Review. *Used with author's permission.*

Mary Livoni

Ashland #8, from the series "101 Days and Nights in Chicago"

Albert DeGenova

The Bus Stop

Here I stood under an umbrella watching water flow along the curb like racing rapids – where on winter mornings I waited wrapped in scarves and down coat and hat pulled down tight over my ears and forehead only my nose and eyes exposed to the wind, nose running, my young thin moustache frozen – where I stood waiting for the Archer Ave. bus that would take me from 55th Street on Chicago's southwest side first to California Ave. and grammar school, then to Throop Street and high school, then all the way into "the Loop" for college. The corner at Archer Ave. and 55th where I hung out with my rock band buddies at Chicken LaBelle drinking cokes and eating fries joking with the owner Joe Arkelian and flirting with his daughters; next door Pisa Pizza, where my sister hung out, we would order gravy bread, crusty Italian bread dipped in red sauce, 50 cents; across the street, Jack-In-The-Box where we ate tacos for the first time, where Laura Schnear, that beauty with huge brown eyes and pouting lips, hung out with her pot-head friends; the grassy triangle space we called "the Hill" that filled the angle of Archer as it met 55th where all the long-haired "freaks" hung out and we "greasers" wouldn't dare. This is the bus stop where I saw Gina DiDomenico every morning, a girl from our "gang" and Chicken LaBelle, eventually asked her to go to a party with me, for months after that we necked in the backseat of the bus we called the "green limousine," went to my prom, got married three years later still riding the bus, me still in college, she on her way to work in the credit office at Wieboldt's department store. Years earlier, my mother waited on the same corner, met my father on the Archer bus, he would get on at Lockwood Ave., they'd ride downtown together – Mom was a ticket girl at the Chicago Theatre, Dad worked at the Palmer House Hotel.
They divorced too.

From A Good Hammer, *(Timberline Press, 2014)*

Keith S. Wilson

53rd street

thank you for this empty street.
for a parking lot stricken with midnight
and not another voice, not even a politeness,

only the resignation of the trees, harmless and navy
blue and royal. bless this walk, just mine,

and the animal that orchestrates this shadow. thank you
for each blonde saucer of light that dips beneath me

as if i were the president of this timid land.
for this blessed movement, legs that let spread

proudly as an occupation, a seat on the bus.
if it was earlier in the evening, the streets would throb, and a man
might ask me for help. i'd admit i have no money,
save nothing. i say i'm sorry

a dozen times a day, as if i can hardly be bothered with sacrifices
that aren't worn around the neck. i think
about neckties too, ever since i invested in a future and thought. thank you
for this stubble and night, unconfined.

it is hard to not be grateful for being able to walk like this,
alone but unaware of how i cannot be alone, the dark

within me that scares other men just enough – how my arms let me be
single, how the register of my voice is a foregone conclusion like the dusk
reminding a white of its black. how a sign that says *beware of dog*
is enough to make a man move on, the very next house. chicago is still for me.

i get to be a boy on this street. it's as good as being young,
when grown folks are mountains that block other mountains, or men
that wrestle with their god, and i am unaware of my advancing
the impasse under which an omen sleeps.

Keith S. Wilson

only once, i beat blood from my brother's nose as if he was whole
wheat dough. he became a rose that overtook me. lord, i am

a ministry, i am a billboard that slips into the sky, and a mythical
bird. i am a battalion of hearts and this street is a parade,
that, i know, is just a street, but listen,

isn't a metaphor a promise –
a swear that what seems at first to be
is not? my adam's apple is an inauguration.

i'm thankful to not be afraid,
though i slip closer to it every year; i worry that i am old
enough to trade making light
of my own permanence for the permanence of my own light.

that what has already past is past. that what i say is more important to hear
than to keep. i can't remember how i used to pray. directly, i think,

instead of this. on this street
i can be both a memory of smallness
and a behemoth, worry past nothing, every alcove – only the bodies

and the blankets and my hotness
through butter. even the boyish violences that made me
afraid are good to me. the streets
where i cut myself on dares, saw dogs raised
in the air like sails, all of us traveling by our necks, swaddled

tenors beneath us. we peered into the open composition
of a bird that had been taken from a blue movement to a sidewalk
that was not wet enough to reach us but too wet for us to touch

An earlier version of "53rd street" was published in Obsidian Journal (Issue 45.1).

Patricia McMillen

Yang

There's nothing womanish about me. When I'm a man, I walk right in: no *"Knock-knock!,"* no *"Yoo-hoo, anybody home?"* I step right up, slap my two bucks on the counter, grab all three baseballs in one hand; I wind up and let fly. When I am a man, I hoist myself into the chair, smack boot heel to wrought iron, say *"The usual, Tony."* I cross LaSalle Street, halting traffic with an outstretched hand, and all the buildings – Monadnock, Sears Tower, John Hancock – look just like me. When I get where I'm going, a receptionist with red fingernails will ask me twice whether it's *"Stephen"* with a *"ph"* or a *"v."* It's like she's from another species – a mynah bird, say, or some kind of endangered cat. When I'm a man, I make war, not love. There's always someone waiting to hear from me, never time to call: it's a shave, a shower, and I'm back at the wheel, in the air, behind the lawn mower. Dogs scatter when I'm a man. It's a day's work just carrying my shoulders around.

Earlier version first published in Third Coast *(Fall 1999, Western Michigan University); again in* After Hours *Issue #4, Winter 2002. Recorded and broadcast with music by WGLT Radio (Bloomington, IL, 2002) as part of its "Poetry Radio" series. Inspired by Charlie Rossiter's "Yin."*

Olivia Maciel Edelman

Dear Lisi:

...How many themes are left to play out
maybe in that little bar next to the river, called *Life is Short*. What about Galileo,
Bruno, Cusa, Vico or Ficino in this time

of new old dogmas?
Rememorize how to say *selva oscura, selva oscura,* or drink wine in a closed vineyard,
one that would inspire Dante

and Bernini,
Góngora, Garcilaso and his silva?
There would be other questions we couldn't dodge:
Turtles laying eggs when the sea rests
on the coasts of Oaxaca, talking about the South and the Plata about the
purple ribbon that runs along the woods
at sundown.
Remember the conversations at the table with Bertha

and Mary Jo?
Laughing hysterically, remembering Swinburne, Eliot,

and Yeats,
the captive sea transcendent, the gated moon, the thought. Memorable
afternoons with hats, repeating

Miguel Hernández's or Luis Cernuda's verses, plunging into the sea depths or climbing to starry spaces. They have asked me for 300 words, when I know that one

contains the firmament
and I'd like to consider these mysteries too.

...We have so much left to cover
"el círculo luminoso, la lámpara con enaüillas,"
Isn't it a pretty line?
Remember the *pampero* whistling Lugones' themes? Verlaine's convulsive gusts?
What do you say if one of these days we go down to Pilsen, or Chinatown,
or just have a cappuccino?...

From Sombra en plata / Shadow in Silver *(Swan Isle Press, 2005).*

Lasana D. Kazembe

Chicago

chicago is sunday cheese grits
garnished with pepper and butter trails
scrambled eggs mayonnaise sandwiches
apple butter biscuits and a jelly glass full of tang
chicago is knowing neighbors who know you
plus the things your children do like the one-
eyed spooky lady at the end of the block wearing
a frock of flamingo pink keeping her one good
eye on things dee dee richards was the rain
maker if we were having too much fun or got too
close to her late husband's LTD she was just
mad cause we were fresh bones in fine bodies
with no concept of late rent/time spent arguing with the
janitor with no time to genuflect over yellowed
photos taken with flash powder cameras chicago
is green dumpsters oxidized dumpsters of
discarded huggies and insulin needles
funky emerald sentinels standing guard outside
brown tenements brown tenements housing furry
brown tenants brown tenements housing furious brown
tenants spending good money on glue traps and d-con
setting off elaborate smoke bombs and
watching with a hypnotic mix of excitement and disgust
as rats and roaches come out with their hands up
pesky POWs who shall never again see their
families faint on the kitchen floor surrender to a higher power
like a church-going auntie chicago is a crème colored no-wax
floor camouflaged with raid and roach eggs
and warped wooden porches winding alleys snake

alleys that swallow super rats and del monte cans
snake alleys that swallow men whole men with
holes and shadowy souls called winos
bragging how they are cousins of jesus pitching
pennies in front of the last black quickie mart
chicago is the gospel according to donnell

Lasana D. Kazembe

winos with razor bumps bragging about the tepid
accomplishments of grown children whom they never
knew whom they never knew of, yet brag on
as though philosophizing or proselytizing truth
be told they just jiving and side winding
telling overripe lies riding night trains up
and down winding snake alleys shedding the
decayed skin of ugly tomorrows sunning
themselves against flat bony rocks marking the
perimeters of green tomato gardens

chicago is hot side streets hot
side streets with aluminum can rings
pressed deep into melting black asphalt
yellow lines losing their yellow silently
acquiescing to a steady stream of el dorados and 442s
chicago sees the innocence of eight year olds
in orange short sets holding barbie court little
princesses plea bargaining in sizzling circles of
mister freeze, cutthroat jumprope
soprano seances of *so out you may go-*
with the dirty, dirty dishrag on your left and right toe!

then the cooling/the generous cooling by
cool black boys/native sons liberate dishwater and
bathwater from unused hydrants to creating a
bethesda pool two blocks long the jagged
edges of similac cans professionally polished
against raggedy strips of rough concrete
big black boys tenaciously scrape the tectonic plates
little black boys water-logged little boys with bloated bellies
stretched out on sultry stretches of black street
the amalgamation of cold water and hot sidewalk
parties with their senses as they dream bad dreams
of scantrons and meatloaf day good dreams
of fist picks funtown and talking stuff through window fans
good dreams of being real cool skipping school
elaborate back flips off pee-stained mattresses
in the corner lot next to the cut-rate store

Lasana D. Kazembe

under the hawk eyes of overweight play cousins and
a recently released uncle
sipping cold duck and yelling *uno!*
from his mama's front porch

chicago is black children
black children who know du sable black children
dancing to scott joplin on the tastee freeze truck
tasting rainbows on their tongues
and dreaming of cereal presents and secret money
how they gon' buy mama this n' that n' this n' that
when they hit the number chicago
is a nine o'clock bath to bathe off lighting bugs
and grass stains going to sleep in anticipation of
seeing a fifth grade teacher sometimes called mama
iowa tests and number two pencils raspberry glacé
and pinky bets monkey bars chico sticks
and innocuous giggles in between choruses
of ol' mary mack mack mack
all dressed in black black black
chicago is being dressed in
black black black chicago is
black is bitter is sweet memories
black bittersweet memories
remember?

Amanda Williams

Cadastral Shakings (Chicago v1), 2019

Vincent Francone

Ashland Avenue

Walking the same streets
my grandfather walked
in his paperboy cap, black coat
or seersucker, my grandfather and his
winsome ladyfriends wearing
pressed yellow dresses
and laughing in step
in spring along Grand
and Western, where his son
remembers playing baseball
and his wife wore out rubber gloves
scrubbing pots and freezing gravy
from St. Joseph's day.

Along the west town side streets,
I'm picking landmarks off
like they're fruit, the skyline east
looms cold, an electric invite
to something more refined
than standing in a soup line.

And here at last is the bakery
across the 16th Street
viaduct parting neighborhoods
like the Red Sea,
the midday steam and hiss
of train cars marooned, backing
traffic back to Halsted.

I get out, stretch and seek
an empanada with sweet potato,
champurrado and elotes
respite in the languid afternoon
on any Friday in Chicago
not working hard
like crossing guards warning pedestrians
to please be mindful of the lights
changing yellow, red
like the sky as the sun sets west

Vincent Francone

on Racine, like it did
when I was twenty-two
and came to know
intimately the futility
of afternoons in classrooms
when the L&L opened early
and asked only a dollar a draft,
an eyeful of infinite lake water
and a nose full of car exhaust.

My father felt
all the danger palpable
when walking down Ontario
west where the sting of sirens
was common Saturdays growing up
toward the suburban relocation
that precipitated moving two states
away from Gonnella bread,
side-street alleyways kicking cans,
busted glass underfoot.
My father went walking
through Erie and Western,
an upbringing he romanticizes
when back for christenings
and I walk his steps, and his father's steps,
and my great uncle's, who
grew into a drunken disappointment,
inside the house hiding
from a tyrannical father
or so I imagine are the roots
of my life in Chicago
digging back toward Bari,
salt-sea town brighter than
the streetlights of Taylor and
Laflin where I wash up
like the dead fish
on a 6AM beach.

This Tri-Taylor evening holds
the homeless to its breast,
the unyielding night
of passersby without
a dime to spare
for the beggars of Ashland,

Vincent Francone

and agony over
unearthed projects
remade as banks and condos,
though the neighborhood long ago
went to the lions of the
University of Illinois
and Maxwell Street is
no longer the filthy bazaar
we like to recollect
in our most mythological moods.
Only a matter of time
and the dirt and grime got
paved into pubs where they charge
six dollars a pint across the street
from where Joe DiMaggio's statue
stands, the Yankee Clipper's
swing about to be unfurled
and fewer Italian families
living among the walk-ups
or buying Italian ice from Mario's
or beef from Al's.

I walked Taylor Street arriving
like an immigrant from Archer
Avenue, which is where I'd call home
if I had to plant a flag, make my
family proud of their south side,
the undeniable Polish bakeries, the taquerías
Toro Loco bar, Lindy's Chili and
Gertie's Ice Cream, Unique
thrift stores flanking the potholed,
pigeon strewn asphalt across
Archer from Chinatown to Resurrection
Cemetery past Argo Products
rendering corn meal into acrid stink,
the high school down on 63rd street
in a haze of maize fog and marijuana,
like dead-eyed Mike and Lou and Chuck
delivering pizzas to the Pink Palace sex motel.

Walking Archer
precarious at night
along the Summit, IL crack
across Harlem, the Deep Summit Pub

Vincent Francone

open until 2AM and then
another round at Touch of Class
open until 4 and ensuring
a mix of every social strata
on the southwest side, and then
to El Faro for a fat burrito and thin horchata
before Bosa (which does not stand
for Brothers of Saudi Arabia) Donuts
opens and the weary lights
climb over Damen Ave.

Truck drivers sip weak
coffee at the Huck Finn
diner after sleeping
in a sleeper behind
the cab, stopping
for solace on Archer,
driving across Indiana,
Illinois, Iowa
and all towns in-between,
to deliver,
as my Grandfather did,
plywood or other such
necessary sundries.

Truckers get going and the
Stevenson enlivens,
morning traffic moving,
stray dogs
making their way from
Back of the Yards,
nearing Bridgeport
and the old stomping grounds
of the old boss and his son
traveling by more regal
escort from 35th Street
to City Hall,
not stopping in Pilsen,
as I do for a view
of the tiled Orozco
school with mosaics
of Octavio Paz
Frida and Diego,
Siquieros, Chavez

Vincent Francone

and, claro, Orozco himself
rubbing shoulders with
Tezcatlipoca and Quetzalcoatl
huffing the strong scent
of tortillas cooking
at El Milagro where
Sundays are devoted
to ensalada de nopales
and 18th Street strolls that
take you through the
main artery of a divided
neighborhood, snaking
at Halsted to Ruble
to the expressway
back north to Roger's Park
and an omnipresent glance
across the street and over
the shoulder as you nervously
fumble for your keys.

The weather grows
warmer and with the rise
in temperature is the rise
in fear because
every denizen knows
how gunshots grow
when spring gives up the ghost.
Even in Edgewater there
were knives out and nights
when walking home seemed
a heroic task.
The Ethiopian restaurants
stop serving at ten, just time
enough to walk off
baskets of injera and
back to your door
and hope to avoid
the reckless taxis
rolling down Broadway
south to Uptown's ragged
avenues, toward the
Uptown Theatre
which went the way
of all flesh long ago, yet

Vincent Francone

without the good sense
to let go the boards
and long-grown dust
that can't remember
whether Tommy Dorsey
or Duke Ellington
was supposed to have
led a stomp on the
dilapidated hardwood.

Spy the planks
covering up the Uptown,
advertisements pasted
over the wood,
construction ivy climbing
its walls, its marvelous
façade eclipsed until
it is time to walk again
and leave the old white
elephant on Broadway,
as generations have done,
flying by on the Red Line through
the Lawrence stop to Wilson
and the slow crawl across
construction hot spots,
yawning in the morning rush
and back north in the evening
past the old weathered homes
these two flat buildings,
riddled with the shards of countless
tenants, slanted floors and dull
painted rooms housing
dusty remembrances
of things passed over,
the oven needing a match-light,
the living room heated
by a Warm Morning furnace
shaking when ignited,
these museums of past
domesticity dating from just after
the Chicago Fire, having sprung
from the reconstruction
to be rented to students
or others equally financially

Vincent Francone

embarrassed, finding stucco
walls fit for back scratching
and windows leaking summer rain.

The Red Line subway
before it rises out of subterranean
belly-crawling, weaves and
jerks and, worse,
stalls between Chicago and
Clark and Division
where I take in two men chatting:
"You just moved here?
Man, you'll love it.
You'll love Chicago,"
and the newcomer smiles as
newcomers do before they become
beaten by the bleary persistence
of the morning commute, the grind
of the train when signals
prohibit clearance and
you wait wondering
about the roach you saw
when you got home last night,
about the car and tax hikes
and gas prices and the winter
that's clawed this city's streets
and won't lessen its grip,
about the people you know
and the ones you knew
and who left when
and went where and
who slept with whom and
stuck around to grow
older every year
and the lake looks green
and the river is dyed that way
every St. Pat's day
but they can't get it back
to blue, as we say every year
and laugh at the old joke
as if it were the least bit funny.

You're going to love
Lincoln Park and Lakeview,
Old Town, The Gold Coast,
where the young come

Vincent Francone

to town, where they feel safe
among other young people,
where they drink Fridays
and sleep Sundays
and jog and bike
and eat tapas and Thai,
where they sweat in apartments
they can't afford
until they finish law school
and join the uppercrass
overfed or otherwise
run from the near north side
and discover Jefferson
Park or Ravenswood,
Old Irving or some
such residential part
of town to plant
their family trees.

You'll love Chicago
the way I've loved it
in my vagabond youth
and came to commit myself
fully to every mile
of the so-called second city
that I first saw
as an infant
and have since left
so many times
in search of a more
perfect plane
that I tried to manufacture
and does not seem to exist.

You'll love Chicago
the way my grandmother's father
loved it and left it
and came back from a failed
strawberry farm in Louisiana
and reclaimed his stake
on Western Avenue
and raised eleven children
who couldn't leave either.

Previously published as "Chicago" on the State of Illinois website after winning the 2009 Illinois Emerging Writers Gwendolyn Brooks Poetry Award.

Faisal Mohyuddin

A Shared Oneness

Susan Yount

Chicago 2004
after Carl Sandburg

Candy Maker for the World,
Deep Dish Pizza Baker, Seller of Futures,
Trader of Fortunes, Strider of the Magnificent Mile,
Soupy, Stalwart, Honking,
City of the Proud Suburbs.

They tell me your traffic is severe and I believe them, for I have shoved through your
 expressways and streets at rush hour.
And they tell me your winters are wicked and I answer: Yes, it is true. I have felt your
 piercing teeth gnaw my bones and your gales whip the sight from my eyes.
And they tell me you are merciless and my reply is: On the hardened leather faces and
 empty, out-stretched hands of the hopeful and homeless I have seen the sallow
 stain of suffering.
And having acknowledged so, I look into the faces of those who stand agape gazing at the
 wonder of my adopted city, and I see my reflection and say to them: Come my
 friend, come and tell me of another city with such big shoulders so luminescent
 with opportunity and fierce and bold and confident.
Advancing from the Blue Line amid the morning race of suits and cell phones, here is a five
 foot, seven inch competitor glittering against the city's litter;
Strong as bailer's twine cutting calloused hands fisted for action, navigating with the uncanny
 accuracy of a chick sexer,
 Scarf headed,
 Preparing,
 Plotting,
 Planning,
 Composing, decomposing, and recomposing.
Under the train tracks, water on her heels, walking with the smirk and speed of Ceres,
Under the pressure of tomorrow, striding as a younger woman would stride,
Striding even as a fool walks off a cliff,
Smiling and striding, certain that the life in her step will lead her to the next and in her heart
 flows the blood of the people,
 Racing!
Echoing the soupy, stalwart, honking laughter of Life, suited, knuckling, proud to be
 Maker of Quality Candies, Baker of Golden Crusted Deep Dish Pizza, Financial
 Engineer, Trader and Strider of the Magnificent Mile.

First online publication: (Summer 2006) Wicked Alice, Sundress Publications.
First print publication: Licking River Review (2006-2007), *Northern Kentucky University.*

Carlos Cumpián

La Décima Musa
Dedicated to founders: Carmen Velasquez and Rosario Rabiela

It's after hours, Pilsen's Décima Musa's silent
restaurant, it's kitchen oven and stove now cooled,
the empty sink's faucet drips.
At 3 a.m. lone passing car's radio hints at music
when in the main room ghostly realm's banter begins.

Décima Musa, the Tenth Muse, named for the rebellious
Mexican Catholic nun Sor Juana Ines de la Cruz –
a place for: community organizing, enjoying food,
drinks, music and dancing –
but also, stories and poesia cuentos and poetry.

In the performance room, its wall host posters of leaders
like Mexico's "Raza Cosmica" José Vasconcelos laughs
with mystical poet and novelist Rainer Maria Rilke,
a Bohemian-Austrian voice giving advice
about the craft to emerging young writers.

The two agree, old man Siqueiros should paint a new mural
somewhere on South Loomis that won't intimidate
the virgin or tradition bound "Taco Artists" many enjoy
but always annoy local celebrity artist, Marcos Raya.

In response, David Alfaro Siqueiros furrows his bushy eyebrows
and says, "You two philosophers should get your own video channel."
Then he goes back to reading Chicago's Spanish
cultural newspaper, Contratiempo. Benito Juárez asleep in his suit.

The other political & literary poster figures like Pablo Neruda
and José Marti that populate the walls refrain from commenting
about "pocho" poems heard at the open reading but instead
praise the evening's charming Puerto Rican poet hostess
Ms. Vasquez Paz who stood at the matte gunmetal mic.

So, blessed be the memories that were made better
with tequila or just ice tea, never needing
a fire extinguisher while a late-night beacon burned
for over 28 abriles for the los fine Adelitas y otro
Rebeldes swinging bilingually and trembling our
collective buzz for la palabra pura at this old
port-of-entry in the city "simón que sí," but now it's all history.

Peter Kahn

Upstairs at Ronny's Steakhouse
Circa, 1992

*Hey white boy! This ain't
American Bandstand! This is the Soul
Train! Now move them hips!* shoots
out of some stranger's mouth
after a woman winking pulls me
pre-rum to the naked wooden square.
It's usually packed already
but it's the first time upstairs
has been open since the cops
closed it down three months earlier.
My crew falls out of the booth
as I rickety rock my hips to
The Percolater, looking like a rusty
pendulum, even though I'm only
twenty-four. Joyce buys me a double
that floor-burns the back of my throat.

I remember one Friday when Joyce and I
bottom-up at least six times before I step
onto that squared-square in front of the dj
booth. Bobby busts a broken Butterfly
with a light-skinned woman
seven inches taller and one-hundred
jiggly pounds heavier than him.
Reba's hips pendulum against a grinning
old guy who feigns fainting in her arms.
*It's time for the percolator, It's time
for the percolator,* gyrates the air: the amp's hot
breath blasting our soaked bodies as we bump
and dip and grind into one heap of happy
hour in the Loop of the most segregated
city in America, where I'm the only white
person each week, a true stereotype stumbling
around looking drunker than I could ever be.

From Little Kings *(Nine Arches Press, 2020).*

Robin Metz

Midtown Lowdown

Hard to miss, four stories high,
midst Oak St.'s leafy, dappled charm
this neon lime catalpa sprouting
from a brownstone Beaux Arts frieze:
a swag, an urn, a chink, a breeze…

through tree aimed skyward
like a bow, a prow, a prong,
a tuning fork, a sax, a song,
a seed sown updraft from its
gritty pigeon peckings curbside.

Naturally you'd think I'd register
surprise at trudging hangdog by
for three months never glimpsing
silhouetted tree till garbage haulers
wrangled rats and felines curbside.

Then this day the taboo tree by lake born
rage is gusted, thrashed and toppled,
neon lime catalpa thwacked like love,
umpteenth, crash-burned, last-urned
and topsy-turvied curbside.

Such am I now, rarely learning,
always yearning, often wafted,
warbled, timbered, tumbled,
dashed alas and swept from
muddy gutter smithereened.

Vincent Romero

A Chicago Street

Tall trees
old and umbrellaed
line a short stretch on Whipple Street,
our kids ride their bikes around only our block
a playlot bench holds all the secrets
we parents can't know
summer fountains refresh them while running and sliding
the diamond baseball field keeps those dreams high and alive
it happened on Whipple Street
back of the 'Sactoe' (Sacramento) playlot
popsicles cool to the lick and flavored of Kool-Aid
hot buttered corn from the old elote' man
topped off with mayo and cheese
that lot's the star and home was the backup place
we didn't live with a playlot behind our house
our house lived behind the playlot
the ball court cracked to this day
playing till dusk till they heard mom's sharp whistle
back behind the tall gate
beware the funky mutt dog - she licks too
back to the new large deck
the custom long steps
where grand babies played
counting the fancy string lights
over many a dance
many a barbeque
where 'what flavor pop' was asked
of neighbor kids crushing on
sweet school friends
first kissers
young rappers
old odd hippie pals
nonprofit divas and gurus
southside organizers
rotating native families
gracing the premises
with their big Indian drum
beating all the ancient prayer
songs once again
into the tall trees on Whipple Street

Maya Marshall

Montrose Beach, Before the Funeral

When my friend's husband died, we drove
to the bird sanctuary to breathe and walk awhile,

to wander and praise the sparrows' play.
A brief relief. We'd just turned thirty

and death, which happens to everyone else,
had come. The shore along the sanctuary was empty.

The water turned over and followed
more water, like years. I asked what next?

Radiation had arrived before cold storage,
so there would be no sibling

to the ended almost child. A full-grown
sage thrasher flew by, a dappled

shell remnant clasped in her feathers.
We walked along the shore talking

chemo and inviable nests, not the flowers
for the funeral, but fibrous growths.

Every body is in disrepair. A gander limped
across the visible street. A gaggle waddled

in loose phalanx around a row of port-a-johns,
filled the disappearing field behind a stranger

as we wandered. Our two bodies empty
of bodies. A friend and a widow on the shore.

First published in Kettle Blue Review, 2016.

Rashayla Marie Brown

Chocolate City (Chicago: Johnson Publishing Company)

Yolanda Nieves

Remembering the Division Street Riots

This is what I remember about
the Division Street Riots:

My mother hums by the sink
she tends dishes and cups
it will be my birthday soon
near her feet I dress a paper doll
then the world stops silent.

A moment suspended
squeezed in a fist until –

screams fill our kitchen
breaking glass shatters
outside
nearby
my father's footsteps
drum the stairs.

He slaps the door open
swings me onto one arm
clutches my mother in the other
out third floor rear.

Down then across we stumble
feet crunching broken glass
traffic frozen
neighbors trapped in front
of police cars
while bloody hands
hold open wounds

I look at guns without knowing
what they are for.

Yolanda Nieves

Everyone scatters in fear!
Where did our happiness go?

Two blocks north on Hoyne
in front of my grandmother's apartment
my child's eyes
behold blue helmets
police in rows and columns
marching south to Division Street.
Shields, guns, clubs
like one big animal spreading its claws
ready to pounce

looking
neither
right
nor
left!

More shouts!

Horror stretches into the evening.
Was there no one to protect us?

Bullets hit a target.
Near my feet I pick up an empty bullet shell.
I wonder why he falls
a blood-stained youth carried by his sister
curled into a battered car.

I wander to his side.
His mouth stops moving,
arms no longer clasp
his sister's shoulders.
I think in pieces

Where is my father?

Yolanda Nieves

It will be my birthday soon.
More gunshots!
Flesh rips,
bones split under a trembling glove
with a club.
I sink a little deeper inside.

The world rains despair.
Today
I forgot something I want to remember.

What had we done so wrong?

The hatred that floats
over us and wants to be our keeper.
This hatred is a barb-wire fence that surrounds us.

Three days in June!
Eight dead in the street!
Their absence wails from the eyes of the people.

There were mothers who loved them.
One played baseball.
Another had hoped to marry my aunt.

It will be my birthday soon
No one will mention it.

My memory is a soft cloth
rubbing the pieces together.
We still live inside this wound
on Division Street.

Grady Chambers

Infinite Jest

All June I swore I'd tattoo a passage from the book to my torso,
then I didn't. It was summer: huge storms rolled through.
A boy I'd known as "Gordo" had grown into a man. His pain had grown inside him
to his exact size and shape: when he killed the one, he killed the other.
Those storms were black, oblivious as tankers.

/

I was done with college but still in love.
We had kissed, visited Auschwitz, chucked our bedding in a dumpster,
then college ended: Sara left for Florence on a Fulbright –
I moved in with my parents. Flat on my back on the hot black roof
I watched the high strands of lightning
flash and shift like a pianist's hands.

/

That passage I never tattooed had to do with death. When we were nineteen,
as a plea for attention, Sara had swallowed so many pills
they spilled from her stomach
when the campus medic touched her tonsils.
For Gordo, no such luck. Dead when they found him,
his empty hangers clicked like cartoon bones.

/

But what I remember most that summer is skipping work: A six pack of beer, exhaustion,
the stone wall I sat on
overlooking Lake Michigan. The light of that beach
before the sun had set: golden, low, glowing. The grey seagulls circled like fans
above the bodies on the sand.

First published (in a slightly different form) in The Los Angeles Review of Books.

Emily Thornton Calvo

My Chicago

Chicago is no woman.
He is the cousin who owes you money,
pays you back with a wink and a smile.
You don't ask where the money came from.

He is well-read, but better fed.
You can dress him up to dazzle in a tux,
but more T-shirt and jeans,
his shirttails run amok.

No, Chicago is no woman.

Chicago plays smart, but acts stupid
Raised with muscle,
he hustles and guzzles three-dollar brews.
He knows all the back rooms
and how to keep secrets.

He's a little James Bond and a lot John Belushi.

In summer, he is a brawny lug of hot air
edgy and ready
with a knuckle punch,
a "don't cross me, chump, or I'll…"
His heat smothers like an open oven.

In winter, he gets drunk on snow
high on blow
of winds that pummel buildings
like a boxer on a punching bag.
His cold sands my face.

Spring and fall pass in a blur
like two Red Line trains
slapping the tracks in opposite directions
to close a lapse in time.
He teases with a gentle touch.

When planners raised blocks to grids,
he trampled angles
across lawns. Worn paths became Archer,
Lincoln, Elston and Ogden.

Emily Thornton Calvo

No longer taking stock in the yards,
he gambles on the exchange,
opens and closes small businesses
like traveling circuses.

His skyline evolves like heartbeats across a monitor
Build one, knock one down, build one…

His river rolls between towers
paces defiantly in all directions.
His parks grant reprieves
from concrete with carpets green.
He feeds theater and laughter to the Big Apple.

He's a sucker for poets and writers,
hides his artistry behind lions,
spits poems in bars,
blows solid blues.

Greektown. Chinatown. Little Italy.
He disguises segregation
with neighborhood pride.
His grid makes it easy to plot a course.
His grit makes it rough to move around.

His riches are not Gold Coast fare.
Look for his treasure
in magnificent smiles
all colors, all shapes.
See it at sunrise,
when diamonds blanket lake water
at dusk, as lights jewel the horizon,
Hear it in the sound of distant tongues.

No, Chicago is no woman.
Perhaps, Chicago is no man.
Maybe this city is androgynous,
The yin-yang in each of us:
The vegan behind the bakery counter,
The cop who *thinks* he can help,
The gangsta with a poem,
The optimistic Cubs fan.

Chicago's riches reflect everything –
the best and worst of you, me, us.

Bob Chicoine

The Quincy Stop

Meet me at the Quincy stop, old love,
on the Brown Line once the Ravenswood.
Why, even Dante Alighieri traded in for good
his *selva oscura* for the raven wood!

Atop a namesake street of one block's length
from Wells to Franklin, where nobody strolls,
with no shop or tavern open early or late.
Middle name of a side-burned forgotten President,
our 8th. So can we make it a date?
Are we industrial dust, or kindred souls?
It's been here since 1897 at the same intersection!
Say let's make hay at this railway station:
neoclassical, ornate, Palladian,
undercover spot for us, heaven-bent
or hell-sent to be a man or lady in!

If you'll meet me on the wooden platform
I'll go and be your afternoon companion
watching the north to south trains pass
while clouds like thoughts cross east to west
over the rims of our downtown canyon.

I'll caress you, and you'll kiss me
for luck and for history, at Quincy.
We'll hop on a train into our future:
semi-glorious, or all the way mimsy.
And when we arrive tonight somewhere
sure to be met warmly with delight
we'll say "Oh don't serve us anything fancy;
we have only just come from Quincy."

Triple Elegy
for John Slater

By now your brother's memorized every blueprint of the Cook County Admin Building, and knowing how its rigid bracings allow its middle to stay hollow, upright, he falls asleep tracing its façade above the base, how it sweeps back, slight, a curve, and how its insides were designed tube-within-a-tube. Not entirely sure what that means, he finds every door that wouldn't open for you and the five others, every stairwell identical to the one where you ran out of air. Dreaming the route each night, he counts every step you would've taken, worries the last seconds: if you knew the fire had trapped you; if you kicked at the door one last time; if you knew how much he'd have to learn – architecture, engineering, high-rise evacuation, faulty sprinkler systems – to grieve for you. Just before his first child is born, named after you, your brother studies how Joan Miró left behind, on Brunswick Plaza, facing west, that tucked away steel-reinforced concrete and ceramic tile, that bronze and mesh wire figure reaching out, the one Miró had called "The Sun, the Moon, and one Star" and that the city re-named something else.

First published, in a slightly different form, in RHINO, 2009.

Eduardo Arocho

Rainbow Shoes

I am the Tour Guide
I am the Docent
I walk with rainbow shoes
CONVERSE – thick-laces

 I haven't gone anywhere – I haven't left
 I've survived La *División* Street – *Paseo Boricua* is next
 Chicago – Our story defies your attempts to gentrify
 These steel *Banderas* – are *Residentes Permanentes*

 I walked here when we were within
 Shooting distance from each other
 I walk here now and we are within
 Loving distance from each other

 I remember before I had
 Rainbow shoes
 On this corner
 The BLUE-shoe gang
 On that corner
 The GREEN-shoe gang
 On the next corner
 The BROWN-shoe gang
 Three blocks away
 The RED-shoe gang
 Six blocks away
 The YELLOW-shoe gang

 So many obstacles – colonial divisions
 The wrong shoes might get you jumped
 Or chased – Just to get to school a few blocks
 Away – So I prayed for rainbow shoes

 They came to me – A gift from The Three
 Un tesoro de los santos
 No son JORDANS – But I can jump
 ¡Triumfando!

I'm not afraid anymore – we made it difficult to be erased
Murals in every corner – Our-story is safe
I walk in freedom now – *yo ando feliz*
Steel Banderas above me – and rainbow shoes on my feet

Sara Salgado

The Last Poem About My Neighborhood

begins less with a bullet and more with
a wifebeater
with the chest out

a girl in the window
faces, glass wounding some blood, the colors
in the backpocket

The Last Poem about this place begins by untelling
the urban legend of a good cop & what is a neighborhood watch anyway

The Last Poem about this place ends with a wrench
& drench with fire hydrant water In the street

my mother won't let me play up in

The Last Poem about this place
ends somewhere
outside,
somewhere less cat call & more subtle glance
less paleta & more popsicle
less abuela & more grandma
less lengua maternal & more speak this
here
now
The Last Poem about this place ends less with bullet & more with a baby
In their home

Terry Evans

Summer Bur Oak, Jackson Park

Barry Silesky

Tree of Heaven

When I first came back to the city I wanted
to bring the chain saw. The scar
above my left knee, cut when a young oak fell
the wrong way in the woods I left was fresh,

and I can still see the torn
jeans, the gap the chain
opened as it leaped by into the snow.
I stared at the wound, breath

gone smoke as blood spilled over the space.
But I was afraid I might use it, set the engine
roaring against garbage trucks, el trains
screeching past the porch, drunks

splattering bottles in the alley. I swore
this was no place to live. Then every June
catalpa's white flowers, October
berries of mountain ash, gaudy reds and golds

of all those immigrant plants painting
buildings, parks, lakeshore remind us
we do. And there's more. The latest storm blows
out over the lake. Leaves turn, fall, come back.

Years later I brought the saw here to trim
ailanthus and mulberry in my new front yard.
The engine needed work, the chain sharpening,
It woke the babies, the neighbors stared.

But I loved the country it brought me, power
filling hands, arms, skin, blotting
airplanes, traffic, rock 'n roll
screaming from the apartment across the street.

Barry Silesky

Now let that scum who snuck in our yard
to steal my bike show his face, the one who clipped
our tulips in their finest bloom a night last May.
The one who beat the old woman down the block.

They grow like weeds, these "trees of heaven"
that stink and spread everywhere,
their shade patches that won't cool
in some paradise no one believes. Roots thicken

under us, invisible ring by ring
until concrete and asphalt swell, buckle;
streets, walks, foundation walls lean and
break open. We've got to cut out those trees

before they do their damage. The one on the edge
of the walk scraped our window all winter, split
the short wall that holds back the neighbor's yard.
I want room for a flowering crab its obscene flush

painting a week so delicious I can almost
taste flesh, flower, spring; or cherry, magnolia,
no matter what diseases these foreigners
might bring. Such May days feel

half the reason we live, and this year I'm going to
clear the junk, lose those extra pounds,
get to work. But I gave the saw away.
No time to keep the engine tuned, chain sharp

for the one day a year it might be used.
I took a bow saw up the ladder, balanced
in the first crotch, roped the bough to pull it
and cut the notch in front so it would fall

in our yard when I made the back cut.
Almost, though, I stepped on the ladder, leaned
and held the other branch, sawed down.

Barry Silesky

And it worked: the familiar sweat and crack

as the bough broke off. Now the window's quiet
in the wind, but more than half that tree is
left, leaning over the deck next door.
The lower trunk's flush against the fence.

If I had the chain saw I could cut a notch,
work the tip into the back. I'd have to be
careful, fell it against its lean.
But that machine's gone.

With only the bow saw, a ladder too short,
a little rope, I can't figure how
I'll get the rest of it down.
Last week someone sprayed a gang sign

on my back door. It looks like a fetus, blown up and
twisted beyond anything we can name.
This is my neighborhood, and I'm going to paint it
over, though I know they could be back any night.

They're everywhere. It looks like some version
of my initial. That scar on my knee's almost
gone now, but a month later a dozen new twigs
break from the old trunk. No saw can stop it.

Previously published in The New Tenants *(Eye of the Comet Press, 1991).*

Jeffery Renard Allen

Hush Arbor
for Mahalia Jackson

I.

He moves in red shocks
Shells and shucks,
a furious rhythm soon to be forgotten

Tight-fisted buds exact blood-demand from
white-willed hands

Generals give out
Soldiers drone

Declare witness in the
sawed-off voice of
short season

Strong sway cut
blade song and pine-knot glow

II.

Wanders the riverfront
a child thinking way out of the beyond

Splinters old barges with her
snake-headed ax

Nothing strange in that
kindling for the homefires

Sack mean-eyed coal from
Beasaw tracks

Sweet potato and ash

Life lived
lean, lard

Back'a town
Water and Audubon
funeral glory

Jeffery Renard Allen

New Orleans Second Line
and a preacher with seed-specked teeth

Got jus one thing to tell you:
cry coming/laugh going

Joy on the first floor
Sorrow on the second

So Swing Mr. Adam
Swing Miss Eve
Swing Mr. Adam before you leave

III.

Fire take the church
Heart commence to turn over
Great Lord! The whole thing been jump

IV.

Snatch hold a prophet's tail
hang and ride
high-ease, clean ties and planks
Panama Limited, City of New Orleans or some such

Remove yo hat and let your hair hang
like a willow tree

Chunk them countrified ways on
coat rack

Useless here

Draw up them wide muddy shoulders and
knock this city off
her feet

Move on up
Downhome

Take your place at the welcome table
dram and drink steaming up steaming up
big black iron pot
and all manner of meat

Jeffery Renard Allen

V.

Mr. Dorsey say,
"Blues don't own no notes

"You can embellish all you want
but don't kill the singer"

This Miss Jackson, she
old line caller
 she
new line blues

Eagles running with the chickens

VI.

Crab-grass a-dyin, lookin mighty fine
Sun in the west, somephun glistenin on my vine

"Gon drive this big fat hog
by the name of Mr. C
Deliver deliver deliver
Me
If you see my saviour
Tell Him, Thanks a lot"

Said he would
Said he would

"What pay I got he need?
Tell you what,
sing him up real fine"

A cash-padded peacock
in a lavender leather nest

"Lil ole me
fish and bread singer"

VII.

Tree limb couldn't hold me
Ditch sho tried
Jumped the gun for freedom
Closer every stride

Jeffery Renard Allen

"I ain't comin to Montgomery
to make no money off them
walkin folks!"

VIII.

Her seven-branched chair
satin seat
burnished throne
antique

His seven-silked hat
pear-handled eyes
and rat's alley dice

Nerves bad tonight

She drops a question on his plate
which steams up locomotive-like
with the hamhocks

How to begin?
He smooths his smooth hair
(Her-Tru-Line removes curls and kinks)
Sips his iced tea
Holds his response in his throat

She clutches a chicken leg to chin teddy bear-like
Curls into sleep

IX.

Mr. Lazarus
stand at the door
knock

She's found
She's found

Unused words bleed
under the skin

This side of Judgment
the yearned light does not free you

From Stellar Places *(Asphodel Press, 2007).*

Simone Muench and Philip Jenks

Dear Chicago –

On election night, this grid of yours
was love blown to lava. Lit up by onions
& fireworks, a delirium of this plus that.
Did you read Max Weber's postcard about you?
Your smoky sediment; your shouldered sonata.
You are smaller in person but shimmer
on camera. Burning at a distance we walk
into you: falling glass, lake effects & electricity –
a Midwest lesson on skyscraper elation.
Perfect spot for *Henry: Portrait of a Serial Killer*
& adoptive home to Nelson, Gwendolyn & Studs.
How on earth are you doing, Chicago?
Your eloquent 90/94 gouged us in two.

Will you piece that together for us, Chicago?
We still love the elongation of your body
against the frosted lake; ice is the new modernism.
Once meat. Now, you shudder
your crocuses in ground faux new-age storefronts,
abundant flatness under this lithography
of bodies. This intimate ethnography:
a human being with its skin removed.
Both city "on the make" & "on the take."
You are contradictory & quarrelsome
– as full of crooks as a saw with teeth –
yet you are also a glorious canary-filled clarity
breathing change in a young, but stumped, century.

First published in Disappearing Address *(BlazeVox Press, 2010).*

Beatriz Badikian-Gartler

How to make a fire (a sonnet)

Light a match. Watch the blue wedge
flutter in the strong wind, weakening,
weakening. Hurry up. That's your last
one. Throw it on top of the woodpile

swiftly, before it goes out.
Sit and wait now. And hope the red flame
grows big enough to warm you up in
this dank crook of the world, chilled

to the bone as you are. Breathe
deeply and watch: the darkness might
bring uninvited guests. Sooner or later,
the sun will rise, the wind will die down.

It will be your time to stand up then, to go out
into the world and start other fires, other fights.

C. Russell Price

Gay $ *

> *"How can I not reach where you are / And pull you back. How can I be / and you not. You're forever on the platform"* –Mary Jo Bang

Research shows that the songbird
dreams of singing, I dream
of you, sick, finding you
like a recovered rusty lockbox.

This world was not made
with our dancing in mind,
but you did like along a fissure.
What I want: a multiverse
where: you still clank
vodkas over Pall Malls,
where: you are safe
in rain-lashed gardens
of marigolds and misfits,
where: you're on the brink of green
and young and pretty.

They treated you in this world
like an impossible receptionist.
They treated you like someone
else's mess to mop up.
They touched you like a used
kleenex left on a public surface.
As you laid dying, the women held you
like a telephone, like on a honeymoon.
Making love like tangled roller coasters
didn't kill you, capitalism did.
While all the men were dying,
Chicago stood around strangely
like a horse (in your bedroom)
making things cry.
They drove by just to see if lights're on.
When a body cannot consume,
it cannot contribute to America.
There is intentionality behind
everything, especially the silence

C. Russell Price

of neighbors, coworkers, empty streets,
the erasure of you from the city.
Did you ever imagine me then
like I imagine you now: gay $,
gay apartment, gay hair
beautiful like a coifed cruise liner?
The great resistance will start
with remembering, the need not
for another world, but this one
made if only a little bearable for you to sing.

* *In response to the AIDS epidemic, Chicago bars stamped "Gay$" on currency to show gay economic power, visibility of the illness, and the lack of social engagement in response.*

Mary Phelan

Catching The Sun

James McManus

Smash and Scatteration

1

About a year and a half ago my then girlfriend
Linda's parents came home from an Eric Burdon
concert and found QT, their thirteen-week-old

black Labrador retriever, dead on the floor
of their great room, his muzzle lodged – locked
– inside a box of Screaming Yellow Zonkers.

The TV was on, since QT always liked to hear
human voices when Linda's parents went out
without him for more than a couple of minutes.

A young Chinese man in a gleaming white shirt
was standing in front of a tank. Linda told me
her mother was struck by the fact that QT's

hungry asphyxiation had probably caused him
to suffer, and that when the camera panned back
there were fourteen or fifteen more tanks.

2

Last month my great aunt Mae committed suicide
by jumping from her eighty-second-story bedroom
window. Her third husband had recently died

and she had been suffering from Alzheimer's
and stage-4 cervical cancer. She apparently smashed
through the triple-ply glass with a miniature

dumbbell, put down the dumbbell and thought
about things for a while, then stepped out the hole.
Buffeted furiously by the Venturi Effect,

she bounced down the sunny south side of her
building, the Hancock, for almost twelve seconds.
When she finally hit the sidewalk on Delaware

James McManus

her gray head snapped off and caromed back up
in the air. According to three gore-bespattered
eyewitnesses, the wicked backspin imparted

3

to her head by the impact made it kick
back up toward the Hancock in a kind of
American twist. Chris Burden fired a pistol

at a 747. I watched Linda's face while
she watched him. In shorts but no shirt, Pablo
drew nudes with a light pen. Mick Jagger

put on a suit, slicked back his hair, and taunted
some corporate nancies. Chris Burden had himself
shot in the left biceps with a .22-caliber

copper-jacketed slug. Three men brandishing
semi-automatic rifles burst in on an opening
at the Randolph Street Gallery and kidnapped

a frail-seeming elderly gentleman by placing
the muzzle of an Ingram MAC-10 to his gums
and marching him out the door backward. On

4

that evening's news, between Gorbymania
stories, the elderly gentleman allegedly turned
out to have been a confederate, the weapons

authentic. A skinny little guy with black hair
stood his ground as fifteen tanks tried to advance.
In shorts and no shirt, ol' Pablo drew nudes

with a cigarette. Tim Mostert drew witheringly
sardonic caricatures of me while he was supposed
to be listening to, indeed taking notes on, my

lecture on *Endgame*. During the concert he gave
while QT was coveting Zonkers, Eric Burdon
exhibited his denim-clad crotch in a provocative

manner. Two nights ago, on David Letterman's
show, Kevin Costner, a father of four, exhibited
his denim-clad crotch in a provocative manner.

5

A handsome black model busted for gang rape
and Murder 1, when scar-faced white trash
were the culprits, kissed Madonna. Blood oozed

from wooden facsimiles of his model brown eyes.
He was innocent! Sporting stigmata and backlit
by twelve burning crosses, a brunette Madonna

shimmied lasciviously as Dread Scott Tyler
placed the American flag on the floor of a gallery.
On the wall perpendicular to the flag were

a notebook and pen and black-and-white photos
implying virulent third-world abhorrence
of imperialist behavior perpetrated under

or in the name of the flag. It was convenient
but not really necessary to stand on the flag
while writing comments in the notebook. Non-

6

verbal responses were implicitly, some averred
illicitly, invited by Tyler's provocative title,
What Is the Proper Way to Display the U.S. Flag?

In *Dick Instruction*, two loinclothed men banged a drum
and shot at each other with sixteen-gauge shotguns.
Laurie Anderson had an affair with Thomas Pynchon

and collaborated with William S. Burroughs. Joy Poe
was raped by Pete Panek. The reactions of the audience
were videotaped. Karen Finley signed books in a strip

mall. Jimi Hendrix performed the national anthem at
sunrise. In *The Long Good Friday* the bird what gobbed
on Eric slapped 'Arold (Bob Hoskins) across the face.

James McManus

'Arold later retaliated by shredding Eric's froat
with the jagged shards of a bottle of thirty-year-old
Macallan. Eric's jugular was shredded. Blood spurted

7

onto 'Arold's silk shirt. Linda K. died in a snuff film.
Hoskins rinsed off the dark blood in the shower
while his (dis)loyal moll burned the shirt. Before

receiving her honorary degree from The School
of the Art Institute, along with Hairy Ed Paschke,
Anderson naked-lunched with me in the Ed Muskie

Room of the Congress Hotel. Following Lin Hixson's
direction, Matt Goulish put on a tutu. Laurie
stifled a belch with her fist. Her mother, an avid

horsewoman from Wayne, Illinois, had taught her
good manners. Following Lin Hixson's direction,
Matt Goulish crashed to the floor. Caucasian David

Nelson painted a portrait of Harold Washington,
the recently deceased African American mayor
of Chicago, wearing white lingerie and hung

8

it in The School of the Art Institute's gallery.
Tony Jones, the School's new Welsh president,
summoned Nelson, a graduating senior, to his wee,

windowless office. He asked Nelson to consider
voluntarily removing the painting, if only to head
off a super-heated confrontation with members

of the city's African American community,
whose rage had been galvanized by seven African
American aldermen. Jones's meeting with Nelson

lasted three and a half hours. When Nelson turned
down Jones's request, his painting was confiscated
by Chicago police officers. It turned out later that

day that the young man Jones had met with
was Timothy Mostert, Nelson's roommate. Chris
Burden resembled Van Morrison. The title

9

of Lin Hixson's performance was *We Got a Date*.
James Fox is beaten, stripped, and beaten again
by belting-wielding cockney mafioso B. Yeltsin.

Linda Krajacik tunes her gold-top Les Paul, slices
up a pomegranate, performs her new Bacon Dance
monologue. An Aer Lingus 747 taxies

to the start of a runway, preparing for takeoff.
An attractive flight attendant pretends
to hassle a handsome serviceman for not having

fastened his seatbelt. Four feet below them, in
the cargo bay, inside a gray suitcase, is a boom-
box tricked out with Semtex. Randy Newman's

best song continues to be "Gone Dead Train."
Paul Newman's best dressing continues to be
Creamy Garlic. Laraine Newman's best role

10

continues to be Connie Conehead. Bob Newman's
best birthday present for both my ex-wives
continues to be little green Micks army knives.

Alfred E. Newman's dopest pastiche continues
to be B. B. Yeltsin. Adrian Piper walks the streets
of London with WET PAINT printed on her blouse.

My fiancé, Linda Krajacik, lathers herself
fore and aft, singing to herself about nothing
in melodic perfecto contralto. She scrubs

her flushed face with a washcloth, then loofahs
her abs, pecs, and sternum. She scrubs and shaves
and daydreams and sings. She shampoos her hair,

James McManus

rinses it, turns off the water. When she pulls back
the translucent shower curtain, two scraggly
dudes in Cuervo bandanas are standing there

11

in the bathroom. Say what? One hands her a towel.
The other one presses the well-oiled muzzle
of an Ingram MAC-10 against her pink gums

and tells her to put up her hands. "You're under
arrest!" he barks in unaccented English. "For
what?" she demands, raising one hand and turning

away from the muzzle. "For the murder of Jose
Guillermo Garcia, Celia de la Cerna, Lorenzo
Somoza, Manuel Noriega, Senor David Hidalgo,

Pilar Ternera, Roque Dalton Garcia, Vasco 'Duende'
Goncalves, Carmine Sandino, Santino Corleone,
a-and Jose Rodolfo Viera," says Dude with Gun.

"A-and so put down that towel already, you filthy
little *desaparecida*." Brief pause. "But Dalton
Garcia was already dead," counters Linda. "I'm clean."

12

The scragglier dude, with the MAC, says, "We know that."
Linda is wet, pale, and pink. Goose bumps have risen
on cue. She shivers. Both hands are raised, the white

towel lies at her feet. The better groomed dude,
who gave her the towel, slaps her across the face,
twice, first with the back of his hand, then

with the front, fairly hard. "We already, know that!"
he says. Two nights later, at Randolph Street
Gallery, Linda stands on a table in black satin

mules, heels about two feet apart, and pees
into a Regency teacup: a few drops at first,
then a clear steady stream that lasts twelve,

James McManus

fourteen seconds. Not a drop hits the table.
She stops. Wearing a Fearnley tartan kilt, a
Harris tweed jacket, and kneesocks, I pretend

13

to sternly interrogate her. "Mrs. McManus!
Yes, you! Are you quite bloody finished?"
"I'm pregnant," she says. "Not by you."

"But that sounds but medium true."
"Act IV of Macbeth?" I shake my head no.
"But speaking of the bald Bard of Avon,

what's the dirtiest line, by far, ever spoken
on a prime-time Fifties network sitcom?"
She pauses, pretending to think. "Ward,"

she says finally, "weren't you a little hard on
the Beaver last night?" "Zounds! That is
correct!" I say, quite amazed. "Okay, Cheez Whiz,"

she says, "how many Micks does it take to screw
in a light bulb?" I seem to be drawing a blank. "None!
It's too fookin' hot in dere. (Bloody Jaysus,

14

you're dim.) So how many feminists it take
to screw in a light bulb, huh? . . . That's not funny!
Whaddaya call a Polack in a fi'-hunnerd-

dollar hat?" I look dim, pretend not to know.
"Wellllll?" she says, crossing her toned, jewelry-
free arms. I continue to pretend not to know.

"Pope," she pronounces succinctly. At this
all the artsy po-mo Catholics prick up their ears.
Thumbs-forward hands on her hips, still up on

James McManus

the table, in a little black dress and the mules,
having, mind you, already precision-peed into
a chalice-like teacup – oh, Jaysus!—and spewed

blasphemousness through her mauve bee-stung
lips, still married yet seven weeks pregnant . . .
"And how are women like dogshit!?" she snarls

15

a la Vlad the Impaler. I wonder. "The older they get
the easier they are to pick up!" I am stunned.
Since this noxious brand of stunted macho

viciousness has never been part of our script,
I dare to ask, "Isn't that the sort of unfunny
'bad joke' that could set women back a couple

three weeks?" "Yo, tell me about it, Mr. Premature
Ejaculation," she snaps, whapping a palm with a fist.
"Now, don't get your panties in a wad," I suggest.

Linda leaps down to the floor, whaps her palm even
harder. She can sense, like a dog, that I'm scared.
"What do nine battered husbands have in common?"

I cower and mumble, "Dunno." The agile bitch milks
my confusion for all that it's worth, then barks up my
nostrils, "They Just Wouldn't Fuckin' Listen! Now go!"

16

Just wouldn't fuckin' listen is right. When our son
was born seven months later, we named him Jacques Moran
after the Jacques *pere et fils* in Book II of the Beckett

Tetralogy, as well as after Linda's great-grandfather
Jim, who was also an artist (he whittled and stained
frogs and toads), but lately we've been calling him Air

Jake or Sad Sam. Though he seems to be getting used
to having such a famous artist as his mom, since he
spits up and cries less and less when she uses him

James McManus

in her performances or we take him to see other people's.
We won't leave him home by himself after what happened
that time to QT, and we'll get him his own dog at PAWS.

Linda's even added a "love of the game" clause
to his contract. He's still the only guy in Chicago
to have such a clause besides MJ, as far as we know.

"Smash and Scatteration" appeared in New American Writing 5, Fall 1989, *and in* Best American Poetry 1991 *(selected by Mark Strand).*

Diana Solís

Entrance to Central Barberia, 18th and Laflin Street – c. 1980, Chicago

Susan Hahn

Anna of Devon Avenue

From a patrolled town in the Ukraine
to Baltimore on a boat, then a train to Chicago,
she came to the road that runs
from Boychik's Restaurant to Weinstein's Mortuary.
Here she moved easily in and out
of every store, stopped anyone she recognized
for some talk, wheeled
daughters, granddaughters, great-grandsons
up and down the sidewalk. For seventy years,
day after day, she traveled this route, watched
Manzelman's Market, Mr. Savitsky's Butcher Shop,
Meyer the tailor disappear,
made up her own way
of saying Taj Sari Palace, Gujarat's Grocers,
Psistaria Grecian Imports and once at
Kwong Seng Lo even ate an eggroll,
probably laced with pork.
The last time she strolled
on her street, she hugged

her shopping bag too tight, broke
a rib that forced her inside.
The morning she died she awoke early, pushed
a chair as close as she could to the window
that overlooked the avenue, sat down and stared,
saw her dead husband coming home, tired
from unloading trucks at Sears,
cousins she hadn't thought about in years,
their bosoms covered by flowered aprons,
breathing hard, rushing up
the stairs with stories to tell. She exhaled
their names: Simon, Sadye, Rosie, Belle,
and felt her own slip out
of herself, drift and settle
in place – five blocks east, three blocks west.

"Anna of Devon Avenue" first published in Harriet Rubin's Mother's Wooden Hand *(University of Chicago Press, 1991). Subsequently, it was featured in the* Chicago Tribune Magazine *in 2000, in an article entitled "The Jewish Experience in Chicago."*

Michael Warr

Hallucinating at the Velvet Lounge
To Malachi Thompson (Chicago, April 25, 2004)

When Malachi blew his horn
I dreamed of cornbread, yellow
mounds with burnt edges
on the Velvet's culinary altar.
His sharp cut riffs morphed
into squares of cornbread islands,
floating in streams of warm butter,
clinging to the ribs of my memory.
Speaking in trumpet tongues
of passages and uprisings,
ancient pain and Good Times jiving,
sacred beats and blues timing,
drive-by crying and signifying,
an opiate inside of oppression:
a cratered chunk of bacon-infused,
sweet potato, chicken-smothered,
maple-pecan, custard-filled,
smackin' cracklin', jalapeno
enflamed, cornbread – the crepe
of the slaves, now sold
at Whole Foods, in this
jazz-drenched town, built
of golden bricks, and smoke
stacks billowing fumes of corn
on the cob and catfish.
My mind lost in music
and metaphysics, reminiscing
the Sunday manna served
beside my Mother's succotash.

The poem has been published in the following:
The Armageddon of Funk *(Tia Chucha Press, 2011)*
Fighting Words – 25 Years of Evocative Poetry and Prose from "The Blues Collar Pen," *edited by Judith Cody, Kim McMillon, and Claire Ortalda, (Heyda Books, 2014)*

Angela Narciso Torres

September, Chicago

Almost metallic – this bite in the air – even
 if the almanac says eleven days till autumn. But the
birch trees are impossibly green and the only leaves

turning are these blue-lined pages. Windblown, they fall
 open to where I erased your name. Down,
down to the basement went your letters, still bound in

June heat. Was your handwriting always lovelier
 under a bare bulb? The light bleeds patterns
through ink & paper, insistent glyphs that spell, *Wait. Still here.*

A Golden Shovel poem using a line from Gwendolyn Brooks' poem, "Beverly Hills, Chicago." The line is: "Even the leaves fall down in lovelier patterns here."

Angela Narciso Torres, "September, Chicago" from What Happens is Neither. Copyright © 2021 by Angela Narciso Torres. Reprinted with the permission of The Permissions Company, LLC on behalf of Four Way Books, fourwaybooks.com.

Larry Janowski

Brotherkeeper

Lots and lots of people that's been killed, just part of day-to-day life here in the Ida B. Wells Project. Looks like, you know, a 14-story cemetery.
 – Lloyd Newman, 10th grade, LeAlan Jones, 11th grade

On Thursday, October 13, 1994, Eric Morse, aged five,
was dropped to his death. Derrick Morse,
his eight-year-old brother,
tried to save him. Chicago boys I never knew, who
will not let go. It's like that.

In my dreams, I do not see him fall,
a movie doll dropped for our sadistic thrill,
and I refuse even to think
of screams. But what I do keep seeing
is Derrick whip-slipping down stairs

 floor to
 floor
 down
 blurred banisters
 two
 three
 steps at a time down
 14 floors
 my brother is
 falling
 is
 like
 drowning

I came close once, flailing in a lake's mud bottom
imagining my cries would rise
in cartoon balloon bubbles to burst *Help!*
in that far blue sky water ceiling, but what saved
was not a word but a brother's hand that grabbed
dragged up to air
 but air cares even less
 than water, lets you
 slip through,
 without even a wake
 to mark your passing

Larry Janowski

and because Eric will not steal
candy for the ten-year-olds, they
dangle him from a 14th floor window
and Derrick grabs and gets him
until one of them bites his hand
and he has to let go
 so
 he races
 for the stairs
 I can catch him
 I can catch
 him I can
 catch him
 I can
 be
 there
 before
 he
 hits
 the
 ground

their defense attorney said
 I don't care how big, how mean they want to be,
 five minutes and you're talking to little boys,
 and every one of them . . . they're all savable
 every one of them

except this one
falling

 14 stories

 14 flights

 14 floors

 catch

 him

First appeared in After Hours #11, Summer 2005
included in Brotherkeeper, *The Puddin'head Press, 2007*

Jayne Hileman

Beverly to Calumet markers (left), Calumet area map (right)
(Mapping Beverly to Blue Island Series)

Gwendolyn A. Mitchell

Remaking Maps in Chicago

What tradition in a name —
Keeps writing itself
Year in and year out
Skyline markers still
Rise above the midmorning fog
Lifting from the lake
Our great span of water

Making and remaking maps to mark the city's edge
As I walk along the beach
A father and his children
Just within earshot
Playing the naming game
Identifying silhouettes in the distant
Or the distance between outfield and strike zones of rival stadiums
Dividing north from south east from west
Only neutral places are in shadows of the
Picasso
Eye watching
Birds taking flight
Or at the top of
The building that grew up and changed its name.

Paul Martínez Pompa

How to Hear Chicago

Here a spirit must yell

to be heard yet a bullet

need only whisper to make

its point – sometimes I imagine

you right before your death

with an entire city in your ears.

From My Kill Adore Him *(University of Notre Dame Press, 2009).*

Viola Lee

Wild Abandon

O, I won't write about the corn cob buildings
or Oak Street Beach
beyond sidewalk and trees.
O, instead
let me write about the Lavendaria
on the corner of Armitage Avenue
and Kedzie
where the other day I saw
a little boy
pushing his infant sister
in one of those metal clothes carts on wheels.
O, you know the one
the one found
in those typical city walls.
I go there sometimes
how it feels safe to me,
and home, warm.
O, I won't write about the city's skyline
the stars of the dark
overlooking Damen, past Milwaukee.
O, instead let me write about the car wash
on Lawndale and North,
the joy
of doing it myself,
to go here, means to step outside myself,
and driving,
I have to remember
that the city I love is known as wild abandon
and often it leaves for physical work.

Paul Hoover

The Angel Guardian Orphanage Florist

At the Angel Guardian
Orphanage Florist, I saw
flowers blooming in the

middle of winter,
five degrees below. They
troped against the window

in order to get
more light and wound
up frozen to it

(the window, not the
light.) I also saw
a truck, blue against

the snow, on which
the name was written:
Angel Guardian Orphanage Florist.

It passes through the
streets as something totally
real. I'd thrill to

see it coming with
birds of paradise or
orchids for the prom

opening fertile petals, the
moist buds thrusting out.
Stevens said, "Death is

the mother of beauty."
I don't believe that
yet. A blue truck

on some snow, that
is the mother of
something, call it beauty

Paul Hoover

then. The neighborhood contains
The Midwest Mambo Club
and two stores named

Hosanna. The School of
Metaphysics used to be
located over Harry's Bar,

but now it's somewhere
else, behind an orange
door, some kind of

scam, no doubt, I'm
mental enough already, beetle
brow on fire with

momentary truth, to
stay alive, which takes
attention given. For seven

seconds once, I had
ambition fever, wanted
to be the thee, the

the first for whom a
crowd would wait like
nervous mice, but that

was not the answer,
cancer of the heart.
"The Botticellian Trees" by

William Carlos Williams
sends its "ifs of color,"
delighting the very air,

but word for word
for word, from glass
to light, to flowers.

From *Idea*, (The Figures, 1987).

Luis Alberto Urrea

The Signal-to-Noise Ratio: Chicago Haiku

Jackson & Harlem

I will fuck you up
Come back here motherfucker
You 'bout to get served

\#

Ogden & Western

Oil change and filter –
$39 Special!
Coffee and donuts

\#

Chicago Sun-Times

Killed wife, girl, in-laws –
Several hard hammer-blows –
Insulted manhood

\#

WLS 890 AM

I'm the decider
Conservative Compassion
I'm the uniter

\#

Grant Park

Pigeon on the ice
Picking at yellow vomit
Of homeless soldier

Luis Alberto Urrea

South Loop

Do I transfer here
To catch the Orange Line?
I'll get fired for sure

\#

Between Austin & Roosevelt

Paletas frescas!
Tacos, tortas, menudo!
Go back home, beaner!

\#

Biograph

Lady in Red's ghost
Can't escape alley's mouth:
Johnny Dillinger

\#

South Racine

Why you stone trippin
Babygirl I aint pimpin –
Got your back for reals

\#

Lake Forest

Dave Eggers lived here
And he was a gentleman
I taught him English

Luis Alberto Urrea

Airport

Security check
Remove your shoes and jackets
Welcome to O'Hare

\#

Millennium Park

Do you know Jesus?
If you were to die tonight
Would you go to Heaven?

\#

Proviso East High School

Hallways full of ghosts
From Chicago to Detroit –
No Child Left Behind

Previously published in The Tijuana Book of the Dead *(Soft Skull Press, 2015).*

José Olivarez

wherever i'm at that land is Chicago

forgive my geography, it's true i'm obsessed
with maps. with flags. a Starbucks on the block
means migration. any restaurant with bullet-proof glass
is a homecoming. underneath my gym shoes
is a trail of salt. that last sentence is a test.
does the poet mean:
(a) grief
(b) winter
(c) diaspora
(d) this is the wrong question
(e) all of the above
i'm always out south
of somewhere. i know the sun rises
in Lake Michigan and sets out west.
i got primos i've never met. there's a word
for that. (where did they go?) all the steel mills shuttering up
like conquered forts. one day, there will be an urban tour
through South Chicago. picture the soy cappuccino
sipping cool kids wearing Chicago Over Everything
branded hoodies taking selfies in front of machines
that once breathed fire. pretending the bones
are the real thing.

First published in Poetry (December 2019).

Santiago Weksler

untitled

Mark Turcotte

Hawk Hour

In this city time unwinds in unnatural ways. It doesn't fly, it trips. It passes in coughing fits. It doesn't have enough soul to tick tock tick. It spits and spews under the rusty fenders of all these cars going nowhere fast. It's bad for the body. Even here at the corner of Sheridan and Pratt, the lake and its waves only a block away, I cannot measure my dying. Instead, this taxi pants at the traffic light. Instead, this bus, the Outer Drive Express, lodges in my ventricle. Instead, this city breaks my clock.

On my good leg I wobble between the I-pods wearing all those heads, wearing the same 2.8 million faces. Some idiot calls this a river of humanity, but rivers don't move like this. It's not natural. I stagger past the café that wasn't here yesterday, won't be here tomorrow. Past the liquor store that will be here forever, lubricating the gears and all their broken teeth. I lurch past the rows of trees. Gnarled sticks attacked by choking leaves. I pause near the playlot, listen to the skippers and skaters singing, *the city is a meadow and the people are the sheep, the city is a meadow and the people are the sheep.* I grin. Near the Red Line tracks a squad car screams *up against the wall* to people already up against the wall. I give away a dollar to a man who says, *god bless,* cuz he does not know god has nothing to do with my dollar.

In Loyola Station I give more money to the turnstile. It says nothing as I catch the current. I crawl up the escalator, 90 miles per hour, swivel to the end of the platform at 95. There I linger in a shadow that drapes itself across my eyes. I catch my breath, I stand upright. Above me the shape of a hawk drowns out the rush of the next ten trains and with its beating wings reaches out to stop the sky.

First published in Brute Neighbors: Urban Nature Poetry, Prose & Photography (*DePaul University Humanities Center, 2011*).

Contributors

Elizabeth Alexander, decorated poet, educator, memoirist, scholar, and cultural advocate, is president of the Mellon Foundation, the nation's largest funder in arts and culture, and humanities in higher education. Dr. Alexander has held distinguished professorships at Smith College, Columbia University, and Yale University, where she taught for 15 years and chaired the African American Studies Department. She is Chancellor Emeritus of the Academy of American Poets, a member of the American Academy of Arts and Sciences, serves on the Pulitzer Prize Board, and co-designed the Art for Justice Fund. Notably, Dr. Alexander composed and delivered "Praise Song for the Day" for the 2009 inauguration of President Barack Obama, and is author or co-author of fifteen books. Her book of poems, *American Sublime* (Graywolf Press), was a finalist for the Pulitzer Prize in Poetry in 2006, and her memoir, *The Light of the World* (Grand Central Publishing), was a finalist for the Pulitzer Prize in Biography in 2015. Her latest book, released in 2022, is *The Trayvon Generation* (Grand Central Publishing).

Jeffery Renard Allen is the award-winning author of five books of fiction and poetry, including the celebrated novel *Song of the Shank* (Graywolf Press, 2014), which was a front-page review in both *The New York Times Book Review* and *The San Francisco Chronicle*. Allen's other accolades include the *Chicago Tribune's* Heartland Prize for Fiction, the Chicago Public Library's Twenty-First Century Award, Ernest J. Gaines Award for Literary Excellence, a grant in Innovative Literature from Creative Capital, a Whiting Writers Award, a Guggenheim fellowship, a residency at the Bellagio Center, and fellowships at The Center for Scholars and Writers, the Johannesburg Institute for Advanced Studies, Jentel Arts Residency, and the Schomburg Center for Research in Black Culture. Allen is the founder and editor of *Taint Taint Taint* magazine. He makes his home in Johannesburg, South Africa.

Arthur Ade Amaker is an English professor, poet, writer, and activist residing in Chicago. As a writer, his work has appeared in *In Defense of Mumia, Role Call: A Generational Anthology of Social and Political Black Literature and Art*, and *American Gun: A Poem by 100 Chicagoans*. He is the founding editor of Oyster Knife Publishing and has edited *What It Is: Poems and Opinions of Oscar Brown Jr.* and *Sons of Lovers: An Anthology of Love Poems by Black Men*. His most recently published nonfiction work is an essay in Third World Press' 2018 release: *Not Our President*, an anthology of political essays about life and politics in the age of Donald Trump. He is currently at work on a novel about Chicago and an anthropological/historical study of Maroons in Louisiana and Northeastern Brazil.

Michael Anania was born in 1939 in Omaha, Nebraska. He has published 14 books of poetry, most recently *Heat Lines* (Asphodel Press, 2005), *Continuous Showings* (MadHat, 2017), and *Nightsongs & Clamors* (MadHat, 2019). Anania has also published a novel, *The Red Menace* (Persea Books, 1984), and a collection of essays, *In Plain Sight: Obsessions, Morals and Domestic Laughter* (Moyer Bell, 1992). He worked as an editor at *Audit, Audit/Poetry, Partisan Review* and *TriQuarterly*. Anania has taught at the University of Buffalo, Northwestern University, and the University of Chicago. He is emeritus Professor of English at the University of Illinois at Chicago, where he twice directed the Graduate Program for Writers. He lives in Austin, Texas and along Lake Michigan.

Rey Andújar was born in Santo Domingo in 1977. He is the author of several works of fiction including *Los gestos inútiles* (Premio Alba Latinoamericano de Novela 2015-Cuba), *Candela* (Pen Club of Puerto Rico 2009), *Amoricidio* (FIL-Santo Domingo Fiction Award 2006),

Contributors

and *Saturnario* (Ultramar Literature Prize NYC, 2010). Andújar has been researching the connection between body, language and literature for several years. He is Artistic Associate at Aguijón Theater, and holds a doctorate in Caribbean Literature and Philosophy. He lives in Chicago and teaches Latin American History and Literature at Governors State University.

René Arceo was born and raised in Mexico. He moved to Chicago where he attended and graduated from the School of the Art Institute. Arceo worked for the National Museum of Mexican Art for over a decade, later managing the Chicago Board of Education art collection and teaching art at a K-12th grade school. Arceo co-founded the Galeria Ink Works (1984-87) and the Mexican Printmaking Workshop (1990-96). He founded Arceo Press in 2005 to build bridges through artistic exchanges with artists and to foster international collaborations among printmakers living in different countries. René has exhibited in dozens of solo and group exhibitions in the United States, Mexico, Spain, Nicaragua, Poland, Puerto Rico, Canada, Argentina, Norway, France, and Italy.

Eduardo Arocho is a poet and author of six chapbooks of poetry. His poems have appeared in *We Are* (Chicago Community Trust, 2016), *CENTRO Journal* (Center for Puerto Rican Studies at Hunter College, New York, 2001), *Power Lines: A Decade of Poetry From Chicago's Guild Complex* (Tia Chucha Press, 1999) and *Open Fist: An Anthology of Young Illinois Poets* (Tia Chucha Press, 1994). He translated and performed two poems for Brooks in Translation: A Gwendolyn Brooks Centennial Celebration at the Harold Washington Library in Chicago. Arocho is currently completing work on his forthcoming poetry manuscript, *Nació Maestro*.

Beatriz Badikian-Gartler was born and reared in Buenos Aires, Argentina, and has lived in the Chicago area for over forty years. Badikian-Gartler holds a Ph.D. in English from the University of Illinois at Chicago and has taught at Northwestern University, Loyola University, Roosevelt University, University of Illinois, Columbia College, and others. Her essays, poems, and stories have been published in *The New York Times Travel Section, Third Woman, Diálogo, Blue Lake Review, After Hours, Make Magazine, Hammers, The Winfield Post, The Journal of Modern Poetry, Short Story,* and many other journals, anthologies, and newspapers. In 2000, Badikian was selected as one of the One Hundred Women Who Make a Difference in Chicago by *Today's Woman* magazine. She is an Illinois Humanities Council Road Scholar and a frequent Newberry Library instructor. Her first novel, *Old Gloves – A 20th Century Saga* was published in 2005 by Fractal Edge Press in Chicago. Her new poetry collection, *Unveiling the Mind*, is published by Pandora/LoboEstepario Press.

Vidura Jang Bahadur is a photographer currently pursuing a Ph.D. in communication studies in the program of Rhetoric and Public Culture at Northwestern University, Evanston. His doctoral thesis explores questions of identity, belonging, and citizenship from the perspective of the ethnic Chinese living across India and in the diaspora. The project builds on Bahadur's extensive photographic work on the community (2003-2015) and disputes easy understandings of nation, national culture, identity, and belonging.

Kay Ulanday Barrett is a poet, essayist, and cultural strategist. They are the winner of the 2022 Cy Twombly Award for Poetry by Foundation for Contemporary Arts and a recipient of the 2020 James Baldwin Fellowship at MacDowell. Their second book, *More Than Organs*

Contributors

(Sibling Rivalry Press, 2020) received a 2021 Stonewall Honor Book Award by the American Library Association and is a 2021 Lambda Literary Award Finalist. Their contributions are found in *The New York Times, Academy of American Poets, The Advocate, NYLON, Vogue, The Rumpus, The Lily, VIDA Review*, and elsewhere. They've been featured at the United Nations, Lincoln Center, Brooklyn Museum, Symphony Space, Dodge Poetry Festival, and Lambda Lit Fest.

Virginia Bell won a Chapter One Competition, sponsored by Arch St. Press in 2021, won the Creative Nonfiction Prize from *NELLE* in 2020, and received Honorable Mention in the *RiverSedge* 2019 Poetry Prize, judged by José Antonio Rodríguez. Bell's poems, essays, and reviews have also appeared in *Hypertext, Kettle Blue Review, Fifth Wednesday Journal, Rogue Agent, Gargoyle, Spoon River Poetry Review, Poet Lore, The Keats Letters Project, Blue Fifth Review, Wicked Alice, Cider Press Review*, and *Voltage Poetry*, among other journals and anthologies. Bell is the author of the poetry collection *From the Belly* (Sibling Rivalry Press, 2012), serves as co-editor of *RHINO*, and teaches at Loyola University Chicago.

Monica Berlin is the author of *Elsewhere, That Small* (Parlor Press, 2020), *Nostalgia for a World Where We Can Live* (Southern University Press, 2019), three chapbooks, and a collaboration with Beth Marzoni, *No Shape Bends the River So Long* (Parlor Press, 2015). The Henke Distinguished Professor at Knox College in Galesburg, IL, Berlin also serves as associate director of the Program in Creative Writing.

Tara Betts is the author of the poetry collections *Break the Habit* (TRIO House Press, 2016), *Arc & Hue* (Willow Books, 2009), as well as *Refuse to Disappear* (Word Works Books, 2022). In addition to her work as a teaching artist and mentor for young poets, she has taught at several universities, including Rutgers University and University of Illinois Chicago. In 2019, Betts published a poem celebrating Illinois' bicentennial with Candor Arts. She is the poetry editor at *The Langston Hughes Review*.

Marianne Boruch was born in Chicago and survived its Catholic schools. She has published eleven books of poetry including *The Anti-Grief* (Copper Canyon, 2019) and *Cadaver, Speak* (Copper Canyon, 2014). Her prose includes three essay collections, most recently *The Little Death of Self* (University of Michigan Press, 2017), and a memoir, *The Glimpse Traveler* (Indiana University Press, 2011). Among her honors are the Kingsley-Tufts Poetry Award and fellowships/residencies from MacDowell and Yaddo, the Guggenheim Foundation, the NEA, the Rockefeller Foundation's Bellagio Center, and two national parks (Denali and Isle Royale). Her poems and essays have appeared in *The New Yorker, The Nation, The London Review of Books, Field, American Poetry Review, POETRY, The New England Review, The New York Review of Books*, and elsewhere. On a 2019 Fulbright in Australia, she observed that country's astonishing wildlife to write a neo-ancient/medieval bestiary of poems, *Bestiary Dark* (Copper Canyon, 2021). Going rogue and emeritus in 2018 from Purdue University, Boruch continues to teach in the Graduate Program for Writers at Warren Wilson College.

Daniel Borzutzky is the author of *Written After a Massacre in the Year 2018* (Coffee House Press, 2021); *Lake Michigan* (Univeristy of Pittsburgh Press, 2018), finalist for the 2019 Griffin International Poetry Prize; and *The Performance of Becoming Human* (Brooklyn Arts Press, 2016), which received the 2016 National Book Award. His other books include *In the Murmurs of the Rotten Carcass Economy* (Nightboat, 2015); *Memories of My Overdevelopment*

Contributors

(Kenning Editions, 2015); and *The Book of Interfering Bodies* (Nightboat, 2011). His translation of Galo Ghigliotto's *Valdivia* received the 2017 ALTA National Translation Award. He has translated Raul Zurita's *The Country of Planks* and *Song for his Disappeared Love* and Jaime Luis Huenún's *Port Trakl*. He teaches in the English and Latin American and Latino Studies Departments at the University of Illinois at Chicago.

Jan Bottiglieri lives and writes in suburban Chicago. She is a co-editor for the poetry annual *RHINO* and holds an MFA in Poetry from Pacific University. Bottiglieri's work has appeared in more than 40 journals and anthologies including *december, Rattle, DIAGRAM, Willow Springs* and *New Poetry from the Midwest*. She is the author of two chapbooks and two full-length poetry collections: *Alloy* (Mayapple Press, 2015) and *Everything Seems Significant* (BlazeVox Books, 2019.)

Rashayla Marie Brown (RMB) is an "undisciplinary" artist-scholar, creating visually poetic and emotionally engaging artworks which have been presented at galleries internationally including INVISIBLE-EXPORTS, New York; Krabbesholm Højskole, Copenhagen; La Becque, La-Tour-de-Peilz, Switzerland; Museum of Contemporary Art, Chicago; Museum of Contemporary Photography, Chicago; Museum of the African Diaspora, San Francisco; Rhodes College, Memphis; Tate Modern, London; and Turbine Hall, Johannesburg.

Rosellen Brown's newest novel is *The Lake on Fire* (Sarabande, 2018). Her ten other books include the best-selling novel *Before and After* (Picador, 1992), *Civil Wars* (Knopf, 1984), and *Tender Mercies* (Knopf, 1978); three books of poetry including *Cora Fry's Pillow Book* (Farrar, Straus and Giroux, 1995), which was performed as a one-woman theater piece, and a collection of stories, *Street Games* (W.W. Norton, 2001). The Chicago Literary Hall of Fame gave her their Fuller Award for lifetime achievement in 2016. She teaches at the School of the Art Institute of Chicago.

John Brzezinski is a Chicago native. He bought his first camera in 1966 – used, on lay-away – at the age of 15. Brzezinski quickly discovered that the camera allowed him to compose, record and show what he had encountered in an interesting and compelling way. Initially, he shot only in black and white. It was years before color captured his eye. His most important photographic accomplishment is documenting the best collegiate architecture at well over 600 university campuses, in all the lower 48 states.

Emily Thornton Calvo is a life-long writer, crafting accessible work from humor to commentary while straddling academic and spoken word styles. She has performed in venues such as the Art Institute of Chicago and the Uptown Poetry Slam at the Green Mill. Calvo's work has been published in *American Gun* (Big Shoulders Books, DePaul University), *Nourish, After Hours, Coleré* (Coe College, Iowa), the City of Chicago's tourism website and many others. Her collection of poems, *Lending Color to the Otherwise Absurd* (BookBaby) was published in 2014. In 2019, the Guild Literary Complex recognized Calvo as one of "30 Chicago Writers to Watch." As an educator, she was also poet-in-residence for the Poetry Center of Chicago's Hands on Stanza program, and has been featured at Niles North High School Writers Week. Calvo is an artist who presents her poetry in her paintings, which she calls "wall poems." This work led to commissions from notable poet Nikki Giovanni for her anthology, *Standing in the Need of Prayer*.

Ana Castillo is a celebrated and distinguished poet, novelist, short story writer, essayist, editor, playwright, translator and independent scholar. Castillo was born and raised in Chicago.

Contributors

In 2020 Dr. Castillo was the recipient of the Northeastern Illinois University Distinguished Alumnus Award. Her novel, *Sapogonia* (Knopf, 1994), partly based in Chicago, was a *New York Times* Notable Book of the Year. Twice Lambda award recipient in fiction and nonfiction. Among best seller titles: novels include *So Far From God* (W.W. Norton, 1993)*, The Guardians* (Random House, 2007) and *Peel My Love Like an Onion* (Doubleday, 1999); among other poetry collections: *I Ask the Impossible* (Anchor, 2001). In 2022, Castillo was a recipient of the Fuller Award for lifetime achievement from the Chicago Literary Hall of Fame.

Grady Chambers was born and raised in Chicago. He is the author of *North American Stadiums* (Milkweed Editions, 2018), chosen by Henri Cole as the winner of the inaugural Max Ritvo Poetry Prize. His poems can be found in *The Paris Review, Ploughshares, The Sun, American Poetry Review,* and *The Kenyon Review Online.* Chambers is a former Wallace Stegner Fellow, and currently lives in Philadelphia.

Maxine Chernoff spent the first half of her life in Chicago. She grew up on the Southeast Side and moved to the Bay Area in 1994 to become chair of creative writing at SFSU. She is an NEA winner and a PEN Translation Award winner. Chernoff has published 17 books of poetry and six collections of fiction. Former editor with Paul Hoover of *New American Writing* (begun in Chicago in 1986), she was a writer in residence at the American Academy in Rome in 2016.

Bob Chicoine has been a Chicago CPA for over forty years and a ballpark beer vendor for forty-three, not counting the "lost" season of 2020. He has written and produced documentaries on Comiskey Park and Wrigley Field. Chicoine has found that when you write poetry as a hobby, rather than as an art, you never suffer from writer's block.

Sandra Cisneros is a poet, short story writer, novelist, essayist, performer, and artist. Her numerous awards include NEA fellowships in both poetry and fiction, a MacArthur Fellowship, and national and international book awards, including the PEN America Literary Award, and the National Medal of Arts. President Obama awarded Cisneros the National Medal of Arts in 2016. More recently, she received the Ford Foundation's Art of Change Fellowship, was recognized with the Fuller Award for lifetime achievement from the Chicago Literary Hall of Fame in 2021, and won the PEN/Nabokov Award for Achievement in International Literature. Cisneros's first Chicago address was in the Lawndale neighborhood and her last in Bucktown. A citizen of both the United States and Mexico, she currently lives in San Miguel de Allende and makes her living by her pen.

Marta Collazo is a poly queer Latinx artist. Most of her life has been spent practicing art daily however life informs. A meditation practice of over 13 years has guided her spiritually and artistically.

Kristiana Rae Colón is a poet, playwright, actor, educator, creator of #BlackSexMatters, co-founder of the #LetUsBreathe Collective, and executive story editor on Season 5 of Showtime's *The Chi*. Her play *Tilikum* won Best New Play at the non-equity Joseph Jefferson Awards. In 2017, she was awarded Best Black Playwright by The Black Mall. In 2013, Kristiana toured the UK for two months with her collection of poems *promised instruments*, winner of the inaugural Drinking Gourd Poetry Prize and published by Northwestern University Press. Kristiana is an alum of the Goodman Theatre's Playwrights Unit where she developed her play *florissant & canfield*, which debuted at the University of Illinois at Chicago in Febru-

Contributors

ary 2018. She is a resident playwright at Chicago Dramatists and one half of the brother/sister hip-hop duo April Fools. She appeared on the fifth season of HBO's *Def Poetry Jam*. Kristiana's current work explores Afrofuturism as a catalyst for social change.

Nina Corwin is the author of two books and three chapbooks of poetry, including *The Uncertainty of Maps* (CW Books, 2011) and *Dear Future* (Glass Lyre Press, 2017). Her poetry has appeared in *From the Fishouse, Drunken Boat, Forklift OH, Harvard Review, Hotel Amerika, New Ohio Review, Verse* and numerous anthologies. A two-time Pushcart Prize nominee, Corwin curates the literary series at Chicago's Woman Made Gallery. In daytime hours, she is a psychotherapist known for her work on behalf of victims of violence.

Vida Cross is a blues poet and a Pushcart nominee for 2021 and 2018. Her book of poetry, *Bronzeville at Night: 1949* (Awst Press) was published in 2017. Vida is on the board for the Milwaukee Center for the Book and the Poet Laureate Commission. She is the chairperson for the Creative Writing Division of the English Department and the Stormer Connect Mentoring Programs at Milwaukee Area Technical College. She is a Cave Canem Fellow who holds an MFA in Writing and an MFA in Filmmaking from the School of the Art Institute of Chicago, an MA in English from Iowa State University and a BA from Knox College. Her work has appeared in several journals and anthologies including *A Civil Rights Retrospective, Tabula Poetica, Transitions Magazine, The Literary Review, Reed Magazine, The Journal of Film and Video, Through this Door: Wisconsin in Poems, MilwaukeeNoir, Wising Up Anthology: Creativity and Constraint,* and *Cave Canem Anthology XII*.

Carlos Cumpián, a Chicagoan for decades, is a poet and author of *Coyote Sun* (MARCH/Abrazo, 1990), *Latino Rainbow* (Scholastic, 1994), *Armadillo Charm* (Tia Chucha Press, 1996), *14 Abriles* (MARCH/Abrazo, 2010) and recently published *Human Cicada* (Prickly Pear Publishing, 2022). His poems and essays have also been included in numerous anthologies. Cumpián served as a poetry events promoter and editor/publisher for MARCH/Abrazo Press, Illinois' first Chicano, Indigenous and Latino poetry press. He has also worked for various nonprofits, and as a high school and university English teacher. He currently is collaborating with board members of the Charles H. Kerr Publishing Company on a summer 2023 release of the *Collected Poetry & Selected Art of Carlos A. Cortez Koyokuikatl*.

Averill Curdy is the author of *Song & Error* (Farrah, Straus and Giroux, 2014). Her poetry and essays have appeared widely, including on the PBS NewsHour website, *The Paris Review, Poetry,* and elsewhere. In addition to a Fulbright Fellowship to Istanbul, she has also received grants from the NEA and the Illinois Arts Council. She currently teaches at Northwestern University.

Paul D'Amato was born in Boston where he attended Boston Latin School at the height of racial unrest and civil rights. He moved west to attend Reed College and claims to have learned as much from traveling cross-country – often by hitch-hiking and freight trains – as he did in class. After receiving an MFA from Yale, he moved to Chicago where he discovered the community of Pilsen. The pictures and writing D'Amato produced there were made into the book *Barrio*, (University of Chicago Press, 2016). His book of images made in the African-American community on Chicago's West Side, entitled *Here/Still/Now* and published by Kehrer Verlag, was awarded the Lucie Foundation Book Prize in 2018. *Rave* (Skylark Editions, 2019) is about work made in the early underground Techno scene in the early 90's.

Contributors

D'Amato is now finishing work for a book entitled *Midway*. His work is in the collections of the Museum of Modern Art, The Metropolitan Museum of Art, and the Art Institute of Chicago among many others.

Albert DeGenova is an award-winning poet, publisher, and teacher. He is the author of four books of poetry and two chapbooks. A third chapbook, *Mama's Blues*, is forthcoming from Finishing Line Press. His work has appeared in numerous anthologies and journals including: *RHINO, The Paterson Literary Review, The Louisville Review, Aesthetica Magazine, The Café Review, Fifth Wednesday Journal,* and others. He is a three-time nominee for a Pushcart Prize. DeGenova is the founder and editor of *After Hours* magazine, a journal of Chicago writing and art, which launched in June of 2000. DeGenova received his MFA from Spalding University in Louisville. He is also a blues saxophonist and one-time contributing editor for *DownBeat* magazine.

Nicolás de Jesús was born in Ameyaltepec Guerrero, Mexico. He learned to paint as he learned to breathe. In the Aztec Nahuatl region, he developed and illuminated his inspiration, based on the belief and awareness of his ancestors. He moved to Chicago four years ago. His work has been exhibited in Europe, Indonesia, Canada, and in a large part of the US. His work is part of the permanent collections in museums including the Smithsonian in Washington DC; Neuberger Museum of Art NY; University of New Mexico Art Museum, Albuquerque, NM; and the National Museum of Mexican Art, Chicago.

Rachel DeWoskin is the award-winning author of five novels: *Someday We Will Fly* (Penguin Random House, 2019); *Banshee* (Dottir Press, 2019); *Blind* (Penguin Random House, 2015); *Big GirlSmall* (Farrar, Straus and Giroux, 2011); *Repeat After Me* (The Overlook Press, 2009); and the memoir *Foreign Babes in Beijing* (W.W. Norton, 2005), about the years she spent in Beijing as the unlikely star of a Chinese soap opera. DeWoskin's poetry collection, *Two Menus*, was published by the University of Chicago Press' Phoenix Poetry Series in 2020, and *Foreign Babes in Beijing* and *Banshee* are currently being developed for TV. DeWoskin's poems, essays, and articles have appeared in numerous journals and anthologies, including *The New Yorker, Vanity Fair, Ploughshares,* and *New Voices from the Academy of American Poets*. DeWoskin is an associate professor of practice in the arts at the University of Chicago and is an affiliated faculty member in Jewish and East Asian Studies.

Joanne Diaz is the author of *My Favorite Tyrants* (University of Wisconsin Press, 2014) and *The Lessons* (Silverfish Review Press, 2011). Her poems have appeared in *AGNI, The American Poetry Review, The Missouri Review, The New England Review, Poetry,* and *The Southern Review*. She is the recipient of fellowships from the Illinois Arts Council, the National Endowment for the Arts, the Bread Loaf Writers Conference, and the Sustainable Arts Foundation. She is a professor of English at Illinois Wesleyan University. She co-hosts, with Abram Van Engen, *The Poetry for All* podcast.

Alma Domínguez was born in México (Chihuahua) but she has lived in the Chicago area for over 15 years. She has been a visual artist for more than two decades, working with different techniques and materials, on metal, paper, or canvas, with mixed techniques. Domínguez is a psychologist with a Masters in Social Science. Her work has been exhibited in México, the US, Spain, Italy, Nicaragua, Argentina, Chile, France, and Russia. She has the honor of being the only Latina in the Chicago Society of Artists. The "CSA" is the oldest continuing

Contributors

association of artists in the United States. She's the founder of Pintoras Mexicanas, approximately 350 painters of Mexican origin around the world who organize exhibitions to promote their work and to support different organizations. She is also co-founder of OPEN Center for the Arts, where members work to share, inspire, and promote different artistic expressions through workshops, exhibitions, and public art in Chicago.

Stuart Dybek is the author of two books of poetry, *Brass Knuckles* (University of Pittsburgh Press, 1979) and *Streets in Their Own Ink* (Farrar, Straus and Giroux, 2004), and six books of fiction including *The Coast of Chicago* (Knopf, 1990), which was a One Book, One Chicago selection. Dybek grew up in Pilsen and Little Village, and those neighborhoods have been a setting for both his fiction and poetry. His work has appeared in *The New Yorker, The Atlantic, Harper's, The Paris Review, Poetry*, and is frequently anthologized. He has been the recipient of many literary awards including a Guggenheim Fellowship, a Whiting Writers Award, a Lannan Award, two NEA's, an Academy Institute Award from the American Academy of Arts, the Harold Washington Literary Award, and a fellowship from the MacArthur Foundation. In 2018, the Chicago Literary Hall of Fame gave Dybek the Fuller Award for lifetime achievement.

Olivia Maciel Edelman received her Ph.D. in Romance Languages and Literatures from the University of Chicago. She was awarded the Poet's House Award (New York City, 1996) for *Más salado que dulce / Saltier than Sweet* (MARCH/Abrazo Press, 1996) and the José Martí Award for essay writing in homage to Sor Juana Inés de la Cruz (University of Houston and Consular Body of Houston, 1993). Maciel is the author of *Luna de cal / Limestone Moon, Filigrana encendida / Filigree of Light, Sombra en plata / Shadow in Silver* (Swan Isle Press, 2005); *Cielo de Magnolias. Cielo de Silencios* (Pandora Lobo Estepario Ediciones, 2015); and the monograph *Surrealismo en la poesía de Xavier Villaurrutia, Octavio Paz, y Luis Cernuda (México 1926-1963)* (Edwin Mellen Press, 2008), among other publications. She is currently at work on a new volume of poems, translations, and a manuscript of short stories.

Kelly Norman Ellis is the author of *Tougaloo Blues* (Third World Press, 2003) and *Offerings of Desire* (Willow Books/Aquarius Press, 2012). Her poetry has appeared in *Sisterfire: Black Womanist Fiction and Poetry, Spirit and Flame, Role Call: A Generational Anthology of Social and Political Black Literature and Art, Boomer Girls, Essence Magazine, Obsidian, Calyx, Cornbread Nation*, and *Appalachian Reckoning*. She is a recipient of a Kentucky Foundation for Women writer's grant and is a Cave Canem fellow and founding member of the Affrilachian Poets. Ellis is an associate professor of English and creative writing and chairperson for the Department of English, Foreign Languages and Literatures at Chicago State University.

Elaine Equi's most recent book is *The Intangibles* (Coffee House Press, 2019). Her other books include *Voice-Over* (Coffee House Press, 2011), which won the San Francisco State Poetry Award; *Ripple Effect: New & Selected Poems* (Coffee House Press, 2007), which was a finalist for the Los Angeles Times Book Award and on the short list for the Griffin Poetry Prize; and *Sentences and Rain* (Coffee House Press, 2015). Widely published and anthologized, her work has appeared in *American Poetry Review, Brooklyn Rail, Court Green, The Nation, The New Yorker, Poetry*, and in many editions of the *Best American Poetry*. She teaches at New York University and in the MFA Program in Creative Writing at The New School.

Donald G. Evans grew up in the Avondale and Cragin neighborhoods of Chicago's Northwest Side until moving to Downers Grove just before high school. He has lived as an adult in Wrigleyville, Uptown, and Old Town, and for the past 15 years settled in Oak Park. He is

Contributors

the author of a novel set in the shadows of Wrigley Field, *Good Money After Bad* (Atomic Quill Press, 2006); a short story collection, *An Off-White Christmas* (Eckhartz Press, 2018); and an anthology of Chicago Cubs literature. He is the Founding Executive Director of the Chicago Literary Hall of Fame.

Terry Evans has been guided by the prairie ecosystem since 1978. She photographs the prairies and plains of North America and the urban prairie of Chicago. Combining both aerial and ground photography, she delves into the intricate and complex relationships between land and people, especially where local people's landscape is threatened by corporate industrialization. Evans has exhibited widely including one-person shows at Art Institute of Chicago, Nelson-Atkins Museum of Art in Kansas City, Smithsonian National Museum of Natural History, the Field Museum of Natural History, and Amon Carter Museum of Art. Her work is in museum collections including Museum of Modern Art, New York; the Art Institute of Chicago; Nelson–Atkins Museum of Art, Kansas City; and many others. Evans' books include *Heartland: The Photographs of Terry Evans* (Yale University Press, 2012), and *Prairie Stories* (Radius Books, 2013). She is a Guggenheim Fellow and the recipient of an Anonymous Was a Woman award.

Angela Davis Fegan is a native of Chicago's South Side. A graduate of Chicago's famed Whitney Young High School, she received her BFA in Fine Arts from New York's Parsons School of Design and her MFA in Interdisciplinary Book and Paper Arts from Columbia College Chicago. Angela has mounted shows at Galerie F, Chicago Artists' Coalition, the DePaul Art Museum, The Center for Book Arts (NY), the University of Chicago's Arts Incubator and Center for the Study of Gender and Sexuality, the Hyde Park Art Center, SAIC's Sullivan Galleries, Columbia's Glass Curtain Gallery and SPACES (OH). Her work has been selected for book covers including *The Truth About Dolls* by Jamila Woods, *Secondhand* by Maya Marshall, and *All Blue So Late* by Laura Swearingen-Steadwell. Her MFA thesis, and on going practice, "the lavender menace poster project," has been written up by *The Offing (LA Review of Books)*, *Hyperallergic*, *Chicago Magazine*, *RedEye*, *Go Magazine*, *Pop Sugar*, the *Chicago Reader*, and *Newcity*.

Tony Fitzpatrick is a Chicago-based artist best known for his multimedia collages, printmaking, paintings, and drawings. Fitzpatrick's work is inspired by Chicago street culture, cities he has traveled to, children's books, tattoo designs, and folk art. Fitzpatrick has authored or illustrated eight books of art and poetry, and for the last two years has written a column for *Newcity*. Fitzpatrick's art appears in the Museum of Modern Art in New York City, the Museum of Contemporary Art in Chicago, and the National Museum of American Art in Washington, DC, and also on the Neville Brothers' album *Yellow Moon* and Steve Earle's albums *El Corazon* and *The Revolution Starts Now*. In 1992, Fitzpatrick opened a Chicago-based printmaking studio, Big Cat Press, which exists today as the artist exhibition space Firecat Projects. Before making a living as an artist, Fitzpatrick worked as a radio host, bartender, boxer, construction worker, and film and stage actor.

Calvin Forbes grew up in Newark, New Jersey. His collections of poetry include *Blue Monday* (Columbia University Press, 1974), *From the Book of Shine* (Burning Deck, 1979), and *The Shine Poems* (Louisiana State University Press, 2001). His work has been collected in many anthologies. Branford Marsalis and Kurt Elling recorded his poem "Momma Said," originally published in *Poetry* magazine, on their 2016 album *Upward Spiral*. He is Professor Emeritus at the School of the Art Institute of Chicago, where he taught creative writing, lit-

Contributors

erature, and jazz history. He is the recipient of fellowships from the Illinois Arts Council, the NEA, and the Fulbright Foundation. He previously taught at Emerson College, Tufts University, the University of Copenhagen, Denmark, and Howard University.

Vincent Francone is the author of *Like a Dog* (Blue Heron Book Works, 2015) and *The Soft Lunacy* (Blue Heron Book Works, 2019). His work has appeared in *Newcity Magazine*, *Three Percent*, *Southword*, and other journals. He won first place in the 2009 Illinois Emerging Writers Competition and his poem "Mud" was nominated for a Pushcart Prize.

Krista Franklin is a writer and visual artist. She is the author of *Too Much Midnight* (Haymarket Books, 2020), the artist book *Under the Knife* (Candor Arts, 2018), and the chapbook *Study of Love & Black Body* (Willow Books, 2012). She is a Helen and Tim Meier Foundation for the Arts Achievement Awardee, and a recipient of a Joan Mitchell Foundation Painters and Sculptors grant. Franklin's visual art has exhibited at Poetry Foundation, Konsthall C, Rootwork Gallery, Museum of Contemporary Photography, Studio Museum in Harlem, Chicago Cultural Center, National Museum of Mexican Art, and the set of 20th Century Fox's *Empire*. She has been published in *Poetry*, *Black Camera*, *The Offing*, *Vinyl*, and a number of anthologies and artist books.

Naoko Fujimoto was born and raised in Nagoya, Japan. Recent work appears or is forthcoming in *Poetry*, *Kenyon Review*, *Seattle Review*, *Quarterly West*, *North American Review*, *Prairie Schooner*, and *Hayden's Ferry Review*. She is the author of *Glyph: Graphic Poetry=Trans Sensory* (Tupelo Press, 2020), *Where I Was Born* (Willow Publishing, 2019), and three chapbooks. She is an associate and outreach translation editor at *RHINO* Poetry.

Cynthia Gallaher, born and raised in Chicago, is author of four poetry collections, including *Epicurean Ecstasy: More Poems About Food, Drink, Herbs and Spices* (The Poetry Box, Portland, 2019), and three chapbooks, including *Drenched* (Main Street Rag, Charlotte, N.C., 2018). Her memoir/creativity guide *Frugal Poets' Guide to Life* won a National Indie Excellence Award.

Rachel Galvin's books include *Elevated Threat Level* (Green Lantern Press, 2018), a finalist for the National Poetry Series; *Pulleys & Locomotion* (Black Lawrence Press, 2009); and *Uterotopia*, forthcoming from Persea Books. She is the translator of Raymond Queneau's *Hitting the Streets*, which won the 2014 Scott Moncrieff Prize; and co-translator of *Decals: Complete Early Poetry* by Oliverio Girondo, a finalist for the 2019 National Translation Award. She received a 2021 National Endowment for the Arts Fellowship for her translation of Mexican poet Alejandro Albarrán. Her work appears in *Best American Experimental Writing 2020*, *Best American Poetry 2020*, *Boston Review*, *Colorado Review*, *Fence*, *Gulf Coast*, *McSweeney's*, *The Nation*, *The New Yorker*, *PN Review*, and *Poetry*. She is associate professor of English and comparative literature at the University of Chicago.

Edgar Garcia is a poet and scholar of the hemispheric cultures of the Americas. He is the author of *Skins of Columbus: A Dream Ethnography* (Fence Books, 2019); *Signs of the Americas: A Poetics of Pictography, Hieroglyphs, and Khipu* (University of Chicago Press, 2020); *Infinite Regress* (Bom Dia Books, 2021); and *Emergency: Reading the Popol Vuh in a Time of Crisis* (University of Chicago Press, 2022). He is associate professor of English at the University of Chicago, where he also serves as director of undergraduate studies in creative writing. In 2022, he is editor-in-chief of *Fence*.

Contributors

Reginald Gibbons is the author of eleven books of poetry, including the recent *Renditions* (Four Way Books, 2021), as well as *Slow Trains Overhead: Chicago Poems and Stories* (University of Chicago Press, 2017), and *Creatures of a Day,* a finalist for the National Book Award (Louisiana State University Press, 2008). He has published a book of very short fiction, *An Orchard in the Street* (BOA Editions, 2017), and translations of Sophocles' *Antigone* and Euripides' *Bakkhai*, and many other books. He was the editor of *TriQuarterly* magazine from 1981 to 1997, taught for many years in the Warren Wilson MFA Program for Writers, and has taught since 1981 at Northwestern University, where he is a Frances Hooper Professor of Arts and Humanities. Gibbons was recognized with the Chicago Literary Hall of Fame's Fuller Award for lifetime achievement in 2021.

Regie Gibson is a literary performer who has lectured and performed widely in the United States, Cuba, and Europe. In Italy, representing the US, Regie competed for and received the Absolute Poetry Award and The Europa in Versi Prize. He has served as consultant for the NEA and "The Mere Distinction of Colour" exhibit at James Madison's Montpelier home. He appears regularly on NPR and has been published in the *Iowa Review, Harvard Divinity Magazine*, and *Poetry*, among others. He teaches at Clark University and is the creator of *The Shakespeare Time-Traveling Speakeasy* – a multimedia performance focusing on the works and influence of William Shakespeare.

Barry Gifford is the author of more than forty published works of fiction, nonfiction, and poetry, which have been translated into thirty languages. He began his literary career as a poet and eventually turned to biography and novels. He grew up in Chicago where his father ran an all-night drugstore on the corner of Chicago and Rush, and had racketeer friends. His most recent books include *The Up-Down* (Seven Stories Press, 2015), *Writers* (Seven Stories Press, 2015), *Sailor & Lula: The Complete Novels* (Seven Stories Press, 2010), *Sad Stories of the Death of Kings (*Seven Stories Press, 2010), *Imagining Paradise: New and Selected Poems (*Seven Stories Press, 2012), *The Roy Stories (*Seven Stories Press, 2020), and *Landscape with Traveler* (Dutton, 1980). Gifford lives in the San Francisco Bay Area.

Juana Iris Goergen is a poet and emeritus professor at DePaul University in Chicago. Her publications include *La sal de las brujas* (finalist of Letras de Oro Awards, Betania, 1997), *La piel a medias* (2001), *Las Ilusas/Dreamers* (in Desarraigos, contratiempo, 2008), and *Mar en los huesos* (Pandora/Lobo estepario, 2018). Her poetry has been published in numerous anthologies, most recently, *LatinUsa (*Mexico, 2017). She was initiator and co-organizer for eleven years of the Chicago International Poetry Festival Poesía en abril. She has edited nine poetry anthologies, among them: *Susurros para disipar las sombras, Rapsodia de los sentidos* and *Ciudad Cien en (Erato Poesía, Poesía en abril Chicago).* She has been awarded contratiempo Poesía/Cultura Award, 2013, and the José Revueltas Poetry Award, 2017. At the moment she is working on two poetry collections, *La celda del iris / Iris' Prison Cell* and *Requiem al sueño americano*.

Chris Solis Green is the author of four books of poetry: *The Sky Over Walgreens* (Mayapple Press, 2007), *Epiphany School* (Mayapple Press, 2009)*, Resume* (Mayapple Press, 2014)*, and Everywhere West* (Mayapple Press, 2019). His poetry has appeared in such publications as *Poetry, The New York Times, Court Green*, and *Prairie Schooner*. He is a founding editor of Big Shoulders Books whose mission is to disseminate, free of charge, quality works of writing by and about Chicagoans whose voices might not otherwise be shared. He has edited four anthologies including *I Remember: Chicago Veterans of War* and *American Gun: A Poem by 100 Chicagoans* (Big Shoulders Books, 2020). He currently teaches in the English department at DePaul University.

Contributors

John Guzlowski's writing appears in *Garrison Keillor's Writer's Almanac, North American Review, Rattle, Ontario Review, Salon.com,* and many other journals. His poems and personal essays about his Polish parents' experiences as slave laborers in Nazi Germany and refugees making a life for themselves in Chicago appear in his award-winning memoir *Echoes of Tattered Tongues* (Aquila Polonica Press, 2017). He is also a columnist for the *Dziennik Zwiazkowy* (the oldest Polish language daily in America) and is the author of *Suitcase Charlie* and *Little Altar Boy*, noir police procedurals set in Chicago. Guzlowski's most recent book of poetry is *True Confessions: 1965 to Now*, (Darkhouse Books, 2019).

Susan Hahn is the author of nine books of poetry, two produced plays, and two novels. Among her honors for writing are a Guggenheim Fellowship in poetry, being the inaugural writer-in-residence at The Ernest Hemingway Foundation during 2013-2014, Pushcart Prizes, and Special Mentions in fiction and poetry, The Society of Midland Authors Award, and many Illinois Arts Council Fellowships and Literary Awards. She was the editor of *TriQuarterly* literary magazine for 14 years and co-founder of TriQuarterly Books.

Duriel E. Harris is the author of three critically acclaimed volumes of poetry, including *No Dictionary of a Living Tongue* (2017), a finalist for the Audre Lorde Award. Multi-genre works include the one-woman show *Thingification*, the video-poem *Speleology*, and the conceptual project *Blood Labyrinth*. Appearances include performances at the Greenhouse Theater, the Chicago Jazz Festival, Naropa, Babylon Cinema (Berlin), Votive (Auckland), Babel Theatre (Beirut), and the Art Institute of Chicago. Her work has been featured in *The New York Times, BAX, Letters to the Future, Of Poetry and Protest, PEN America,* and *Poets.org,* among others. Harris is a professor of English at Illinois State University and editor of the publishing platform *Obsidian: Literature & Arts in the African Diaspora*.

Janet Ruth Heller is president of the Michigan College English Association. She has published four poetry books: *Nature's Olympics* (Wipf and Stock, 2021), *Exodus* (WordTech Editions, 2014), *Folk Concert: Changing Times* (Anaphora Literary Press, 2012), and *Traffic Stop* (Finishing Line Press, 2011). The University of Missouri Press published her scholarly book, *Coleridge, Lamb, Hazlitt, and the Reader of Drama* (1990). Fictive Press published Heller's middle-grade chapter book about sibling rivalry, *The Passover Surprise* (2015, 2016). Her children's book about bullying, *How the Moon Regained Her Shape* (Arbordale, 2006; 6th edn. 2018), has won four national awards.

Aleksandar Hemon is the author of *The Lazarus Project*, which was a finalist for the 2008 National Book Award and the National Book Critics Circle Award, and three books of short stories: *The Question of Bruno; Nowhere Man*, which was also a finalist for the National Book Critics Circle Award; and *Love and Obstacles*. He was the recipient of a 2003 Guggenheim Fellowship and a "genius grant" from the MacArthur Foundation, and the 2020 Dos Passos Prize. Born in Sarajevo, Hemon lived and worked in Chicago from 1992 until 2018. He is a regular contributor to *The New Yorker*, as well as *Esquire, The Paris Review,* and *The New York Times*. He teaches at Princeton.

P. Hertel is an artist, writer, and editor. Her paintings and photographs have appeared in various venues including Around the Coyote and Old Town Triangle Art Center, as well as several schools, bookstores, and cafes. She is a former editor of the *Oyez Review* as well as the editor of two novels, two memoirs, and lots of poetry. She spent six years living in the Czech Republic and working as features editor of *The Prague Post*, a weekly newspaper. She is a for-

Contributors

mer university professor and adult educator who has taught subjects as diverse as medical terminology and "The biographical background of Franz Kafka's *The Trial*." Along with Albert DeGenova, she has been the co-editor of *After Hours, a Journal of Chicago Writing and Art*, since its inception in 2000.

Jayne Hileman works as a visual artist, carpenter, curator, and was an art and design teacher for many years on the South Side of Chicago. Mapping projects about Chicago's South Side include Mapping Beverly to Blue Island, and Mapping Public High Schools and Public Golf Courses on Chicago's South Side. She is a contributor to *Notes for a People's Atlas: People Making Maps of Their Cities*.

Edward Hirsch was born in Chicago in 1950 – his accent makes it impossible for him to hide his origins – and educated at Grinnell College and the University of Pennsylvania, where he received a Ph.D. in Folklore. He has received numerous awards and fellowships including a MacArthur Fellowship. In 2008, he was elected a Chancellor of the Academy of American Poets. Hirsch's first collection of poems, *For the Sleepwalkers* (1981), received the Delmore Schwartz Memorial Award from New York University and the Lavan Younger Poets Award from the Academy of American Poets. His second collection, *Wild Gratitude* (1986), won the National Book Critics Circle Award. Since then, he has published six additional books of poems and five prose books, including the national bestseller *How to Read a Poem and Fall in Love with Poetry* (1999). Hirsch taught at Wayne State University and the University of Houston. He is now president of the John Simon Guggenheim Memorial Foundation.

Paul Hoover is the author of *O, and Green: New and Selected Poems* (2021) and, with Maxine Chernoff, editor and translator of *Selected Poems of Friedrich Hölderlin* (2008). Professor of creative writing at San Francisco State University, he is editor of two editions of *Postmodern American Poetry: A Norton Anthology* (1994/2013) and the annual literary magazine *New American Writing*.

Priscilla Huang found art, again, after over 30 years as a financial professional in the business world. Art was her first love. Her painting was juried in several local and online exhibits and received special recognitions. She is an associate member of Oil Painters of America and a member of Plein Air Painters of Chicago.

Luisa A. Igloria is originally from Baguio City in the Philippines. She is the author of 14 books of poetry and four chapbooks. She is a professor of creative writing and English, and from 2009-2015 was director of the MFA Creative Writing Program at Old Dominion University. Her work has appeared or been accepted in numerous anthologies and journals, including *New England Review* and *TriQuarterly*. Igloria's many national and international literary awards include the 2019 Crab Orchard Open Competition Award for Poetry and the 1998 George Kent Award for Poetry. She is an 11-time recipient of the Carlos Palanca Memorial Award for Literature in three genres (poetry, nonfiction, and short fiction) and its Hall of Fame distinction. The Palanca Award is the Philippines' highest literary prize.

Angela Jackson is Illinois' fifth Poet Laureate and one of twelve Chicago authors honored with the Chicago Literary Hall of Fame's Fuller Award for lifetime achievement. She has published three chapbooks and four volumes of poetry. Born in Greenville, Mississippi, and raised on Chicago's South Side, she was educated at Northwestern University and the University of Chicago. Her collections of poetry include *Voo Doo/Love Magic* (1974); *Dark Legs*

Contributors

and Silk Kisses: The Beatitudes of the Spinners (1993), which was awarded the Carl Sandburg Award and the Chicago Sun-Times/Friends of Literature Book of the Year Award; *And All These Roads Be Luminous: Poems Selected and New* (1998), nominated for the National Book Award; and *It Seems Like a Mighty Long Time* (2015) was nominated for the Pulitzer Prize, the Pen/Open Book Award, finalist for the Hurston/Wright Legacy Award, and a finalist for the Milt Kessler Poetry Prize. She received a Pushcart Prize and an American Book Award for *Solo in the Boxcar Third Floor E* (1985). Jackson's collection, *More Than Meat and Raiment: Poems*, was published by Northwestern University Press in 2022.

Kara Jackson is a singer/songwriter, musician, and writer from Oak Park, Illinois. Jackson served as the third National Youth Poet Laureate from 2019-2020. She is the author of *Bloodstone Cowboy* (Haymarket Books, 2019). Her EP *A Song for Every Chamber of the Heart* is available now on all streaming platforms.

Rachel "Raych" Jackson is a writer, educator, and performer. Her poems have gained over two million views on YouTube. She is the 2017 NUPIC Champion and a 2017 Pink Door fellow. Jackson recently voiced 'DJ Raych' in the Jackbox game Mad Verse City. She voices Tiffany in *Battu*, an upcoming animation recently picked up by Cartoon Network. Her latest play, *Emotions & Bots*, premiered at the Woerdz Festival in Lucerne, Switzerland. Jackson wrote a room dedicated to her city for 29Rooms' first installment in Chicago, through Refinery 29. She co-created and co-hosts Big Kid Slam, a monthly poetry show in Chicago. Jackson continues to instruct workshops through Poetry Foundation, InsideOut Literary Arts, and more. She pushes educators to implement culturally relevant poetry within their curriculum using her five years of experience teaching elementary grades in Chicago Public Schools. Jackson's work has been published by many journals – including *Poetry, The Rumpus, The Shallow Ends,* and *Washington Square Review*. Her debut collection *Even Saints Audition* was recently published through Button Poetry. That collection won Best New Poetry Collection by a Chicagoan in the *Chicago Reader* in fall of 2019.

Larry Janowski, son of a used car dealer, grew up on the South Side of Chicago and earned his BA at the University of Illinois Chicago, after which he went to graduate school at the University of Wisconsin in Madison and seminary at Aquinas Institute of Theology in Dubuque, Iowa. He earned an MFA from Vermont College. He joined the Franciscans in 1968, and was ordained in 1973. He has won prizes in fiction and poetry, received development grants from the state of Wisconsin and city of Chicago, a residency at the Blue Mountain Center, and the J.R.H. Moorman Scholarship at St. Deiniol's Residential Library in Great Britain. He has published two chapbooks: *Chicago Cantata* (2001) and *Celibate Dazzled* (2003). His full-length collections include *Brotherkeeper* (Puddin'head Press) and *Dancing A Dizzy Holiness* (After Hours Press, 2019).

Jac Jemc is the author of the novels *My Only Wife*, winner of the Paula Anderson Book Award, and *The Grip of It*, plus the short story collections *A Different Bed Every Time* and *False Bingo*, winner of the Chicago Review of Books Award for fiction and finalist for the Story Prize and a Lambda Literary Award. Her forthcoming novel, *Empty Theatre*, will be published in 2022. Jemc currently teaches creative writing at UC San Diego.

Philip Jenks is the author of three full-length books of poems, most recently *Colony Collapse Metaphor* (Fence Books). He also co-authored a book of poetry with Simone Muench, *Disap-*

Contributors

pearing Address. Jenks earned a BA from Reed College, an MA in creative writing from Boston University, and a Ph.D. in political science from University of Kentucky. He lives in Chicago. He has taught at many colleges including Portland State University, University of Illinois, and Roosevelt University. Recently, he had the honor of teaching grades 6-12 at the wonderful Fusion Academy. He is pursuing a Master's degree in special education.

Tyehimba Jess is the author of two books of poetry, *Leadbelly* and *Olio*. *Olio* won the 2017 Pulitzer Prize, the Anisfield-Wolf Book Award, the Society of Midland Society Author's Award in Poetry, and received an Outstanding Contribution to Publishing Citation from the Black Caucus of the American Library Association. It was also nominated for the National Book Critics Circle Award, the PEN Jean Stein Book Award, and the Kingsley Tufts Poetry Award. *Leadbelly* was a winner of the 2004 National Poetry Series. The Library Journal and Black Issues Book Review both named it one of the "Best Poetry Books of 2005." Jess, a Cave Canem and NYU Alumni, received a 2004 Literature Fellowship from the National Endowment for the Arts, and was a 2004-2005 Winter Fellow at the Provincetown Fine Arts Work Center. Jess is also a veteran of the 2000 and 2001 Green Mill Poetry Slam Team, and won a 2000–2001 Illinois Arts Council Fellowship in Poetry, the 2001 Chicago Sun-Times Poetry Award, and a 2006 Whiting Fellowship.

Tonika Lewis Johnson is a photographer, social justice artist, and life-long resident of Chicago's South Side neighborhood of Englewood. Her art often explores urban segregation. Tonika's acclaimed *Folded Map* project visually investigates disparities among "map twins"— Chicago residents who live on opposite ends of the same streets across the city's racial and economic divides – and brings them together to have a conversation. *Folded Map* debuted as an exhibition at Loyola University Museum of Art in 2018. Since then, Tonika has transformed *Folded Map* into an advocacy and policy-influencing tool that invites audiences to open a dialogue about how we are all socially impacted by racial and institutional conditions that segregate Chicago. In 2020, Tonika formalized Folded Map into a nonprofit organization, where she serves as creative executive officer. She is also co-founder of the Englewood Arts Collective and Resident Association of Greater Englewood, which seek to reframe the narrative of South Side communities, and mobilize people and resources for positive change. Tonika is working on her newest project: *Inequity for Sale*, which highlights the living history of Greater Englewood homes sold on Land Sale Contracts in the 50s and 60s.

Richard Jones is a poet, editor, and professor of English at DePaul University. His most recent book of poems is *Avalon* (Green Linden Press, 2020), and his many poetry collections include *Stranger on Earth, Country of Air, At Last We Enter Paradise, A Perfect Time*, and *Apropos of Nothing* (all from Copper Canyon Press). His selected poems, *The Blessing*, won the Society of Midland Authors Award for Poetry in 2000. For forty years he has been the editor of *Poetry East*, an award-winning literary journal that celebrates poetry, translation, and art from around the world.

Mohja Kahf is professor of comparative literature and Middle Eastern studies at the University of Arkansas. Her six books include the novel *The Girl in the Tangerine Scarf*, the story of a Syrian immigrant family in 1970s Indianapolis. Her writing has been translated into Arabic, Turkish, Persian, Urdu, Japanese, Italian, German, and French. Winner of a Pushcart Prize and an Arkansas Arts Council Individual Artist award, Kahf is a founding member of the Radius of Arab American Writers, served on the board of the Ozark Poets and Writers

Contributors

Collective in Fayetteville, Arkansas, and is a member of the Syrian Nonviolence Movement, founded by protest organizers inside Syria.

Peter Kahn is an English teacher and Spoken Word Educator at Oak Park and River Forest High School, where he created the Spoken Word club in 1999. A founding member of the London poetry collective Malika's Kitchen, he also co-founded the London Teenage Poetry Slam. As Visiting Fellow at Goldsmiths-University of London, Kahn created the Spoken Word Education Training Programme. A runner-up in the NCTE and Penguin Random House Maya Angelou Teacher Award for Poetry, Kahn edited *The Golden Shovel Anthology: New Poems Honoring Gwendolyn Brooks* with Patricia Smith and Ravi Shankar. He is the author of *Little Kings* (Nine Arches Press, 2020).

Lasana D. Kazembe, a Chicago native son, is an Assistant Professor of Education and Africana Studies at IUPUI. He is a poet, educator, and critical Black scholar examining culture, race, and arts pedagogy. A major aspect of his work examines the history, political thrusts, expressive culture, aesthetic foundations, and audiopolitics of 20th century Global Black Arts Movements. Kazembe's latest book, *Keeping Peace: Reflections on Life, Legacy, Commitment, and Struggle* (2018) was published by Third World Press Foundation. His blues poetry opera, *The Voodoo of Hell's Half-Acre: The Travelin' Genius of Richard Wright*, premiered nationally on PBS.

Mary Kinzie is the author of seven volumes of poetry, including *Drift, Autumn Eros, California Sorrow,* and *Summers of Vietnam*. The poem included here, "The Mary Chapel," appeared in her volume *Ghost Ship* (Knopf, 1996). Kinzie has served as the literary executor of American poet Louise Bogan. She is the author of *A Poet's Guide to Poetry* (University of Chicago, 2013), and has written extensively about poetry and fiction. For 44 years, until she retired in 2019, Kinzie taught at Northwestern University.

Aviya Kushner grew up in a Hebrew-speaking home in New York. She is the author of *Wolf Lamb Bomb* (Orison Books, 2021), winner of the Chicago Review of Books Award in Poetry; *The Grammar of God: A Journey into the Words and Worlds of the Bible* (Spiegel & Grau / Penguin Random House, 2015), a National Jewish Book Award Finalist and Sami Rohr Prize Finalist; and the chapbook *Eve and All the Wrong Men* (Dancing Girl Press, 2019). She is *The Forward's* language columnist and is an associate professor at Columbia College Chicago.

Quraysh Ali Lansana is author of 20 books of poetry, nonfiction, and children's literature. Lansana is currently a Tulsa Artist Fellow, Writer-in-Residence, and Adjunct Professor at Oklahoma State University-Tulsa. Lansana served as Director of the Gwendolyn Brooks Center for Black Literature and Creative Writing at Chicago State University from 2002-2012, and was associate professor of English/creative writing there until 2014. Lansana's work appears in *Best American Poetry 2019*, and his forthcoming titles include *Those Who Stayed: Life in 1921 Tulsa After the Massacre*.

Li-Young Lee is the author of five critically acclaimed books of poetry, most recently *The Undressing* (W.W. Norton, 2018), *Behind My Eyes* (W.W. Norton, 2008), and the chapbook *The Word From His Song* (BOA Editions, 2016). His earlier collections are *Book of My Nights* (BOA Editions, 2001); *Rose* (BOA, 1986), winner of the Delmore Schwartz Memorial Award from New York University; *The City in Which I Love You* (BOA, 1991), the 1990 Lamont Poetry Selection; and a memoir entitled *The Winged Seed: A Remembrance* (Simon and Schuster,

Contributors

1995), which received an American Book Award from the Before Columbus Foundation and was reissued by BOA Editions. Lee's honors include fellowships from the National Endowment for the Arts, the Lannan Foundation, and the John Simon Guggenheim Memorial Foundation, as well as grants from the Illinois Arts Council, the Commonwealth of Pennsylvania, and the Pennsylvania Council on the Arts.

Viola Lee graduated from NYU with an MFA in Poetry. Her book *Lightening after the Echo* was published by Another New Calligraphy. She has published poems in literary journals throughout the US, and has published in *Crazyhorse, Bellevue Literary Review, Literary Mama, Hong Kong Review, Crosswinds Poetry Journal, After Hours,* and *Another Chicago Magazine*. She has poems forthcoming in *Barrow Street, BOAAT PRESS, New Plains Review, Lotus Magazine,* and *North Dakota Quarterly*. She has collaborated with the *Chicago Reader* and the Poetry Foundation, and was a featured reader in the Poetry Foundation's Open Door Reading Series. She lives in Chicago with her husband, son and daughter. She teaches 1st, 2nd and 3rd graders at Near North Montessori School.

Laura Letinsky earned her BFA from the University of Manitoba, Winnipeg, Canada, and her MFA in Photography from Yale University's School of Art. Letinsky has been a professor at the University of Chicago since 1994. She shows with Yancey Richardson Gallery, NYC, and Document, Chicago, and exhibits internationally including PhotoEspana, Madrid; the Israeli International Photography Festival; Mumbai Photography Festival, Mumbai, India; MIT, Cambridge, MA; Basel Design, The Photographers Gallery, London; and Denver Art Museum, CO. Awards include the Canada Council International Residency; Kunstlerhaus Bethanien, Berlin; The Canada Council Project Grants; the Anonymous Was a Woman Award; and the John Simon Guggenheim Fellowship. Her work is published in monographs and catalogues such as *To Want For Nothing; Roman Nvmerals,* 2019; *Time's Assignation,* Radius Books, 2017; *Ill Form and Void Full,* Radius Books, 2014; *Feast,* Smart Museum of Art, University of Chicago Press, 2013; *After All, Damiani,* 2010; *Hardly More Than Ever,* Renaissance Society, 2004; *Blink,* Phaidon Press, 2002; and *Venus Inferred,* University of Chicago Press, 2000.

Mary Livoni is a multimedia artist who lives in Chicago. Since 2016, she has collaborated with not-for-profit art alliances to create video, multimedia artworks, and motion graphics honoring notable Chicago authors, past and present, and emphasizing social justice. In 2017, she began a series of #cinepoems; these short original video collages amplify a section from a known work of poetry with metaphoric imagery, text, and music. From 2019 through Spring 2021, she served on the Chicago Literary Hall of Fame Board of Directors. She is currently in post-production on her first short film, *The Apprentice,* based on the Stuart Dybek story of the same title.

Haki R. Madhubuti is an award-winning poet, and one of the architects of the Black Arts Movement. He founded Third World Press in 1967 (the oldest continuously publishing independent Black book publisher in the world). His first four books of poetry from the Black Arts Movement, *Think Black* (1967), *Black Pride,* with an introduction by Dudley Randall (1968), *Don't Cry, Scream!* with an introduction by Gwendolyn Brooks (1969), and *We Walk the Way of the New World* (1970), all published by Broadside Press of Detroit, Michigan, sold over 140,000 copies between 1967-1971, making him one of the best-selling poets in the world. Madhubuti has published over 36 books (some under his former name, Don L. Lee). His book, *Black Men: Obsolete, Single, Dangerous? The African American Family in Transition* (1991)

Contributors

has more than one million copies in print. His poetry and essays have been published in over 100 anthologies and journals between 1997-2022. Madhubuti has taught at many colleges and universities, including Columbia College Chicago, Cornell University (making him the first Black poet-in-residence at an Ivy League University), Howard University (first poet-in-residency), Chicago State University (first Black male faculty member to be named University Distinguished Professor), and DePaul University (the last Ida B. Wells-Barnett University Distinguished Professor). He has shared his poetry and essays on four continents and over thirty-eight states in the United States. His latest book, *Taught By Women: Poems As Resistance Language, New And Selected* (2020), pays homage to women who influenced him. He is currently completing *We Are a Hated People: Poems and Essays of Who We Are*. In 2015 the Chicago Literary Hall of Fame presented Madhubuti with the Fuller Award for lifetime achievement.

Tom Mandel is the author of more than two dozen books. His poetry has been published in dozens of literary journals, magazines, anthologies, and other publications, as well as on websites that feature innovative writing. Mandel has been on the faculties of the University of Chicago, the University of Illinois Chicago, and San Francisco State University. He has also been a serial entrepreneur in the computer and Internet industries and was a pioneer in the development of social interaction and collaboration on the Web. He has worked as a consultant to UNESCO, a marketing executive, an acquisitions book editor at the Macmillan Company, a door-to-door salesman, and a short order cook. Mandel grew up in Chicago and was educated in its jazz and blues clubs as well as on the University of Chicago's Committee on Social Thought. He has lived in New York, Paris, San Francisco, and Washington, DC, and now resides in a small town on the Atlantic coast.

Kerry James Marshall, born in Birmingham, Alabama, is an internationally renowned artist, known best for his revolutionary portraits of Black subjects. Marshall's work interrogates Western art history, challenging and recontextualizing the canon to include themes and depictions that have been historically omitted. Marrying formal rigor and social engagement, Marshall's practice foregrounds painting but encompasses a range of media, from comics to sculpture, striving towards a literal and conceptual Black aesthetic. His highly successful career survey exhibition *Mastry* was exhibited at the Museum of Contemporary Art in Chicago in 2016 and traveled to the Met Breuer and the Museum of Contemporary Art, Los Angeles. He has had other solo exhibitions at such prominent institutions as the Reina Sofía, Madrid (2014), National Gallery of Art, Washington, DC (2013); the Secession, Vienna (2012); the Camden Arts Centre, London (2008); the Studio Museum in Harlem, New York (2004); The Renaissance Society at the University of Chicago (1998); and many others. He is the recipient of such honors as the W.E.B. Du Bois Medal from Harvard University (2019) and the Wolfgang Hahn Prize from the Museum Ludwig in Cologne (2014), and was appointed to Barack Obama's Committee on the Arts and Humanities in 2013.

Maya Marshall is the author of *All the Blood Involved in Love and Secondhand*. She is co-founder of *underbelly*, the journal on the practical magic of poetic revision. Also an educator, Marshall is the 2021-2023 Poetry Fellow at Emory University. She has taught at Northwestern University and Loyola University Chicago, and holds fellowships from MacDowell and Cave Canem, among others. Marshall's writing is forthcoming or has been published in *Boston Review*, *Crazyhorse*, in *Best New Poets*, and elsewhere. She works as an editor at Haymarket Books.

Paul Martínez Pompa is the author of *My Kill Adore Him* (Notre Dame University Press,

Contributors

2009). He edits for *Packingtown Review* and teaches at Triton College, River Grove, IL.

Marty McConnell is a poet, educator, and healer based in Chicago. She is the author of *when they say you can't go home again, what they mean is you were never there,* winner of the 2017 Michael Waters Poetry Prize. McConnell's first full-length poetry collection, *wine for a shotgun,* received the Silver Medal in the Independent Publishers Awards, and was a finalist for both the Audre Lorde Award and a Lambda Literary Award. YesYes Books recently released McConnell's first nonfiction book, *Gathering Voices: Creating a Community-Based Poetry Workshop.* She is the co-creator and co-editor of *underbelly,* a website focused on the art and magic of poetry revision. An MFA graduate of Sarah Lawrence College, McConnell's work has appeared in numerous journals and anthologies, including *Best American Poetry, Southern Humanities Review, Gulf Coast,* and *Indiana Review.*

Daniel McGee is a triplet, poet, and film enthusiast from the Chicagoland area. He is currently an MA student at the University of Illinois Chicago. He has been published in literary journals including *After Hours, Wales Haiku Journal, CP Quarterly,* and *The Hopper.*

Campbell McGrath is the author of eleven books of poetry, including *XX: Poems for the Twentieth Century,* a finalist for the 2017 Pulitzer Prize. His many awards include the Kingsley Tufts Award, a Guggenheim Fellowship, and a MacArthur Fellowship. His poetry has appeared in numerous magazines such as *The New Yorker,* and in scores of literary reviews. He lives with his family in Miami Beach and teaches at Florida International University, where he is the Philip and Patricia Frost Professor of Creative Writing and a Distinguished University Professor of English.

James McManus is the author of *Positively Fifth Street, Going to the Sun,* and nine other books of poetry, fiction, and fact. His work has appeared in *The New York Times, The New Yorker, Esquire, Harper's, Paris Review, The Believer,* and in *Best American* anthologies of poetry, sports writing, political writing, magazine writing, and science and nature writing. He was born in the Bronx and has taught since 1981 at the School of the Art Institute of Chicago.

Patricia McMillen is a banjo player, activist, and retired lawyer from northern Illinois. Since 1998, her poems have been published in */nor, RHINO, After Hours,* and other journals, plus several poetry anthologies. Her poems have opened the door to several residencies at Ragdale Foundation. Her chapbook, *Knife Lake Anthology,* was published in 2006 by Pudding House Publications (Columbus, OH). When not writing or revising her poetry and memoir, McMillen also serves as honorary human for Joey, a mini Bernedoodle puppy born in December 2020.

Robin Metz (1942-2018) published poetry, fiction, and creative nonfiction in the *Paris Review, International Poetry Review, Visions International, Epoch, Other Voices, Abiko Quarterly (Japan), New Welsh Review (Wales), The Wolf (UK), Van Gogh's Ear (France), Rosebud, Fourth River, Writers' Forum,* and some eighty other US and international journals, as well as numerous anthologies. His book of poetry *Unbidden Angel* was awarded the Rainer Maria Rilke International Poetry Prize, nominated for the London Guardian Book of the Year Award, and cited for excellence by the White House Commission on Complementary and Alternative Health. Metz won numerous writing awards and fellowships including PEN International, NEA, Illinois Arts Council, Harper and Row, and Best American Stories. In

Contributors

2007, he was named American Poet-in-Residence in Kathmandu, Nepal, and won the First Prize of the Literal Latte International Poetry Competition (New York City). Metz presented performance readings of his work in over 50 U.S. cities and 22 nations, including the United Kingdom, Italy, Cuba, Kosovo, Greece, Poland, Romania, Germany, Ireland, France, and India. For 51 years he served as the founding Director of Creative Writing at Knox College. He was co-founder/Executive Producer of Vitalist Theatre Company (Chicago), where his play *Anung's First American Christmas* was initially produced.

Gwendolyn A. Mitchell is a poet, publishing consultant, and former senior editor of Third World Press. She has conducted workshops and seminars on poetry and the literary arts across the country. Mitchell is co-editor of two literary anthologies and the author of *House of Women* (Third World Press, 2003).

Faisal Mohyuddin is a writer, educator, and visual artist. The author of *The Displaced Children of Displaced Children* (Eyewear Publishing, 2018) and the chapbook *The Riddle of Longing* (Backbone Press, 2017), his work has received an Illinois Arts Council Literary Award, a Gwendolyn Brooks Poetry Award, *Prairie Schooner's* Edward Stanley Award, and acclaim from the Poetry Book Society, the Forward Arts Foundation, and the Association of Asian American Studies. His poetry has appeared in several journals and anthologies and been featured on "On Being's" *Poetry Unbound* podcast and on the YouTube series *Ours Poetica*. His visual art was selected for the American Muslim Futures online exhibition and graces the cover of *New Moons: Contemporary Writing by North American Muslims* (Red Hen Press, 2021). Faisal teaches at Highland Park High School in suburban Chicago and at the School of Professional Studies at Northwestern University. He also serves as a master practitioner for Narrative 4, a global not-for-profit dedicated to fostering empathy through the exchange of stories.

Simone Muench is the author of several books including *Orange Crush* (Sarabande, 2010), *Wolf Centos* (Sarabande, 2014), and *Suture* (Black Lawrence Press, 2017), sonnets co-written with Dean Rader. Most recently, she co-edited *They Said: A Multi-Genre Anthology of Contemporary Collaborative Writing* (Black Lawrence). A recipient of an NEA poetry fellowship and a Meier Foundation for the Arts Award, Muench is a professor at Lewis University, where she serves as faculty advisor for *Jet Fuel Review*. She is also a poetry editor for *Tupelo Quarterly*. Her latest collaborative chapbook, *Hex & Howl*, co-written with Jackie K. White, is from Black Lawrence Press, 2021.

Dipika Mukherjee's latest poetry collection, *Dialect of Distant Harbors*, will be published by CavanKerry Press in October 2022. She is the author of the poetry collections *The Palimpsest of Exile* (Rubicon Press, 2009) and *The Third Glass of Wine* (Kolkata: Writers's Workshop, 2015). Her poetry appears in publications around the world, including *RHINO*, *PostColonial Text*, *World Literature Today*, *Asia Literary Review*, *Del Sol Review*, and *Chicago Quarterly Review*. She teaches at the Graham School at University of Chicago as well as at StoryStudio Chicago.

Julie Parson Nesbitt is the author of *Finders* (West End Press, 1996), and received the Gwendolyn Brooks Significant Illinois Poet Award. Other publications include *A Cool Baby and A Good One Too: Reflections Of A White Mom (What Does It Mean To Be White In America* (2Leaf Press, 2016). A veteran of the first Chicago poetry slams, she served as Executive Director of the Guild Complex and Development Director of Young Chicago Authors. She

Contributors

is currently doing research for a book on families' experiences of exclusionary punishments in Chicago public schools for a doctorate at DePaul University.

Aimee Nezhukumatathil is the author of *World of Wonders: In Praise of Fireflies, Whale Sharks, and Other Astonishments* (Milkweed Editions) named 2020 Barnes and Noble Book of the Year and finalist for the Kirkus Prize in nonfiction. She is also the author of four books of poetry, and poetry editor of *Sierra*, the national magazine of the Sierra Club. With Ross Gay, Nezhukumatathil co-authored *Lace & Pyrite: Letters from Two Gardens* (Organic Weapon Arts, 2014), a chapbook of poems about their respective gardens. Awards for her writing include a fellowship from the Mississippi Arts Council, Mississippi Institute of Arts and Letters Award for poetry, National Endowment for the Arts, and the Guggenheim Foundation. She is professor of English and creative writing in the University of Mississippi's MFA program.

Yolanda Nieves, born and raised in Chicago's Humboldt Park neighborhood, is an award-winning poet, playwright, director, educator, actress, and founder of the Vida Bella Ensemble. Author of two highly acclaimed poetry books, *Dove Over Clouds* (Plain View Press, 2007) and *The Spoken Body* (Plain View Press, 2010), Nieves's research and poetry have been featured in journals including Hunter College's prestigious *El Centro Journal for Puerto Rican Studies*. She is an associate professor at Wright College, and holds a bachelor's degree from Loyola University Chicago, a master's degree in Organizational Development from Loyola University Chicago, a master's degree in Reading from Northeastern Illinois University, and an Ed.D. in Adult Education from National-Louis University.

Raúl Niño is the author of *Breathing Light* (MARCH/Abrazo Press, 1991) and the chapbook *A Book of Mornings* (MARCH/Abrazo Press, 2007). In 1992, he was named Poetry Ambassador to Chicago's sister city Mexico City by Mayor Richard M. Daley. He was the 1994 recipient of the Significant Illinois Poet Award, selected and presented by Gwendolyn Brooks. He writes book reviews for *Booklist* magazine.

Xavier Nuez's unusual, innovative and painterly approach to lighting and photography has created a distinct celebration of all things scary, ugly or banal. *The New York Times* has called his "Alleys & Ruins" series a masterpiece. His photographs have been featured in solo and group exhibitions in museums and galleries internationally, and are in numerous collections worldwide. Xavier's family is from Spain. He was born in Montreal and lives in Chicago.

Ugochi Nwaogwugwu is a multidisciplinary creative. A professional poet, writer, internationally renowned musician, poetry instructor, and founder of Spirit Speaks, Inc., Ugochi has executive produced, written, and co-arranged three album projects: *African Buttafly, A.S.E.* and *Love Shot*. Her poems have been published in *Storm Between Two Fingers*, an international anthology released in the UK, and *Golden Shovel Anthology*, honoring Gwendolyn Brooks. Ugochi has created an original Pan-African poetry form called #Ikepoem, paying homage to her Igbo family of Nigeria as well as her Black African cousins throughout the diaspora. She has also written newsworthy blogs and essays including "Not My President," published by Third World Press.

Achy Obejas is the author of the bilingual collection *Boomerang/Bumerán* (Beacon, 2021), as well as several novels and story collections. As a translator, she's worked with Rita Indiana, Wendy Guerra, Junot Díaz, and many others. Currently, she's a writer/editor for Netflix in the San Francisco Bay area.

Contributors

Dwight Okita is the author of the poetry collection *Crossing with the Light* (Tia Chucha Press, 1992). He has also written speculative novels: *The Prospect of My Arrival*, *The Hope Store*, and *Before I Disappear*. Okita is currently working on a memoir, THE INVENTION OF FIREFLIES: A Memoir of the Magical & the Monstrous.

José Olivarez is the son of Mexican immigrants. His debut book of poems, *Citizen Illegal* (Haymarket Books, 2018), was a finalist for the PEN/ Jean Stein Award and winner of the 2018 Chicago Review of Books Poetry Prize. It was named a top book of 2018 by *The Adroit Journal*, NPR, and the New York Public Library. Along with Felicia Chavez and Willie Perdomo, Olivarez co-edited the anthology *The BreakBeat Poets Vol. 4: LatiNEXT*.

Elise Paschen is the author of *The Nightlife* (Red Hen Press, 2019), named one of the top poetry books of 2017 by the *Chicago Review of Books*; *Bestiary, Infidelities* (Red Hen Press, 2009), winner of the Nicholas Roerich Poetry Prize; and *Houses: Coasts* (Story Line Press, 1996). As an undergraduate at Harvard, she received the Garrison Medal for poetry. She holds M.Phil. and D.Phil. degrees from Oxford University. A recipient of the Rupert Costo Chair in American Indian Affairs Medal, Paschen is an enrolled member of the Osage Nation. Her poems have been published widely, including *Poetry, The New Yorker, A Norton Anthology of Native Nations Poetry*, and *The Best American Poetry 2018*. She has edited numerous anthologies, including *The Eloquent Poem* (Sycamore Press, 1985). Paschen teaches in the MFA Writing Program at the School of the Art Institute and lives in Chicago.

Coya Paz was conceived in Chicago, and raised in Peru, Bolivia, Colombia, Ecuador, Brazil, and the United States. She is the artistic director at Free Street Theater, and an associate professor in The Theatre School at DePaul University. Above all, she believes in the power of poetry and performance to build community towards social change.

Useni Eugene Perkins has been truly blessed with two successful careers. As a human service practitioner, he was president of the Better Boys Foundation in Chicago, president of the Portland Urban League, and director of Chicago State University's Family Life Center. As a poet, playwright, and author, he served as president of the DuSable Museum of African American History, president of the African American Arts Alliance, and chairman of Artists for Harold Washington, a city-wide coalition of artists that campaigned on behalf of Chicago's first Black mayor. Perkins is also the presiding elder for the National Rites of Passage, and was inducted into the Gwendolyn Brooks National Literary Hall of Fame for writers of African descent in 1999. In 2002, he was awarded the National Black Theater Network Award for Playwriting. His illustrated poem for children entitled "Kwame Nkrumah's Midnight Speech for Independence" won the Children's Africana Book Award for 2022.

Mary Phelan is a Chicago urbanscape painter. Her career includes: chairing the Life Drawing and Foundations Departments at the American Academy of Art, Chicago; magazine and book illustration; and commissioned works for universities, hospitals, museums, and private collections. She has exhibited extensively in group and solo shows, most recently at the Miami University Art Museum (Ohio): "Comfort Zones: The Crossroads of Urban and Rural."

Sterling Plumpp, a 2019 Chicago Literary Hall of Fame Fuller Award for lifetime achieve-

Contributors

ment recipient, is the author of 14 books including *Home/Bass* (Third World Press, 2013), *Velvet Bebop Kente Cloth* (Third World Press, 2007), *Ornate with Smoke* (Third World Press, 1997), and *Blues Narrative* (Tia Chucha Press, 1999). He is the editor of several anthologies, including a collection of South African writing. His poetry has won Plumpp many awards, including several Illinois Arts Council Literary Awards, an American Book Award, and a Carl Sandburg Literary Award. He is Professor Emeritus at the University of Illinois at Chicago where he served on the faculty in the African American Studies and English Departments and most recently served as a visiting professor in the Master of Fine Arts Program at Chicago State University. He was born in Clinton, Mississippi, but moved to Chicago in 1962.

C. Russell Price is originally from Glade Spring, Virginia, but now lives in Chicago. They are a Lambda Fellow in Poetry, a Ragdale Fellow, a Windy City Times 30 Under 30 honoree, an essayist, and a poet. They are the author of a chapbook, *Tonight, We Fuck the Trailer Park Out of Each Other* (Sibling Rivalry Press, 2016). Their work has appeared in the *Boston Review, Court Green, DIAGRAM, Iron Horse Literary Review, Lambda Literary, Nimrod International, PANK*, and elsewhere. Their full-length collection is *oh, you thought this was a date?!: Apocalypse Poems,* (Northwestern University Press, 2022).

Christina Pugh has published five books of poems including *Stardust Media* (University of Massachusetts Press, 2020), winner of the Juniper Prize for Poetry; and *Perception* (Four Way Books, 2017), named one of the top poetry books of 2017 by *Chicago Review of Books*. Her poems have appeared in *The Atlantic, Poetry, Kenyon Review, Yale Review*, and other publications. A former Guggenheim fellow and visiting artist at the American Academy in Rome, she is a professor in the Program for Writers University of Illinois at Chicago.

Mike Puican's work has appeared in journals such as *Poetry, Michigan Quarterly Review*, and *New England Review*. His debut book of poetry, *Central Air*, was released by Northwestern University Press in August, 2020. He was a member of the 1996 Chicago Poetry Slam Team, and has been a long-time board member of the Guild Literary Complex. He teaches poetry to incarcerated and formerly incarcerated individuals at the Federal Metropolitan Correctional Center and St. Leonard's House, both in Chicago.

Ruben Quesada is a poet and editor. He is editor of *LatinX Poetics: Essays on the Art of Poetry* (University of New Mexico Press, 2022), author of *Revelations* (Sibling Rivalry Press, 2018), *Next Extinct Mammal* (Greenhouse Review Press, 2011), and translator of *Exile from The Throne of Night: Selected Translations of Luis Cernuda* (Aureole Press, 2008). His writing appears in *Best American Poetry, American Poetry Review, Harvard Review*, and other journals.

Ed Roberson is the author of many books of poetry, including *Asked What Has Changed* (Wesleyan University Press, 2021) and *MPH and Other Road Poems* (Verge Books, 2021). Roberson has lived in Chicago since 2004, and is an emeritus professor in Northwestern University's MFA creative writing program. He has also held posts at the University of Chicago, Columbia College, the University of California, Berkeley, and the Cave Canem retreat for Black writers. His honors include the Jackson Poetry Prize, the Shelley Memorial Award, the Ruth Lilly Poetry Prize, the Lila Wallace-Reader's Digest Writers' Award, and the African American Literature and Culture Association's Stephen Henderson Critics Award.

Luis J. Rodriguez served as Los Angeles Poet Laureate from 2014-2016. He has authored 16 books of poetry, fiction, nonfiction, and children's literature, including the bestselling

Contributors

memoir *Always Running, La Vida Loca, Gang Days in L.A.* (Atria Books, 2005). He is founding editor of Tia Chucha Press, begun in Chicago and now publishing for over 30 years, and co-founder of Tia Chucha's Centro Cultural & Bookstore in Los Angeles. His latest books are *Borrowed Bones: Poems* (Curbstone Books, 2016) and *From Our Land to Our Land: Essays, Journeys & Imaginings of a Native Xicanx Writer* (Seven Stories Press, 2020).

Vincent Romero is a Chicagoan and member of the Pueblo of Laguna of New Mexico. He's a facilitator at the Chicago American Indian Center's monthly Night of Poetry event. Romero is an artist and jewelry maker, as well as a lecturer on Southwest Pueblo people's history. He's also a U.S. Navy veteran and a proud grandfather.

Kathleen Rooney is the founding editor of Rose Metal Press and a founding member of Poems While You Wait. She is the author, most recently, of the novels *Lillian Boxfish Takes a Walk* (Daunt Books, 2017), and *Cher Ami and Major Whittlesey* (Penguin Books, 2020). Her poetry collection *Where Are the Snows*, winner of the X.J. Kennedy Prize, is forthcoming from Texas Review Press in Fall of 2022. She lives in Chicago with her spouse, the writer Martin Seay, and teaches at DePaul University.

Charles Rossiter has hosted the bi-weekly podcast "Poetry Spoken Here" since 2015. He's authored several books and chapbooks of poetry. The most recent is *Green Mountain Meditations*, available from Foothills Publishing.com. Rossiter has performed his poetry on NPR and at such venues as Nuyorican Poets Café, NYC; the Detroit Opera House; Green Mill, Chicago; and the Chicago Blues Festival.

Carlo Rotella is the author of books about cities, literature, boxing, blues, and other subjects. His most recent book is *The World Is Always Coming to An End: Pulling Together and Apart in a Chicago Neighborhood* (University of Chicago Press, 2020). He contributes regularly to the *New York Times Magazine* and the *Washington Post Magazine*, and his work has also appeared in *The New Yorker*, *Harper's*, and *The Best American Essays*. Rotella has received a Guggenheim fellowship and the Whiting Writers Award. He is a professor of English, American Studies, and Journalism at Boston College. He grew up in South Shore on the South Side of Chicago.

Jerome Sala's books include *Corporations Are People, Too!* (NYQ Books, 2017), *The Cheapskates* (Lunar Chandelier, 2014), *Look Slimmer Instantly* (Soft Skull, 2005), *Raw Deal* (Another Chicago Press, 1995), *The Trip* (Highlander Press,1987), *I Am Not a Juvenile Delinquent* (Stare Press, 1985), and *Spaz Attack* (Stare Press, 1985). Forthcoming is *How Much? New and Selected Poems* (NYQ Books). His poems and essays have appeared in *The Brooklyn Rail*, *Conjunctions*, *Pleiades*, *Boundary 2*, *Rolling Stone*, *The Best American Poetry* series, and many others. His blog on poetry and pop culture is *espresso bongo*.

cin salach, poet of page and stage, can almost always be found collaborating with musicians, video artists, dancers, photographers, and most recently, healers, chefs, and scientists. She is the Inaugural Poet Laureate of Covenant Farm in Sawyer, Michigan, where her two books of poetry are housed in the *Porch Swing Poetry Box*. Her business, poemgrown, helps people love louder with commissioned poetry to mark the most important occasions in their lives.

Sara Salgado is a poet and storyteller from Chicago's Hermosa neighborhood. She has appeared in several publications from *Rookie Magazine*, and you can find her in *The End of Chiraq: A Literary Mixtape*. Salgado's latest work also appears in *American Gun: A Poem by 100 Chicagoans*.

Contributors

She is a Kenwood Academy alum but really graduated from her grandmother's house. Her poetry delves into the scary truths and beautiful lessons from Latinidad, her neighborhood, her family, and her achy breaky heart.

Dmitry Samarov was born in Moscow, USSR, in 1970. He immigrated to the US with his family in 1978. He got in trouble in first grade for doodling on his Lenin Red Star pin and hasn't stopped doodling since. After a false start at Parsons School of Design in New York, he graduated with a BFA in painting and printmaking from the School of the Art Institute of Chicago in 1993. Upon graduation he promptly began driving a cab – first in Boston, then after a time, in Chicago – which eventually led to the publication of his illustrated work memoirs *Hack: Stories from a Chicago Cab* (University of Chicago Press, 2011) and *Where To? A Hack Memoir* (Curbside Splendor, 2014). *Music to My Eyes* (Tortoise Books, 2019) is his first non-cabbie-related book. *Soviet Stamps* (Pictures&Blather, 2020) is the second. *All Hack* (Pictures&Blather, 2020) is a summation of his cabbie-related work. *Old Style* (Pictures&Blather, 2021) is his first work of fiction.

Maureen Seaton has authored 23 poetry collections, both solo and collaborative – most recently, *Sweet World* (CavanKerry Press, 2019), a Florida Book Award gold medal winner in poetry. Honors include the Society of Midland Authors Award for *The Sea Among the Cupboards* (New Rivers Press, 1996); the Iowa Prize and the Lambda Literary Award for *Furious Cooking* (University of Iowa Press, 1996); the Audre Lorde Award for *Venus Examines Her Breast* (Carnegie Mellon University Press, 2004); an NEA fellowship; an Illinois Arts Council Grant; and two Pushcart Prizes. Seaton has taught poetry at Columbia College Chicago and the School of the Art Institute of Chicago, and is currently professor of English/creative writing at the University of Miami, Florida.

Leopold Segedin was born in Chicago in 1927, and received his BFA and MFA from the University of Illinois. He has taught at the University of Illinois, US Army Engineers, and at Northeastern Illinois University where he is art professor emeritus. Segedin has also taught at the Horwich JCC and the Evanston Art Center. He has painted full-time since retiring in 1987. Segedin's works have been shown at such museums as the Art Institute of Chicago (including the 60th Annual National Exhibition), the Corcoran Art Gallery in Washington, DC, and the Milwaukee Art Institute. He has had 15 one-man shows. Segedin has been a lecturer, writer, panelist and juror. Two books are available on his life and work: *Leopold Segedin: A Habit of Art* (Outbound Ike Publishing, 2018) and *Segedin x Segedin: Self Portraits and Cameos*.

Sun Yung Shin is the award-winning author of four books of poetry: *The Wet Hex* (Coffee House Press, 2022)*; Unbearable Splendor* (Coffee House Press, 2016)*; Rough, and Savage* (Coffee House Press, 2012); and *Skirt Full of Black* (Coffee House Press, 2007). She's also the editor/co-editor of three anthologies, and the author/co-author of two books for children. With fellow Korean immigrant poet Su Hwang, Shin co-directs Poetry Asylum. She is a full-time artist and cultural worker, and lives in Minneapolis with her family.

Barry Silesky is a poet, biographer, and magazine editor. In over 20 years under his editorship, *Another Chicago Magazine* rose from local renown as a graduate workshop literary magazine to win an international reputation. His books of poetry include *The New Tenants* (Eye of the Comet, 1991), *One Thing That Can Save Us* (Coffee House Press, 1994), and *This Dis-*

Contributors

ease (University of Tampa, 2007). He has also published biographies of Lawrence Ferlinghetti and John Gardner. He lives in Chicago with his wife, fiction writer Sharon Solwitz.

Marc Kelly Smith (born on Chicago's Southeast Side and an ex-construction worker) founded the weekly poetry show, Uptown Poetry Slam, now called the Uptown Poetry Cabaret; nearly 35 years later it is still a going concern at the Green Mill Tavern in Chicago. Under Smith's leadership, performance poetry and poetry slam shows have spread across the globe, into nightclubs, libraries, high schools, universities, and cultural institutions. Germany, Switzerland, France, England, Italy, Canada, Ireland, Madagascar, Singapore, and even the South Pole all have thriving poetry slam communities, modeled after The Uptown Poetry Cabaret. Smith has performed at more than 3,000 national and international venues. His book, *Crowdpleaser* (Collage Press, 1996), celebrates the Green Mill. His poetry has been featured in *Hammer's Magazine, Chicago Magazine, The Outlaw Bible of American Poetry*, and many others. He is on the artistic board of several Chicago-based performing arts companies and has recently debuted *Sandburg to Smith*, a musical adaptation of Carl Sandburg's poems and stories.

Patricia Smith is the winner of the 2021 Ruth Lilly Poetry Prize for lifetime achievement from the Poetry Foundation. She is the author of eight books of poetry, including *Incendiary Art* (Northwestern University Press, 2017), winner of the Kingsley Tufts Award, the *LA Times* Book Prize, the NAACP Image Award and finalist for the Pulitzer Prize; *Shoulda Been Jimi Savannah* (Coffee House Press, 2012), winner of the Lenore Marshall Prize from the Academy of American Poets; and *Blood Dazzler* (Coffee House Press, 2008), a National Book Award finalist. She is a Guggenheim fellow, an NEA grant recipient, a finalist for the Neudstadt Prize, a former fellow at Civitella Ranieri, Yaddo, and MacDowell, and a four-time individual champion of the National Poetry Slam, the most successful poet in the competition's history. Smith is currently a visiting professor at Princeton University and a distinguished professor for the City University of New York. She is currently at work on her first novel and second children's picture book; *Unshuttered*, a book of dramatic monologues accompanied by 19th century photos of African-Americans, will be released in the fall of 2022.

Diana Solís is a Chicago-based visual artist, photographer, and educator whose work includes photography, illustration, printmaking, comics, public murals, and installations. Inspired by Mexican and Chicano culture, memory, cautionary tales, urban culture, oral and personal histories, queer identities and narratives, her work examines notions of place, identity, and belonging.

Frank Spidale is a landscape painter living and working in the Chicago area. He received his BFA from the School of the Art Institute of Chicago and his MFA from American University, Washington, DC. He has exhibited nationally and internationally and was included in the 100 artists to watch in Modern Painters in 2012. In 2022, Spidale will have a solo exhibition of his paintings and drawings at Firecat Projects in Chicago. Currently, he is an assistant professor of painting, drawing, and printmaking at Dominican University, River Forest, IL.

Jennifer Steele is the author of the chapbook *A House In Its Hunger* (Central Square Press, 2018). She received her MFA in poetry from Columbia College Chicago and is a Callaloo Fellow and Poetry Incubator Fellow. She is the executive director of 826CHI, a writing and publishing center amplifying the voices and stories of Chicago's youth. She was featured in *Newcity's* 2020 Lit50 and is the inaugural recipient of the 2019 Lucille Clifton Creative Parent Award from Raising Mothers Magazine. She is the recipient of a 2020/21 Ragdale residency,

Contributors

and her work has appeared in *Hypertext Review, Pittsburgh Poetry Review, Another Chicago Magazine, Callaloo, Columbia Poetry Review,* and others. She is working on a full-length collection of poetry entitled *Belt*, and developing a collection of creative nonfiction.

Heidy Steidlmayer is the author of the poetry collection *Fowling Piece* (Northwestern University Press, 2012), which received the John C. Zacharis Award from *Ploughshares* and the Kate Tufts Discovery Award. Her poems have appeared in *Poetry, TriQuarterly, Ploughshares, The Cortland Review, Literary Imagination,* and *Michigan Quarterly Review*, among others, and in *Poems, Poets, Poetry: An Introduction and Anthology*, by Helen Vendler (Bedford/St. Martin's, 2002). Steidlmayer has been awarded the J. Howard and Barbara M.J. Wood Prize from *Poetry* magazine and a Rona Jaffe Foundation Writers Award.

Ira Sukrungruang is the author of the memoir *This Jade World* (Nebraska Press, 2021). He has written three nonfiction books: *Buddha's Dog & other mediations* (University of Tampa Press, 2018), *Southside Buddhist* (University of Tampa Press, 2014), and *Talk Thai: The Adventures of Buddhist Boy* (University of Missouri Press, 2011). Sukrungruang's two collections include short stories *The Melting Season* (Burlesque Press, 2016) and poetry, *In Thailand It Is Night* (University of Tampa Press, 2013). He is the president of Sweet: A Literary Confection and the Richard L. Thomas Professor of Creative Writing at Kenyon College.

Marvin Tate is an interdisciplinary artist and educator. His work has been heard locally and nationally.

Robbie Q. Telfer has performed and taught in hundreds of venues and institutions around the world. A co-founder of the Encyclopedia Show, he's been an individual finalist at the National Poetry Slam and has a collection of poetry from Write Bloody Publishing. Telfer runs a bi-weekly writing workshop webinar, "Poetry in Place." He is an environmental educator at The Morton Arboretum outside of Chicago.

Angela Narciso Torres is author of three poetry collections. Her most recent book is, *What Happens is Neither* (Four Way Books, 2021). She is a reviews editor for *RHINO*; her work has appeared in *Poetry, Prairie Schooner,* and *Poetry Northwest*.

Tony Trigilio's newest books are *Proof Something Happened* (Marsh Hawk Press, 2021) and *Ghosts of the Upper Floor* (BlazeVOX [books], 2019). His selected poems, *Fuera del Taller del Cosmos*, was published in Guatemala in 2018 by Editorial Poe and translated by Bony Hernández. Trigilio co-edits the poetry journal *Court Green*, and is a professor of English and creative writing at Columbia College Chicago.

David Trinidad's books of poetry include *Swinging on a Star* (Turtle Point Press, 2017), *Notes on a Past Life* (BlazeVOX [books], 2016), *Peyton Place: A Haiku Soap Opera* (Turtle Point, 2013), and *Dear Prudence: New and Selected Poems* (Turtle Point, 2011). *Digging to Wonderland* is forthcoming from Turtle Point in 2022. He is also the editor of *A Fast Life: The Collected Poems of Tim Dlugos* (Nightboat Books, 2011) and *Punk Rock Is Cool for the End of the World: Poems and Notebooks of Ed Smith* (Turtle Point, 2019). Trinidad lives in Chicago, where he is a professor of creative writing/poetry at Columbia College.

Mark Turcotte (Turtle Mountain Ojibwe) is the author of four poetry collections, and lives in Chicago where he teaches at DePaul University.

Contributors

Luis Alberto Urrea is a 2005 Pulitzer Prize finalist for nonfiction and member of the Latino Literature Hall of Fame. He is the critically acclaimed and best-selling author of 17 books, winning numerous awards for his poetry, fiction and essays. Born in Tijuana to a Mexican father and American mother, Urrea is most recognized as a border writer, though he says, "I am more interested in bridges, not borders." In 2021, Urrea was a recipient of the Fuller Award for lifetime achievement from the Chicago Literary Hall of Fame. In all, more than 100 cities and colleges have chosen *Into the Beautiful North* (Little Brown, 2009), *The Devil's Highway* (Little Brown, 2004) or *The Hummingbird's Daughter* (Back Bay Books, 2006), or another Urrea book for a community read. Urrea lives with his family in Naperville, IL, where he is a distinguished professor of creative writing at the University of Illinois Chicago.

Frank Varela is a Chicago expatriate who lived in the city for almost thirty years. He was a Chicago Public Library administrator and one of the curators of that library's annual Poetry Fest which attracted annually over 1,000 poets, writers, critics, and poetry lovers. He has also published four books of poetry: *Serpent Underfoot* (MARCH/Abrazo Press, 1993), *Bitter Coffee* (MARCH/Abrazo Press, 2001), *Caleb's Exile* (Elf: Creative Workshop, 2009), and *Diaspora: Selected and New Poems* (Arte Publico Press, 2016). He is currently a resident of Las Cruces, New Mexico.

Johanny Vázquez Paz won the 2018 Paz Prize for Poetry, given by the National Poetry Series in partnership with the Miami Book Fair, for *I Offer My Heart as a Target / Ofrezco mi corazo_n como una diana* (Akashic Books). Her other publications include *Sagrada familia* (winner of the International Latino Book Award, 2015), *Querido voyeur* (Ediciones Torremozas, Spain, 2012), and Streetwise Poems /Poemas callejeros (Mayapple Press, 2007). She also co-edited the anthology *Between the Heart and the Land / Entre el corazón y la tierra: Latina Poets in the Midwest* (MARCH/Abrazo Press, 2001).

Chuck Walker paints with passion and imagination. His subjects are humble and heroic. They are intersective and not so easy to detect. They can be romantic, vulnerable, and self-absorbed. Chuck Walker's work has been exhibited at numerous venues, including the Rockford Art Museum, IL; Hyde Park Art Center, Chicago; Chicago Cultural Center; Chicago Botanic Garden, IL; Chicago Museum of Contemporary Art; Contemporary Center for Art in St. Louis, MO; and Evanston Art Center and Artspace, IL, to name a few. His work is included in various private and public collections, such as the Chicago Museum of Contemporary Art, and the Tampa Museum of Art, FL. Walker's work has been discussed and reviewed in *Art News, New Art Examiner,* the *Chicago Tribune, Chicago Sun Times,* and *Art in America.* Walker attended the School of the Art Institute of Chicago.

Michael Warr's books include *Of Poetry and Protest: From Emmet Till to Trayvon Martin* (W.W. Norton, 2016), *The Armageddon of Funk* (Tia Chucha Press, 2011), and *We Are All The Black Boy* (Tia Chucha Press, 1990). He is the recipient of a 2021 San Francisco Artist Grant, 2020 Berkeley Poetry Festival Lifetime Achievement Award, and is a San Francisco Library Laureate. Other honors include a Creative Work Fund Award, PEN Oakland Josephine Miles Award for Excellence in Literature, Black Caucus of the American Library Association Award, Gwendolyn Brooks Significant Illinois Poets Award, and a National Endowment for the Arts Fellowship. Michael is the founding director of the Guild Literary Complex (Chicago), former deputy director of the Museum of the African Diaspora, and is a board member of the Friends of the San Francisco Public Library.

Contributors

Rachel Jamison Webster is an Associate Professor of Creative Writing at Northwestern University and author of the books *The Sea Came Up & Drowned* (Raw Books, 2020); *Mary is a River* (Kelsey Books, 2018), a finalist for the National Poetry Series in 2014; *September* (TriQuarterly, 2013); and the cross-genre volume *The Endless Unbegun* (Twelve Winters, 2015). Her poems, essays, and stories appear in dozens of journals and anthologies, including *The Yale Review, Poetry, Tin House, The Southern Review, Prairie Schooner, The Paris Review,* and *The LA Review of Books*. For many years, Webster worked with Chicago First Lady Maggie Daley to establish after-school arts apprenticeships for teens through Gallery 37 and After School Matters.

Santiago Weksler is a photographer and writer who was based in Chicago for many years. His photographs have been featured in a number of exhibitions in Chicago, as well as his native Peru. His work has appeared in *Contratiempo* and *After Hours*, where he was the featured artist for issue #22.

Amanda Williams is a visual artist and architect (Bachelor of Architecture from Cornell University). Her practice employs color as an operative means for drawing attention to the complex ways race informs how we assign value to the spaces we occupy. Williams' installations, sculptures, paintings, and works on paper seek to inspire new ways of looking at the familiar and, in the process, raise questions about the state of urban space and ownership in America. Amanda's exhibitions include the Museum of Modern Art in New York (2021), the Venice Architecture Biennale (2018), the Museum of Contemporary Art Chicago (2020), and at the Pulitzer Arts Foundation in St. Louis, a public commission with Andres L. Hernandez (2017). She is on the Museum Design Team for the Obama Presidential Library Center. Williams lives and works on the South Side of Chicago.

Phillip B. Williams is a Chicago native and author of *Thief in the Interior* (Alice James Books, 2016), winner of the 2017 Kate Tufts Discovery Award and a 2017 Lambda Literary Award; and *Mutiny* (Penguin Poetry, 2021). He received a 2017 Whiting Award and fellowship from the Radcliffe Institute for Advanced Study at Harvard University. He currently teaches in the Randolph College low-res MFA program.

Keith S. Wilson is an Affrilachian Poet and a Cave Canem fellow. He is a recipient of an NEA Fellowship, an Elizabeth George Foundation Grant, and an Illinois Arts Council Agency Award, and has received both a Kenyon Review Fellowship and a Stegner Fellowship. Additionally, Wilson has received fellowships or grants from Bread Loaf, Tin House, and the MacDowell Colony, among others. His book, *Fieldnotes on Ordinary Love* (Copper Canyon, 2019), was recognized by *The New York Times* as a best new book of poetry.

Rose Maria Woodson holds an MA in creative writing from Northwestern University and an MA in community development from North Park University. She is the author of two chapbooks, *Skin Gin* (2017 winner in the QuillsEdge Press chapbook contest) and *The Ombre Of Absence* (Dancing Girl Press), and the mini-chapbook *Dear Alfredo* (Pen and Anvil Press). Her poems have been published in numerous journals including *Inkwell, Clarion, Gravel, Third Wednesday Magazine, Magnolia: A Journal of Women's Socially Engaged Literature, Volume II, Jet Fuel Review,* and *Stirring*. Her short story "Cupcake Payne" appeared in Issue 46 of the *Oyez Review*.

Contributors

Emily Jungmin Yoon is the author of *A Cruelty Special to Our Species* (Ecco, 2018), winner of the 2019 Devil's Kitchen Reading Award and finalist for the 2020 Kate Tufts Discovery Award, and *Ordinary Misfortunes* (Tupelo Press, 2017), winner of the Sunken Garden Chapbook Prize. She has also translated and edited a chapbook of poems, *Against Healing: Nine Korean Poets* (Tilted Axis, 2019). She has accepted awards and fellowships from the Poetry Foundation and Bread Loaf Writers' Conference, among others. She is the Poetry Editor for *The Margins*, the literary magazine of the Asian American Writers' Workshop, and a Ph.D. candidate in Korean literature at the University of Chicago.

avery r. young is an interdisciplinary artist, educator, and co-director of The Floating Museum. He is a 3Arts Awardee and Cave Canem fellow. His poetry and prose have been featured in anthologies including *BreakBeat Poets, Teaching Black,* and *Poetry Magazine*, and alongside images in photographer Cecil McDonald Jr's *In The Company of Black* (Louisiana Literature Press, 2015). As artist-in-residence at the University of Chicago, young created a series of assemblage and sculpture along with his first recording, *booker t. soltreyne: a race rekkid*. His theater credits include co-writing and co-producing the soundtrack for Lise Haller Baggeson's *Hatorgrade Retrograde: The Musical* and writing the libretto for Lyric Opera of Chicago's *Twilight: Gods*. His performance and visual work have been exhibited and/or presented at the Art Institute of Chicago, the Museum of Contemporary Art Chicago, the National Jazz Museum, and other institutions.

Reggie Scott Young is a native of Chicago's North Lawndale neighborhood. He completed undergraduate and graduate degrees at UIC, including a doctorate with creative writing specialization. As a community poet, Young founded Bluesville, Inc., and coordinated the Lawndale Renaissance/Bluesville Creative Writing Workshops. During this time, he was honored with the Gwendolyn Brooks Significant Illinois Poets Award and the PEN Discovery Award. His work in higher education led him to work on faculties at Villanova, LSU, Wheaton College, the University of Louisiana, and other schools. His publications include the poetry volume *Yardbirds Squawking at the Moon*, and his poems, stories, and essays have appeared in a variety of magazines and journals including *African American Review, Fifth Wednesday Journal, Louisiana Literature, Oxford American*, and *Chicago Review*.

Susan Yount lives and works in Bloomington, Indiana.

Acknowledgments

The Chicago Literary Hall of Fame and Founding Executive Director Don Evans would like to recognize the following people and organizations for their support of this book project:

A lot of work and a lot of years went into the completion of this poetry anthology. It started as the brainchild of **Robin Metz** and **Nina Corwin**, back in 2009, and their vision guided me throughout this process. The time Robin and Nina spent collecting poems and hashing out content for the book laid a foundation upon which I built.

Liz Metz worked tirelessly to honor her husband's legacy through the completion of this project. She provided me with all the files and notes and ephemera necessary to investigate the product of Robin and Nina's previous work. She also provided resources and counsel to ensure that the project was funded and generally set up for success.

It was only through the partnership of the two co-publishers, **After Hours Press** and **Third World Press**, along with **MARCH/Abrazo Press'** support, that this idea became a book. **Albert DeGenova**, After Hours' publisher and co-editor for more than two decades, undertook major production and editorial responsibilities, and did so with an unmatched level of determination, creativity and professionalism. **Haki Madhubuti,** among many other accomplishments the leader of the longest running and most respected Black press in America, magnanimously agreed, as always with grace and generosity, to bring his many resources and talents to bear on this project. **Carlos Cumpián**, a wise and seasoned veteran of small publications, freely shared the fruits of his experience as he labored to give this small book big attention. These three men rank high on everyone's list of cultural ambassadors and showed, once again, how their unique combinations of integrity, intelligence, and passion elevate the work that they did and do.

Barry Jung exhaustively proofed this manuscript in order to rid it of all its errors, imperfections, and inconsistencies. His genius begins with obsession and dedication; he's somebody that wants to work and always gets more done than anybody around him.

Gail Bush, editor of the incredible poetry anthology, *Indivisible: Poems for Social Justice,* shared fountains of wisdom gleaned through her own lengthy commitment to making a book of this sort. She also lent her editorial genius to the proofing process.

Faisal Mohyuddin guided us with his sophisticated editorial hand to tighter, cleaner copy.

Gwendolyn Mitchell, an enormously experienced editor, consulted on some of the finer points of the manuscript.

Cate Plys applied her considerable editorial talents to shaping and trimming the extensive biography section of the book.

The uber talented **Rich Kono** and **Hannah Jennings** created a delightful presence for the anthology on the CLHOF website that will be a permanent landing place for those curious about the book.

Breaker Press, particularly **Rich Lewandowski** and **Nicole Huppenthal**, made sure the print quality lived up to the exceptionally high standards of the writing and art.

Acknowledgments

Knox College intern **Jocelyn Ruby** provided editorial help, as well, and worked to secure a grant that in part aided this project. Knox College intern **Luis Mateo** also helped secure funding. Knox College interns **Sage Lundquist** and **Kate Snyder**, as well as DePaul's **Daniel Carroll**, invested their precious academic hours (and then some) to helping this book realize its commercial potential.

Chicago Literary Hall of Fame's Associate Board, including **Kelci Dean, Angie Raney, Melanie Weiss, Joseph Doyague, Allison Manley, Emily Winkler**, and **Sarah Dunne** put in a lot of time to support this book.

The governing Board, led by **Amy Danzer**, made it their mission that this book would succeed. **Randy Albers, Barry Benson, Susan Dennison, Michele Morano, Richard Guzman, Roberta Rubin, Dave Stern, Jarrett Neal, Rebecca Borowicz** and **Barbara Egel** all played parts. Susan also designed and crafted lovely handmade slipcases to gift to some of the angels that made this book possible.

Many of the poets featured in this anthology, notably **Stuart Dybek, Reginald Gibbons, René Arceo, Chris Solis Green** and **Rachel DeWoskin**, took time to consult with me on Chicago's poetic and artistic landscape. So did **Donna Seaman** and **John Lillig**. Their advice led to the inclusion of many additional brilliant poems and images. Chris, whose stewardship of Big Shoulders Press has been an incredible asset to our publishing community, did a great deal to ensure that we were seizing every opportunity to give this book the audience it deserves.

In chasing down desired contributors, it was sometimes difficult to make contact. Many people helped with this, but I'd like to mention **Mapes Jane Thorson**, from Blue Flower Arts – she went above and beyond the call to help me locate an important poet now featured in the book. Likewise, Rhona Hoffman Gallery's **Elise Seigenthaler** and Jack Shainman Gallery's **Anna Model** worked to ensure that we would be able to include their artists in this book.

Finally, the poets and artists included in this anthology: their work is like gold but they get paid in copper. I have a deep admiration for their artistic vision, their meticulous craftsmanship, and all the years they labored and learned in order to produce work of such exquisite quality. **Carlo Rotello**'s extraordinary foreword provided a much-needed missing piece to this puzzle.

Supporting Donors

Elizabeth Metz

Michael Burke, Gail Bush, Rita Dragonette, Nora Duff, Virginia Harding, Michael Lewis, Eve Moran, Shanti Nagarkatti, Susan Nagarkatti, Malcom O'Hagan, Roberta Rubin, and Scott & Adriane Turow.

Contributing Donors

Randy Albers, Ronne Hartfield, Marie Hayes, Gary Johnson, and Della Leavitt.

This poetry anthology was also supported, in part, by the **Gaylord and Dorothy Donnelley Foundation**, the **Illinois Arts Council Association**, and **Third World Press Foundation**.